THESE OUR OFFERINGS

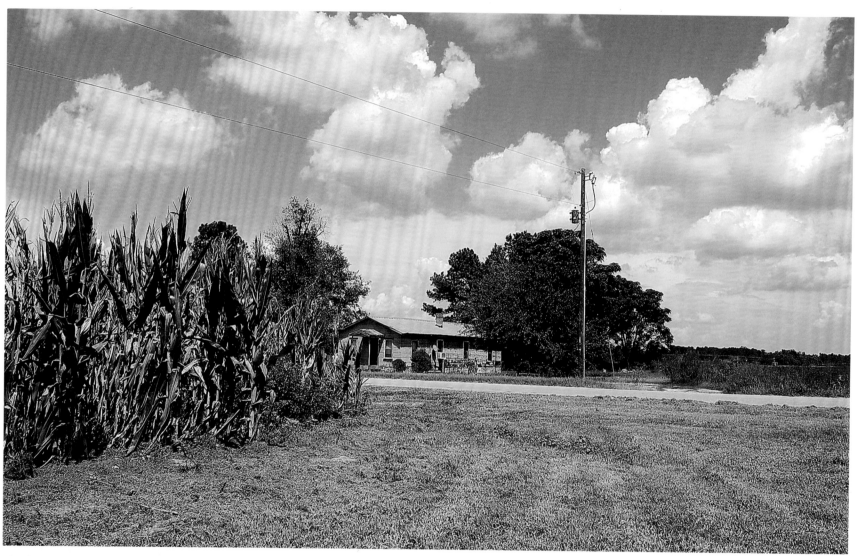

Clouds over a cornfield and homestead, Elloree, S.C.

THESE OUR OFFERINGS

A Place & Time of Southern Magic

POEMS *by* WILLIAM P. BALDWIN

PHOTOGRAPHS *by* SELDEN B. HILL

SHARON CUMBEE

ROBERT EPPS

WILLIAM P. BALDWIN

EVENINGPOSTBOOKS
Our Accent is Southern!
www.EveningPostBooks.com

Published by
Evening Post Books
Charleston, South Carolina
www.EveningPostBooks.com

First printing 2012
Printed and bound in the USA by Sun Printing.

A CIP catalog record for this book has been applied for from the Library of Congress.

ISBN: 978-1-929647-11-8

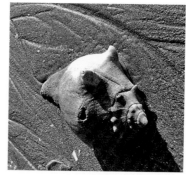

Conch shell, Cape Romain, S.C.

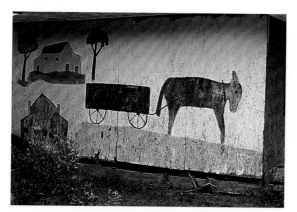

Folk art mural, Hemingway, S.C.

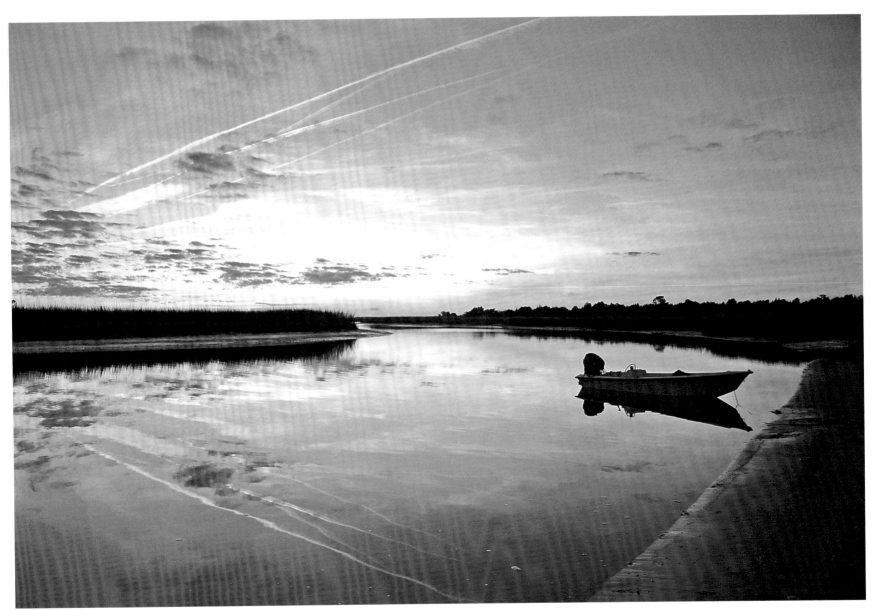

Beached boat at sunset, Cape Romain, S.C.

ACKNOWLEDGEMENTS

All four of us would like to thank John Burbage at Evening Post Publishing Company for his continuing faith in this project—and for his assurance that there is order in the world. And thanks to Katelin McGory, Holly Holladay and Gill Guerry of Evening Post Books. To Katelin for her sales and marketing expertise, to Holly for her encouragement and assistance with editing and production and to Gill for his help with production and design. And thanks again to our country-bred creative director and designer Carley Wilson Brown. As with *The Unpainted South* she did an excellent job of putting things where they belong.

Personally, I'd like to thank Harlan Greene. Harlan read every poem in this book not long after it was written (plus hundreds more), and even if displeased, managed to respond with some encouraging remark. His editing was essential. Thanks Harlan. You're a good and patient friend. For opening my tired old eyes, for saying "look here, look here," and also for a just a tiny bit of patience thanks to Bud Hill, Sharon Cumbee, and Robert Epps. For moral support and advice, I'd like to thank Sam Savage, Jane O'Boyle, Lillian Reeves, Mindy Burgin, Dale Rosengarten, Carlin Rosengarten, Aaron Baldwin, Stephanie Waldron, John McWilliams, MaryLou Thomson, Melanie Hartnett, Ellen Solomon, Maria Kirby-Smith, Lynda Solansky, Richard Wyndham, Sherry Browne, Susan Hindman, Anne Knight and Sam Watson, Alice Jordan, Patty and Jim Fulcher, V. Elizabeth Turk, Pete and Claudia Kornack, Aida Rogers, Dan Lesesne, Nancy Marshall, Andrea Stoney, Susan Glover Black, Suzannah Miles, Jo Humphreys, Emmy and Gary Bronson, Randy McClure, Dick Reed, Annie Banks, Virginia Street, and Rut Leland. And again thanks to Eddie White for being a great force to the good. Thanks to my favorite librarians Pat Gross and Janice Knight. For more religious instructions and great friendship thank you Rev. Jennie Olbrych, Rev. Callie Perkins and Rev. Dick Thomson. For keeping the computer going, my sons Aaron and Malcolm. For everything in the world my wife, Lil. And thank you, Yvonne, for treating Robert and me to lunch so many times.
— *William "Billy" Baldwin* ✒

I would like to start out by saying thank you to Bud Hill and Billy Baldwin for the wonderful friendship we've had over the years. You both inspire and encourage me to do whatever it is that an artist wants to do! Thanks for asking me to be a part of this awesome project! Thanks so much to my parents, Billy and Donna Cumbee, who lent their surroundings as well as love to so many of my photographs. To my sister Michele, who often keeps my head on straight, but encourages me to be who I am, thanks always! Thanks to my friend Tommy McClary who allowed me to stroll around the plantation with my camera! Thanks to my friend Tony Stein for the many boat rides on Cape Romain, stopping and starting just so I could get that perfect shot! To the village of McClellanville and its characters, I couldn't imagine living closer to any other place! To all my friends from photographers, writers, musicians, painters, singers, and the pure salts of the earth, I am one "lucky girl" to have people like you in my life!
— *Sharon Cumbee* ✒

Thanks to DeLorme for publishing their excellent road

atlas of S.C. Over the last four years I have marked up, bent up, and worn out my copy. With the help of those fine maps, I have traveled most of the back roads of the Lowcountry. I still managed to get lost, but with DeLorme's help I always found my way home.

Thanks to all of the wonderful people of the Lowcountry who graciously allowed me to photograph their old tobacco barns, picturesque homes, and historic churches. Thanks to all who pointed me in the right direction . . . to the next great farm or country store . . . to the next cemetery . . . and, of course, thanks for pointing me to my way back home. Sometimes the road atlas just doesn't work.

And thanks to Ford Motor Company for my reliable F-150 pickup truck. It has served me well . . . it has been a faithful traveling companion.

And finally, thanks once again to my family, my friends, and my cousin Billy Baldwin. They remind me so much of the old Gullah saying, "They prop me up in all my leaning places."
— *Selden "Bud" Hill*

Thank you to Chris Condon of Big John's Tavern, The Historic Charleston Foundation and the Aiken Rhett House custodians, Tom and Marion Read of Read Brothers, and thank you to the caretakers of Charleston's Magnolia Cemetery and Savannah's Bonaventure Cemetery. I used Charleston's Rick Rhodes Photography and Imaging for film scans and large scale prints. Thanks to Yvonne Fortenberry for support.
— *Robert Epps*

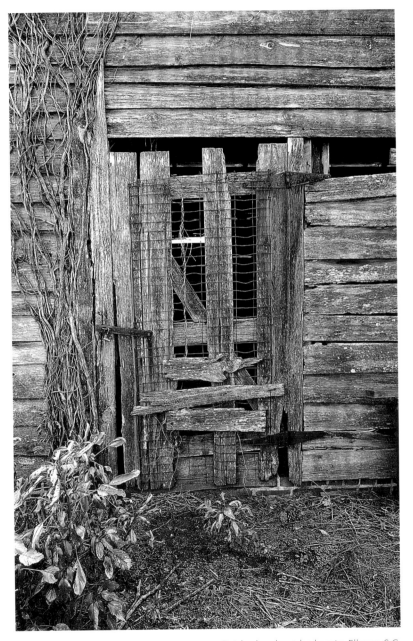

Patched and patched again, Elloree, S.C.

INTRODUCTION

Last year photographer Selden "Bud" Hill and I collaborated on *The Unpainted South,* promising that with mere words and photographs we'd show you The South. It was an ambitious claim, and one we're happy to repeat. For three years, Bud had been driving out from our village of McClellanville, S.C., several mornings a week to photograph abandoned farmlands and related topics, and inspired by his prints, I set myself the goal of writing a poem or song a day. At the end of a year, we had the material for the well-received *The Unpainted South.* Another year has passed, Bud has continued to photograph, and this time he's joined by Sharon Cumbee and Robert Epps, artists who bring complimentary visions to this work. And I've continued to write poetry that deals with related themes. You hold in your hand the result. *These Our Offerings* is just that: These Our Offerings. There are five sections, each beginning with a combination of my poetry and the work of a particular photographer. Then comes a collection of photographs from that photographer suggesting a particular vision of the Southern world—at least that sacred portion found between Savannah, Georgia and Myrtle Beach S.C. It's called the *lowcountry*, a place of swampy, salty, sandy, muddy lands grown thick with marsh, oaks, myrtles and magnolias, zinnias and camellias, a place with a dark past, a place of loss and decay where we also find great beauty and, hopefully, a bright future. This is an ambitious book and in its battle with time, an intensely romantic one.

Selden "Bud" Hill consciously works in the tradition of Walker Evans and Willie Morris, documenting in black and white the continually vanishing world of rural America. Take a drive down any farm-to-market road in this state and you'll see his subject matter for yourself, but Bud brings to this enterprise the tireless eye of a true artist. Every image is composed and lit with a patience few have. If the sun's not obliging, he'll come back another day and another until things are right. And in the process of his wanderings, he meets the residents of this landscape—farmers, store keepers, men and women in all walks of rural life—that is anyone willing to ask "What you doing?" The knowledge gleaned from these conversations does find its way into the photographs. Sympathy. That's Bud's magic ingredient.

Sharon Cumbee is a neighbor and long-time friend of both Bud's and mine. She's a professional singer, a country music artist who still lives in the country. Shulerville is real country, a rambling collection of farms surrounded by the formidable Hell Hole Swamp. But Sharon doesn't restrict herself just to this neighborhood. She photographs everything she comes across and has been doing this since she was a child. People are a specialty of hers, people caught slightly unaware, people being people. The natural beauty of Carolina's Gold Coast is another favorite topic. And here too she brings to bear an eye not just for the fashionable, the dramatic but also the surprising, the overlooked. It's her family, friends, neighbors, and strangers, too—people and their complimenting environment, that she's out to capture.

Robert Epps is a well-known Charleston architect and photographer and a fine lunchtime companion. He works with a traditional 4-by-5 camera and thinks nothing of spending three days on a single photograph. The resulting prints are

astonishing. In these pages you'll see that for yourself, but bear in mind the originals are often 30 by 40 inches. As with Bud Hill's countryside subject matter, Robert concerns himself with the process of decay and with a corresponding threat of chaos that apparently underlies all things. Baroque may not be quite the right word to use here. Robert does photograph architecture, and his use of the widest of wide-angle lenses does suggest that early order. And his photographs of Victorian era statues have something of the same feel. The complexity of the simple, is his aim. I'll give him the complexity part.

And as for the poetry, I'm concerned with what's around me and what was once around me. I'm influenced by conversations I've been having with friends and what I've been reading—whether today's newspaper or 19th century literary theory. Half a century ago at Clemson, I was a mediocre student at best but had some excellent poetry professors and apparently retained something from the lecturers. I enjoy mimicking other poets—on occasion even mock myself. As written in sequence (daily) the poems ran through certain themes, but for this book, I've scrambled the order and assigned poems to the moods of each photographer. In a very real sense, you hold in your hands five separate books. I am a Christian poet. That unites them. But as this collection is particularly indebted to the Irish Poet W.B. Yeats, pagan worship does find its place, especially towards the end. Also I make use of the oral histories collected by Genevieve Chandler and others and of similar histories I've gathered over the years. It's all about story. And it's all about love. And death. And birth. And the outdoors and the indoors. Yesterday, today, tomorrow. Our plans, God's plans. It's all about life.

Note that the simpler, lighter poems tend to be toward the front. As you progress you'll find the poetry becomes more ambitious and darker—but it's never ever my intent to write something beyond understanding or without hope.

My photographs come at the end of the book. Most are portraits, some posed and some not.

— Wm. Baldwin, July 20, 2012

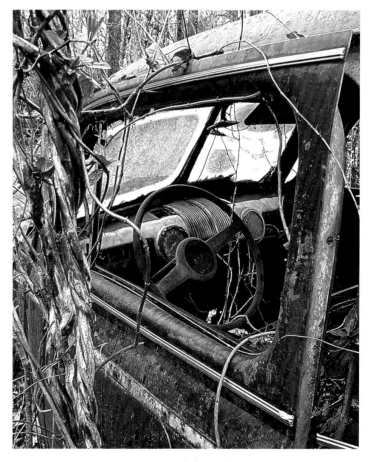

Someone left the window down, Cubbage Hill, S.C.

The PHOTOGRAPHS *of*
SELDEN B. HILL

The POEMS *of*
WILLIAM P. BALDWIN

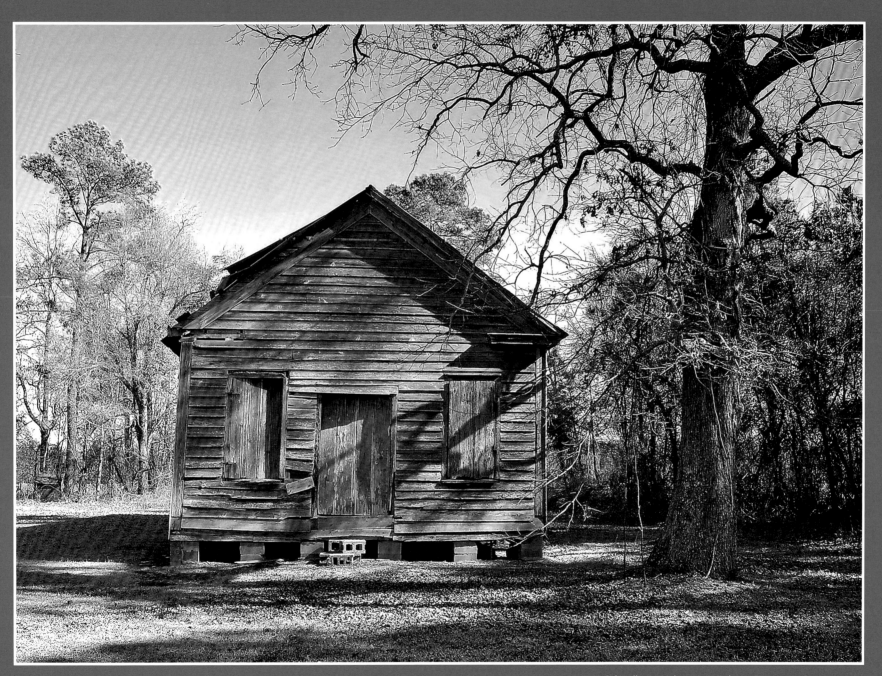

Schoolhouse adjacent to Palmer Cemetery, Centenary, SC

No one at home, Sullivan's Island, S.C.

LUCILLE

When I pick that choir of angels and
Arrange them on the Charleston grass
Just past the chicken pen that lacks a door
With chickens roaming 'tween their robes
And overhead the cork tree's gaully branches
Floating on a blue sky, when I call Granny out,
Stand her on the kitchen step, say *listen*,
I bet she'll be amazed to find
She dwelt in holy places, just lived in troubled times.

FIRST LIGHT

On the dawn of that first morn
Let there be light, God said.
Did Adam have the decoys spread,
And did God shoulder close,
Thermos cup in hand
And whisper Canvas Backs, oh, Man?
I like to think He does.

SUNDAY POEM

I wake each morning,
Accumulate the day's debt,
Then lay down like this to rest,
Worn head to pillow, still seeking,
Eyes open, hand upon your breast.
Butcher, baker, candlestick maker?
Who could see it coming,
This dunning of the world?
To tax the stars is a mad notion.
The moon, she works for free, as well.
The screech owl's cry, these highway's sighs,
All parts of love's labor.
There. You stir, murmur, sleep on,
While the night, with great extended belly,
Gathers cloud skirts about her knees
And calls the midwife in.

SHE WATCHED

She watched as the boats went by,
And she and I got to talking.
I asked of the men out there,
And she skipped from nets and caulking.
One he ran some crab pots,
Another pulled a seine,
There's been two tongers working
In that first broad drain.
Love was all around her,
At least that's what they claimed.

So I asked of a sweet heart on the bay
And she spoke of hard forgetting.
He's clever and honest and right for me
With the looks his mama gave him.
But there's something in salt water,
On hearts it leaves a stain.
The clammers are a mixed bag
The shrimpers hard to train.
Best I look ashore and
Save myself some pain.

THE BIRD HOUSE

Feathered windows, feathered door,
Feathered walls make feathered roost,
I near forgot the feathered roof,
And tail behind and beak before,
Pinions in the wings that soar,
Hollow bones, the craw, the crest,
And beating in this feathered rest,
The heart that hammers feathered chest.

FRIDAY NIGHT

All hail these victories.
The mortal part is spent.
We scatter in the parking lot
Beneath a sky our cheers have rent,
Still bound to earth, still bound.

Our Girls...Our Boys...
Across the cars we call
And give to Friday's children
Sweet pulse of the immortal
And place among the stars.

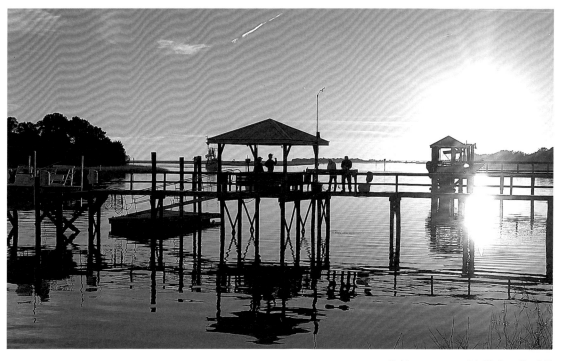

Fishing at sunset, McClellanville, S.C.

13

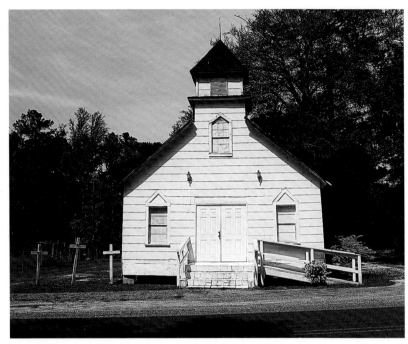

Howard A.M.E. Church, Germantown, S.C.

THE WAY: FOR P.F.
Barbecues and used tires,
And stretching to the hazed horizon,
A pair of silver train tracks and
Concrete block churches.
With a highway that straight,
You can't expect surprises.
From miles away what's coming is
Seen to be coming: Jesus for one.
But that's to be on Judgment Day
Pray then our faults will be forgiven
And dusty deaths lit well by those far
Cumulus clouds tumbling like
The breath of God they are.

HOLY COMMUNION
Jennie's voice, Jennie's touch
Bill leans in to tend the cup.
In the wine I see reflect
The gimlet eye of Newton's wretch.
Oh, power Divine,
Now I see where once was blind.
Amazing grace descend on me.
Cheves helps Miss Sally up,
Return to pew, sing the hymn,
Service done, what's done begun.
In the isle a nod, a smile,
Miss Sally gives me two good hugs
And brings to me and Cheves both
The peace of God, that peace of Cup,
The elemental peace of touch.

THE STORE

I had heard her call my name
Where Cokes are sold 'side fishing canes,
A gap-toothed girl, sun bleached hair,
A phantom girl, oleander in bright hair,
Who again called my name,
Waved at me from black highway
Then faded into whitening air.
And thus I spent the passing years.
Her call's become an endless sound,
It seems the world is more than round,
A murmur in a marshy glade,
Along a ridge adrift in mist
For murmurs are abiding,
A stir of breeze where blue flags wave,
Across the field where corn was laid.
I know that I must find her soon,
Kiss her lips and hold in book worn hands,
Climb some creaking steps, press against the
door,
Say, Good morning to whomever's there.
And with pocket change alone win
That lotto of such calm dimensions
I don't need to scrawl another thing.
But lean against the counter worn by care
And fix upon the worst and best of blessings.

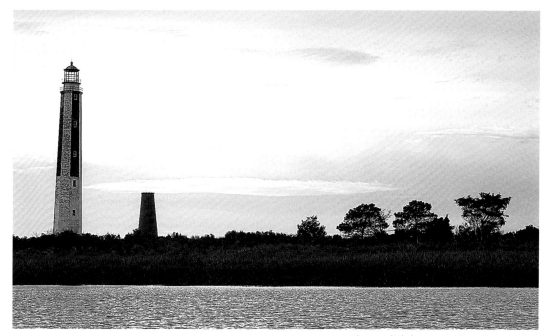

The two lighthouses at Cape Romain, S.C.

ARRIVAL: FOR DALE

More times than not, I find you waiting
In a place of myth and harborscape,
You with one hand to the rail,
The other raised in broadest greeting.
Sepia-toned—thin and anxious—
What etching oceans have you crossed?
In what language do you wave?

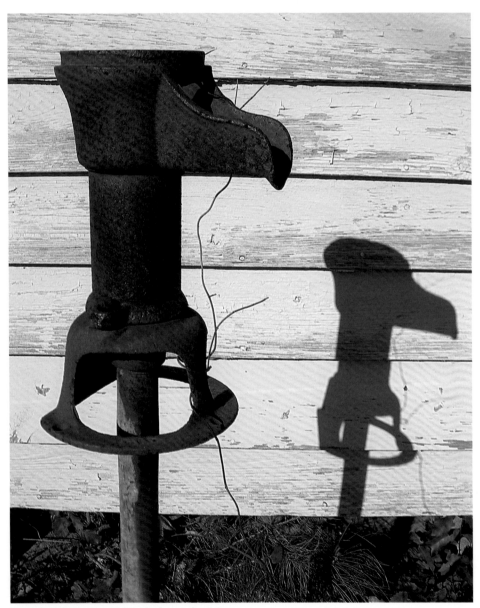
Retired pitcher pump and its shadow, Lane, S.C.

THERE: FOR GABE

Will there really be tomorrow
Or was the sun called off?
I didn't get a notice.
But sometimes mail gets lost.

You can't say for certain,
Not in times like these.
Just get the other shovel
And help me plant this tree.

There. Pat it with your hands.
Press it with your foot.
Nothing says expecting
Like plain old fashion dirt.

AT PEACE

Among the stones that pass, both straight and angled odd,
Through the church yard's untrimmed grass,
There near the south fence,
The wire fence that tangles in the wild grape vine,
I found a stone that made no promise
Of a restful peace
Or even named who was deceased.
Worn slick, in white and scriptless calm,
Still it spoke with eloquence
Of Heaven's waiting balm.

THE OAK

Her decision to live in the tree
Was not made lightly.
Her parents were quite upset
And rightly so. They wanted more
For their daughter (Had hearts set
On her having a career that made room for
Husband, children, and two pets)
But she chose to go unclothed
Among the highest branches
Of the county's oldest oak
And so woke each morning to the cries
Of paparazzi.

Yes, I've been to see this for myself.
Paid admission like the rest
And marveled at the sight
Of perfect pink flesh
Against a mat of gray bark, resurrection
fern,
And those tiny fly orchids.
Spanish moss, of course,
And two jet vapor trails cutting through
The blue beyond.
Time seals all wounds
And sets the crooked hearts aright.
Peace to trees and the women living in
them.

THE CALLING: FOR M.B.

A mattress, damp and sagged deep at the center,
Bent iron bed frame, hand stitched quilt that went
Beneath my chin, when praying's done,
When the Lord's been told that if I die before I wake,
Please take my soul, slip it out, if need be rip it
From that holy place beneath the ribs.
Me, blessed of Jesus, shaking, kneeling, thin bird legs bent,
Breathing out a frozen smoke, the itch of fear
And moonlight slashing at the muslin curtains.
Oh, my soul awake. Awake my soul
To the roar of hail on a cold tin roof,
To the promise of warm piss singing 'gainst the toilet bowl,
And to the calling of my fragile name.

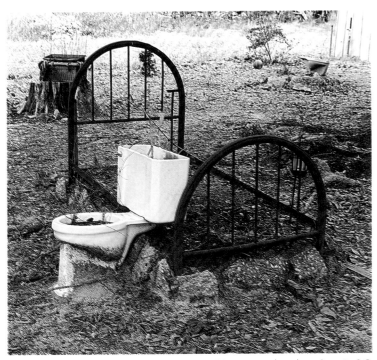

Most unusual yard art, Sampit, S.C.

A SONG INTERRUPTED

Nature has a tooth,
Nature has a claw,
Mosquitoes swarm,
We swat, they soar,
Then swing around,
Come back for more.
Who can speak of kindness
Nestled at Her core?
Not even textiled camouflage
Can hide the simple fact
That Nature waits outside the door
With one intent: Your blood to pour
Into a common coffer
Where float some deadly spores.
And rhapsodies can't dull the truth
Nor poems assuage the grief
There's something wants to bite you
Under every leaf.

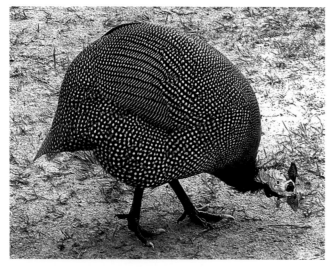

Guinea hen pecking away, Olanta, S.C.

MINDY'S ADVENT SONG

Let us praise all sorts of things,
Those things with claws, black things with wings,
The human mind. The human wrist.
Bless all events we might have missed:
The plying search of dragon flies,
Dust devil's spin and pigeon's eye.
Smell of crushed mint, hard rain on tin,
Wild onion's taste, flicking of a spottail's fin.
The singing of an endless song.
The music of this list goes on.
October days, September light.
Monday morning and last Sunday night,
April sunrise and May bluebells,
Dogs on point and artesian wells.
Let us praise all sorts of things,
Those things with claws, black things with wings,
December's crows in barren course,
They seem a choir of remorse.

And now in winter's memory
Our leaves so green and blossoms sweet
Must compete. No need.
Have faith, draw near.
The world won't end.
Christ is born in us each year.

SUZANNAH AND THE STORM

Yeah, we hear you pushing at the door—
and in the chimney roaring,
Go on, rattle the window panes.
We'll let you spy with your wild spinning eye,
But we won't let you in, Mr. Hurricane.

We'll let you lift with your billowy riff
And play your music born
In tropics where your hand did lift
And stir this wildish storm.
Now from the ground yank the trees,
Raise the ocean, breathe out fear
But we're shouting loud: What do we care?

We hear you pushing at the door—
And in the chimney roaring,
Go on, rattle the window panes.
We'll let you spy with your wild spinning eye,
But we won't let you in, Mr. Hurricane.

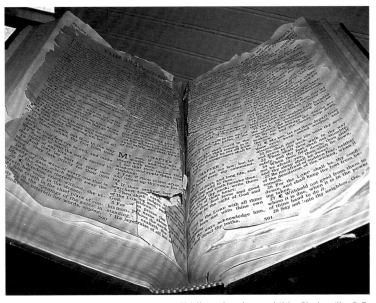

Well-read and worn bible, Shulerville, S.C.

FOR MY WIFE IN THE MIDDLE OF JUNE

In these winter months
Groaning rich in perfect indolence,
We should find in our hearts sympathy
For the other fur-wrapped lovers,
Those pairs once lost in a snow white wilderness
Where the Russian Troika sleigh is dragged pitching
From right runner to left by three abreast
Eye-rolling, frantic gray horses
'Cause the wolf pack's coal black leader
Is nipping at their heels.
But Love's not a far-off thing.
Enough for me climb these fifteen icy steps,
Baton of *The Post and Courier* in hand,
And find you standing in the kitchen
Close-wreathed by the tropic smell of coffee.

THE PEAR PRAYER:
FOR DICK AND MARYLOU

Heaven, yep, I've found it there
Just beyond my reach,
Soon yellow gold, so sweet, so dear,
That Bartlett pear, so far, so near.
I could wait around 'til August ends
When the storms are due.
Stand out in the yard
'neath lightning, hail and
Winds that bend the bough,
Then catch it when it falls,
But I'd prefer December
When the possum's through.

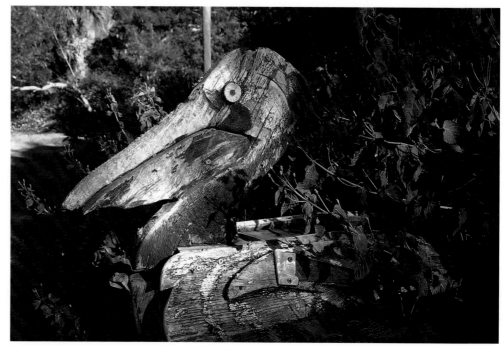

Pelican mailbox, Sullivan's Island, S.C.

THE SHRIMP DOCK

Bon appétit. The grits are done
And every daily race is run,
At least the ones got run 'round here.
Outriggers creak, a pump clicks on,
Down the way a TV spins:
Canned laughter and a feel good tune.
A thin dock cat now stalks the moon
Or so it seems, but who can say
What tricks the trawling clouds might play?

IN THE KEYS

In the Keys but pass that stretch of rock,
Works a man confident of the sun rising,
The tide ebbing and Heaven waiting. See.
He pushes a full basket toward the hold,
Then stops to watch the square tree
Close against the Cape light.
He stands, stretches. See. Dempsey's
Going up to turn the wheel
And tow her back the other way.

THE PETTING ZOO

Sweet Jubilee and hullabaloo
Just slow down,
Take the time to read these hand-lettered signs.
There is NEW, NEW, NEW at the petting zoo.
A YOUNG POSSUM OF TWO MINDS,
Plus a YELLOW DOG WHO
BARKS PHONETICALLY,
And possibly, just possibly, the ONLY
PROBLEM SOLVING EARTH WORM IN CAPTIVITY.
And you won't turn off the road for those?
Oh, oh, oh.
What has happened to pure wonderment?
Have we forgotten where we came from?

HORSE HEAD CREEK

I pray for lightning somewhere else,
For grim green clouds to melt into
A summer squall with hardly any wind at all
And rain drops thunking in the boat, but not so you
Would call to me, *What the hell is this about?*
Let waves lay flat or close enough
And Mother Waters hold in trust
Those deals I made when end was close.
Steam comes rising off the Bay
Horse Head's waiting there to run,
Can't hardly have you thinking
I'm not the bravest son.

THIRTY BOXES

Thirty boxes in the hole and coming 'cross the Shoals
Talking on the radio of far St. Augustine,
Of what was caught,
What those shrimp brought,
And how it might be best to head on down the line.

Thirty boxes in the hole and now behind the beach
Drifting on the flood just past the Clarks Creek Shore.
The doors aboard
And nets bucked on,
Tickler chains are rattling just where the cap's deep scored.

Thirty boxes in the hole, unloading boom swung over.
Big gun done shot. And don't you press your luck.
Let him get a count.
The hiss of water sprayed.
He's straddling the waist. Says his wife has got the truck,
The kids, both dogs, and she is on the way.

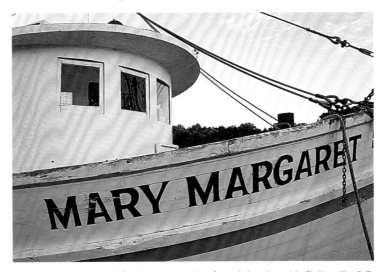

Boat named for Capt. Jimmy's wife and daughter, McClellanville, S.C.

THE OYSTERMAN

There are places cross from Shark Point shore,
Where no one goes, not white, not black.
Though oysters there grow long and fat
You have to slide them in a tub
Over banks and streams of mud.
But sometimes when the sun hits right
The ghost of mighty Moose will stand,
Centaur like, half creek, half man,
Then as the course of life has run,
He wipes ghost hand down his boot
And waves for lesser men to come.

WITH THE DOG

The cautious doe pushed nose in air
And whistled low "It's time to go."
With faun in tow, she crossed the road
And jumped the farther ditch—where
I watched them slip into loose canes
That smilax stitched into a wall.
I called the dog, said "Come along.
As usual, Pup, you've missed it all."
So up he came, bounding joy, ragged-eared,
Pure blooded horse manure.
He ran his nose into the grass,
Back and forth he made a pass
Across that same roadside,
Then with his yip replied:
"You're just a clumsy two
 Foot. Don't know why I bring you. "

Black bird perched on the bow of oyster boat, McClellanville, S.C.

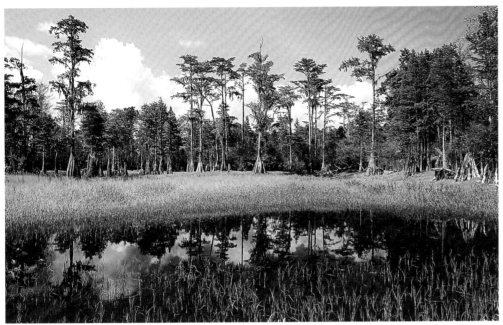

Cypress pond, near McClellanville, S.C.

MOURNING

You two take me in this chair,
One grab here, one grab there.
Lift me high, I won't break.
Set me in the truck again
Lean me 'gainst the door.
Take me to the bowing road
Where the black boar ran
Put the fire in his eye
The razor edge to tusk,
And I will give a whore son's shout
That wakes the pitch in him.

THE CAPTAIN'S GARDEN

Great days, great days!
The world in waiting
Slumbers no more.
Yes. He is certain this is
The darkest line of clouds,
The dang completest rain
To ever cross the Bay—
At least to cross in recent times.
And sure he could water, run the hose,
But he'd rather hope
 A storm to form. If need be, pray.
Cantaloupe, cantaloupe,
Big boy tomatoes, sweet corn and butter beans.
Yes, Sir. Where else could a man be

But standing out in that, hat off
To the rip roar and seeing
Steam rise from the turned ground?
Forget the Shoals and striker's legal problems,
The ice man and hanging webbing,
That leaking stuffing box,
And what they're catching south of here.
Give thanks instead for compost, dirt, and
Life wetted deep on this Great Day.
Now there's something to feed the deer
And every raccoon that passes this way.

YOU REMEMBER

You remember them three Polish woman?
Them ones lived in the dirt tent
There where the oyster factory road
Meets the highway. Well, no you wouldn't.
It was close by them they made the pole corral,
Those three brothers, drovers, real cowboys
With raw hide whips drank theyselves into a blazing fury
And began to strip the flesh off of one another with those whips.
One bled to death.
I was just a boy but that I saw.
I stood beside this sometime lawyer,
Same one my parents named me for
And when the fight was over
And the one brother had life leaving
Him in a long red trickle
That lawyer said, 'None of them three
Got a lick of sense. I won't say what
The Polish women was up to. Titties
And what not. I guess 'bout what you'd expect
That being a place of such limited opportunities.'

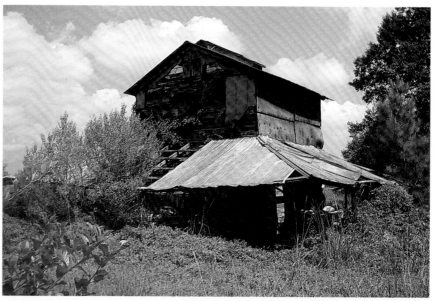

Tobacco barn with classic roof lines, near Marion, S.C.

ISN'T IT?

Isn't that just like a man?
To put the water on,
I mean isn't that just his way
To block the kitchen door
And whistle kettle imitations?
Well, isn't it?
I mean once she's said *just like a man*
That subject's been exhausted.
Just like a woman.
Well, isn't it?
Cat got your tongue.
What?
Afraid to have just one opinion
Come on. Shake your head.
Just go yes or no.
Don't make me have to whistle.

PORPOISES

Porpoises want what we have:
Breathing on demand,
The ability to stand on land,
Clap five fingered hands
And sing
Here fishie, fishie, fishie.
That and access to tide charts
And suntan creams
Plus the means
To buy and sell
Both land and sea.
There may be more.
I'm going by their winsome smiles.
Who can say with certainty?

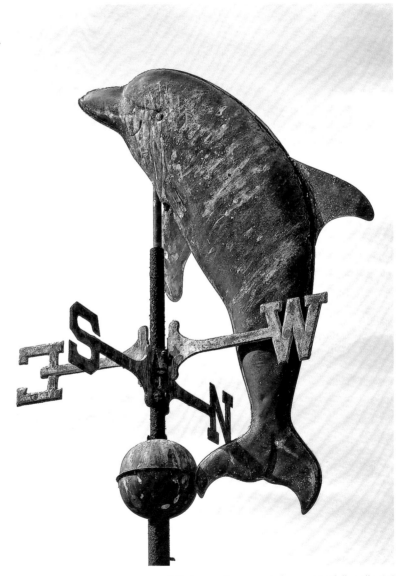

Tilted porpoise on a wind vane, McClellanville, S.C.

SO PETE WON'T FORGET HIS ROOTS

You don't see the ocean,
not from here, though
 dunes are piled in such a way
 an ocean is implied.
Who needs all that?
This river's wide enough.
A mile across
and miles beyond of delta stretch.
Mud, marsh and shell,
held in equal parts, suspended.
We, too, held in puffer belly
traction. Wide frail white shell of boat,
thirty feet from stem to there and
at my ear the little Briggs and Stratton.

Hanging shark fin, Edisto Island, S.C.

What's that? Yes, unmuffled!
BRAM, BRAM, BRAM, BRAM, BRAM.
Screaming Briggs and Stratton, drives the shining clacking belt,
CLACK A LACKA, CLACK A LACKA, CLACK, CLACK A LACKA
that brings the clams from off the river bottom.
The pump? Four cylinder Ford. Yeah, gasoline.
Three-inch Meyers blows the clams clear and clean
to where the boat's momentum drives the sled head through the mud and sand,
See there, at the stern, propeller churning, got that GM screaming,
YEEEEEE, YEEEEE, YEEEE, YEEEEEEEEEEEE, YEA, YEA, YEE, YEE.
Straight pipe.
No muffler there. No muffler on the Ford either.
BRUMMMMMMMMMMMMMMM.
And all day, for all the hours of winter light, that is a day,
rain or shine or sleet, we four pick the clams as they
covey past blistered finger tips,
So glad to finally have a job that pays.
Blue haze of morning.
Here to there
we bang and clang along suspended.
Half of this world where egrets glide,
half of a world upended.
CLACK A LACKA, CLACK A LACKA, CLACK, CLACK A LACKA,
BRAM, BRAM, BRAM, BRAM, BRAM,
YEEEEEE, YEEEEE, YEEEE, YEEEEEEEEEEEE, YEA, YEA, YEE, YEE
And **BRUMMMMMMMMMMMMMMM**
Until the sun has set.
Then quiet
Beyond mortal understanding.

Surf fishing, Edisto Beach, S.C.

I KIND OF WISH

I kind of wish that we were fish,
Borne by surf to splish and splash,
Get that free ride on the past
For in that crawl from out the sea
In our bones a flounder sleeps.
Fingers out of fins have grown,
There're genes that switch parts off and on,
Eyes, brain, nural tube: it's all the same.
Just one thing we miss.
No debt for fish: no credit cards, no hidden taxes,
Bikini waxes or Evinrudes to buy and use.
I swear that's true...except a flounder's flat and thin.
Make mine a tarpon, leaping free,

Silver bright grand scales for me
And you may be my tarponess
With my fins I'll stroke your
Breasts, at least that section they profess
To be breast like....
Gill plate for throat,
Lips the same.
I don't know if this will work.
Who wants a girl who'd kiss a fish?
Another fish, I guess that's true.
Or merman.
I must stop and think this through.
No. Won't happen.
I have no wish to make us fish.
Go on, now, cast it out.
Enough's been said of metamorphosis
And how to make ends meet. I'd miss
Your elbows and stuck out ears
And that behind you swing
As the rod descends and
Monofilament starts to sing.
And how you dance your way to shore.
Truth be told
There's something more.
I'd miss this struggling world
And all its weary cares,
Hey. Hey. You've got a bite.
That's the deal
Reel, girl, reel,
Fight, girl, fight.

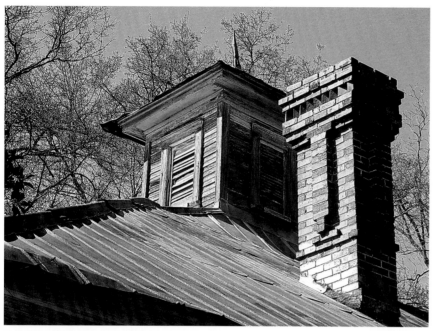

Cupola and chimney, Luray, S.C.

DON'T ASK

Don't ask me why but time chose
This cloud above my house to bleed away.
Pip, pip, pip. Just drops at first,
Then a true hell-to-pay downpour. A deluge.
The roof leaks—despite the steep pitch.
Must be those singles from
The last century. Anyway,
I've gone by narrow steps into the attic,
A space high, wide, and dim
And found pots, plastic trash baskets,
Even blue willow tea cups and a rusty wash tub,
Every one filled to the brim,
Overflowing with bloody time
And more dripping, drip, drip, drip,
Making perfect concentric rings in those blood red
Circular surfaces spread out across the dust-thick attic floor.
Bring newspapers, Granny's quilts, that aromatic bathing sponge,
The one you got for Christmas. Trust me. This won't stop.
Bring me anything to sop time up!
To my wife I shout all that.
What? she answers.
What have you gotten yourself into now?
Do you need a towel?

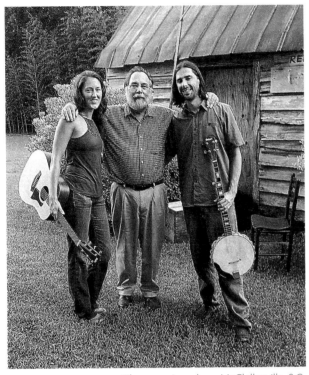
Three music makers, McClellanville, S.C.

HUNGRY MAN

Thirteen weeks and nary a soul
Had come 'round that far off house.
No piece of meat on the place.
Hair tuffs in the traps set out.

It's the cold that hurts I tell you.
He came knocking in the middle of the night.
Said I got a wagon of venisons
I need a woman to cook it just right.

He ate until his eyes were glossy.
With dessert I'd've killed him out right.
We'd all had a party tomorrow.
There'd a been a funeral all right.

Yes, I've sung a song that belongs
To each one in the whole human race,
You may strive and puff and arrive;
Still you got a grand meal to face.

Michael blows his angel horn
Old Gabriel claps his hands,
'Cause Jesus Christ is passing plates
At a table in the welcome land.

And if you've begged forgiveness
And got a soul of light,
Then all that cold and hungry
Has now been set aright.

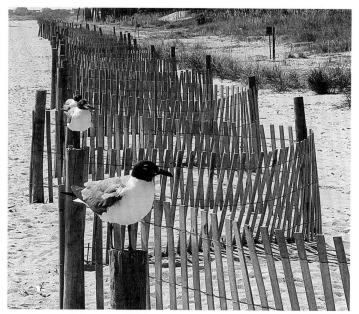

Gulls perched on zig-zag wind break, Edisto Beach, S.C.

THE FLAGG STORM

He swayed upon the bateau stern
The working-end of sculling oar,
For he had seen where he could turn—
A crowd upon the shore.

And though this course change did hush most,
Still, you know, were those who said,
'Who has the Gray Man come to take
From off Magnolia's beach of dead?

With fingers in the sand they scraped
And tugged upon the vest
Dr. Wardie's pa it was
But he just one among the rest.

The watch yet ticked on golden chain.
Whispers now of drowning's blame:
He was a cussing man.
One too proud to shame. Profane.

And having pushed the boat through surf
The shrouded man slipped arms beneath
What still held the dignity of human kind.
Took him in sweet name of Death.

This man of gray? A man, a common man
Shine of spectacles beneath the cowl,
Those rode upon a bright red nose.
Cracked lips that held no hint of scowl.

Yes, some claim vanity in that mustache,
But, I saw the stubble on his chin,
And do recall
No mention made of sin.

And though I'd placed a finger to my lip,
What could I do but sing this song?
Standing at the crowd's edge I
Cried out loud and long.

Cried 'side indifferent sea,
Naming Life with wounded breath,
Because it holds such wonder,
And God has capped it off with Death.

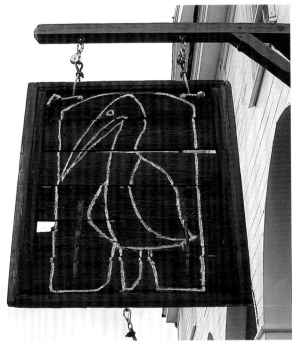

Sign at The Pelican Inn, Pawley's Island, S.C.

OH

Oh, petulant self, he who
Occupies the mind of God,
Throws the covers back,
And beholding paths that Jesus trod,
Puts one foot forward, then another.
Groping so beyond the bathroom door,
Searching now for coffee, paper,
He, with one nod, stuns the sun awake,
 Thus making way for
All that comes
To fill his day with wonder
And night with ancient fear.

THE PHOTOGRAPH

This store's thin siding was last painted
Back when Martha White flour
Promised better biscuits, cakes, and pies, and
Carter's pills brought liver changes.
What's left to advertize—
consume—
For us to linger on the page and read?
Hot boiled P-NUTS
(But only on Saturdays),
Septic tanks installed
And a brief plea that
The Painting Guys want your business,
All nailed against the twisting wall
And sung nostalgic, these our
Three dimensions pressed
As ink into this simple
Bound-to-earth photograph.
It's years have stripped these boards bare,
Popped knots from holes while trimming
Meaning from life's proper role
Which was being what life is.

Target practice, near Kingstree, S.C.

HURRICANE

Heavy they seem,
Yet men they were,
And women they were,
The oaks along Doar Road:
Manigualts, Players, and Munns.
He froze them there,
Limbs stark gray bare,
Near' broke their stout oak hearts.
Pale is the moon that comes around
And dark is the bright sun's spell.
Grief is the price they paid for love.
Where is the shade for those who dream
And where is the shade for me?

APRIL

The boy knows the faint path the buck takes
When he comes slipping t'wards the myrtles by the lake,
When he comes missing antlered crown and tail adrift
To slide through spring bright hickories,
Through dogwoods swollen white,
Flowers, leaves, set to hissing by a sun-driven mist.
Again, the someday man has come to stand, remembered gun in hand,
And listen for that second sound, a thread so light
It can't be heard without him tightening up his fist.

ECHAW WARBLERS

Injured habitats,
Weather by installments,
Except right here is...
You see them in their suddenness
Not three, but four...five...eight...ten
Around the sweet gum limb,
Saffron settled, unsettled,
Beating gold-tinged wings.
Warblers of this family
Tote summer to the swamp,
Bring sway to sweet gum limbs,
And cross the creek as arrows
That melt with lost bird song
Into the deepest greens and browns
Of leaf-thick places summer born.
Sweet sweet gums and arrows of gold
That alone could be the basis
For a new religion,
Replacing what they had, those old men
Of my childhood,
Pretending solvency,
Dressed in seersucker swollen twice their size,
White shirts buttoned to the top,
And wisps of hair crowned with panamas,
Those ones who took their Presbyterianism
Half to heart
And rocked, waiting on the afternoon
When boats would come.

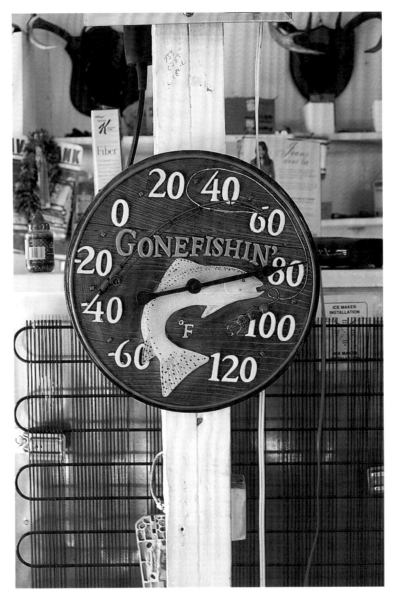

Gone Fishin' thermometer, Ward's Grocery, Trio, S.C.

BUD'S

Offerings

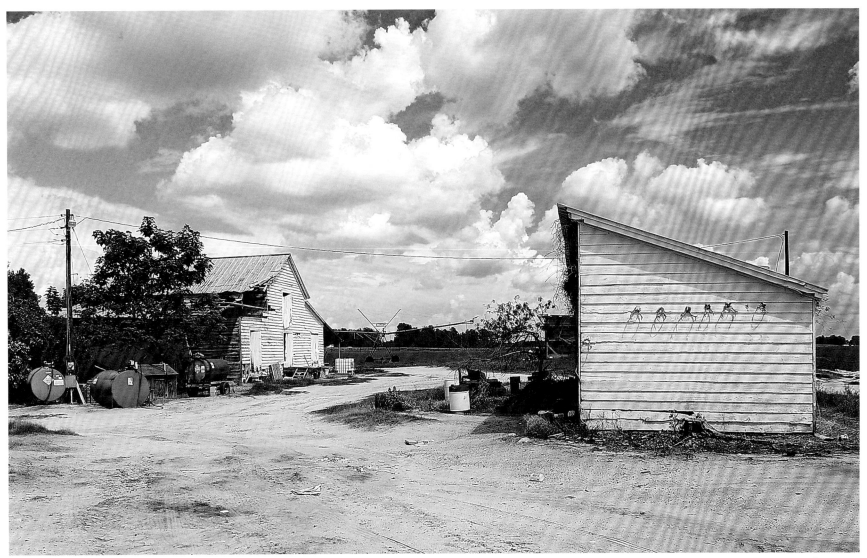

Cotton-like cumulus clouds hang over Bookhart Farms, Elloree, S.C.

A farmer offers advice, Providence, S.C.

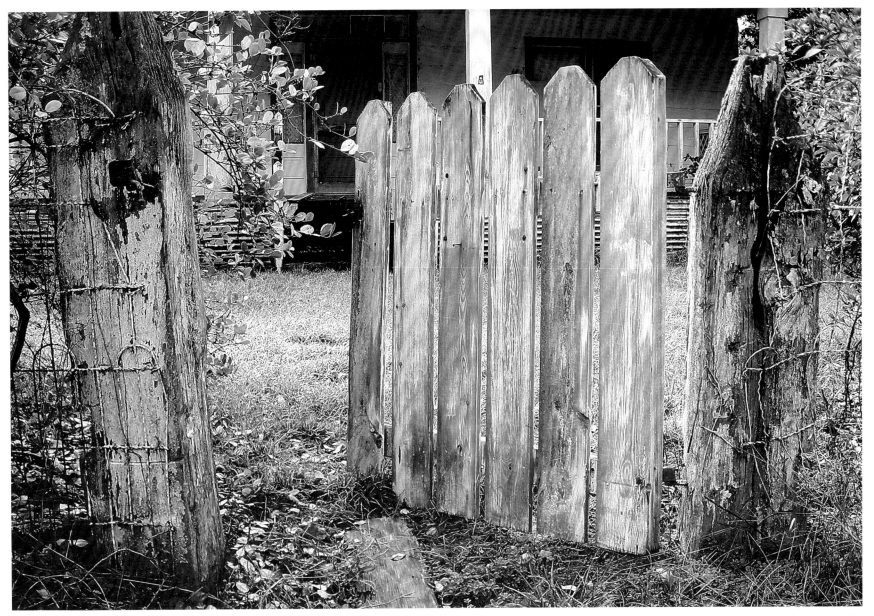

Cottage gate, Cottageville, S.C.

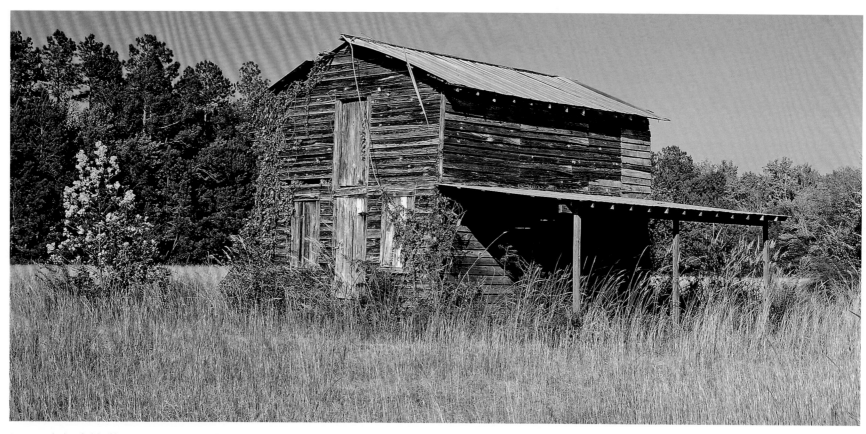

Barn nestled in field of broom straw, Hopewell, S.C.

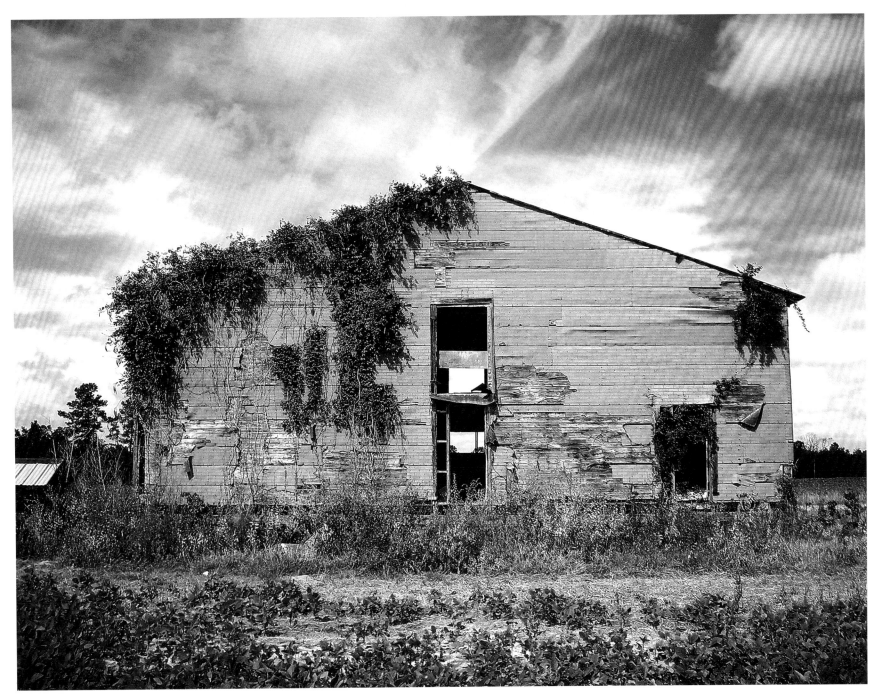

Vines are slowly covering the tar-papered walls of this barn, Mouzon, S.C.

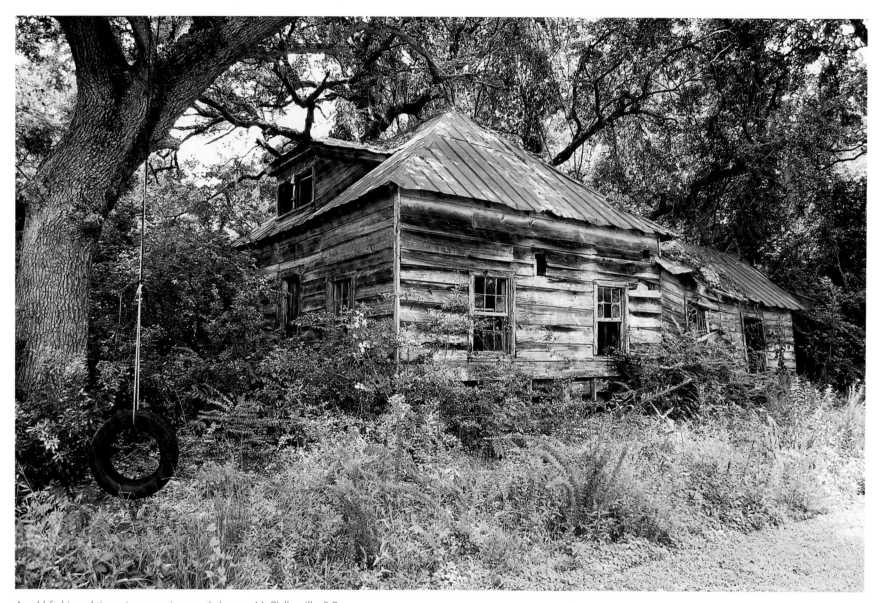

An old-fashioned tire swing sways in a gentle breeze, McClellanville, S.C.

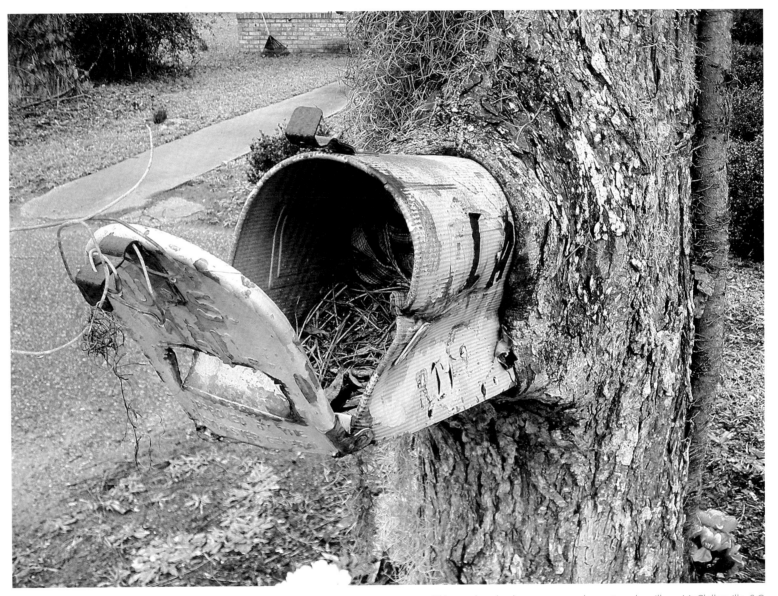

This tree has slowly grown around a mattered mailbox, McClellanville, S.C.

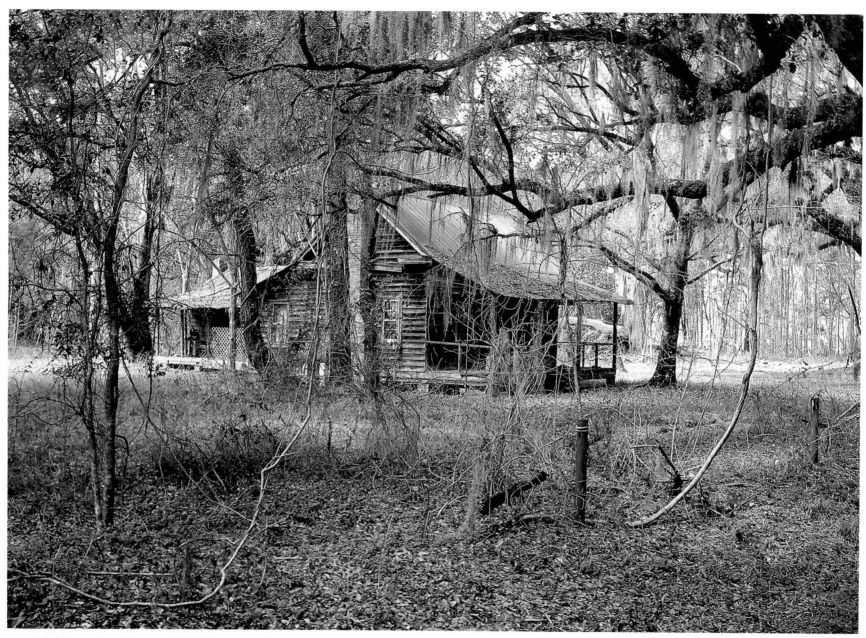

Cabin in the woods, near Gillisonville, S.C.

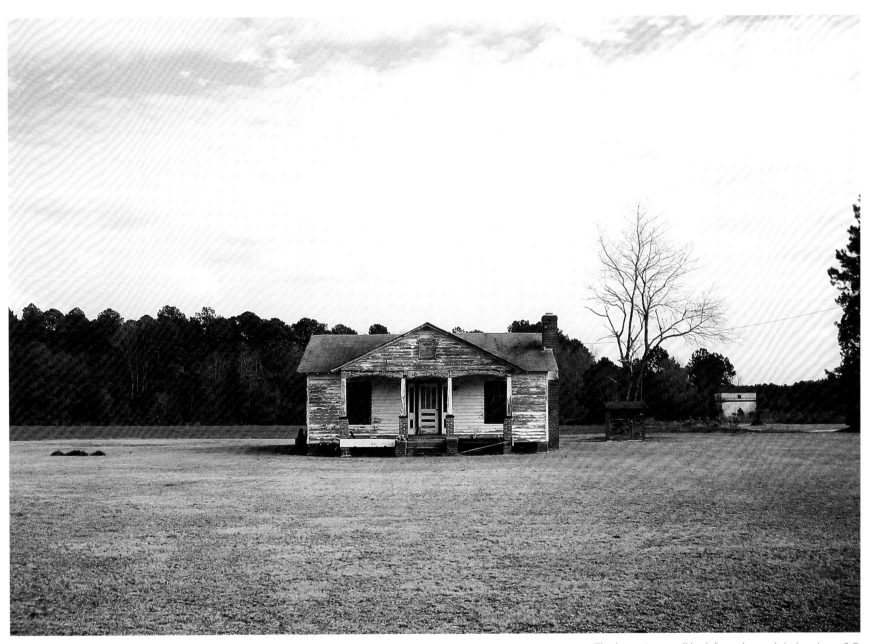

This house is set well back from the road, Jacksonboro, S.C.

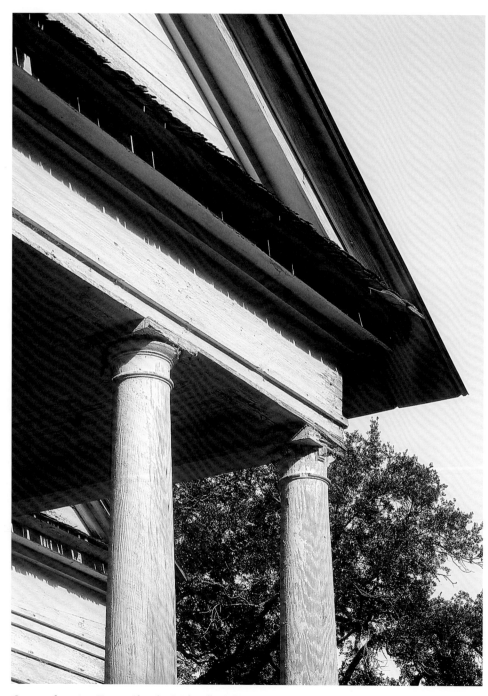

Corner of portico, Taveau Church, Cordesville, S.C.

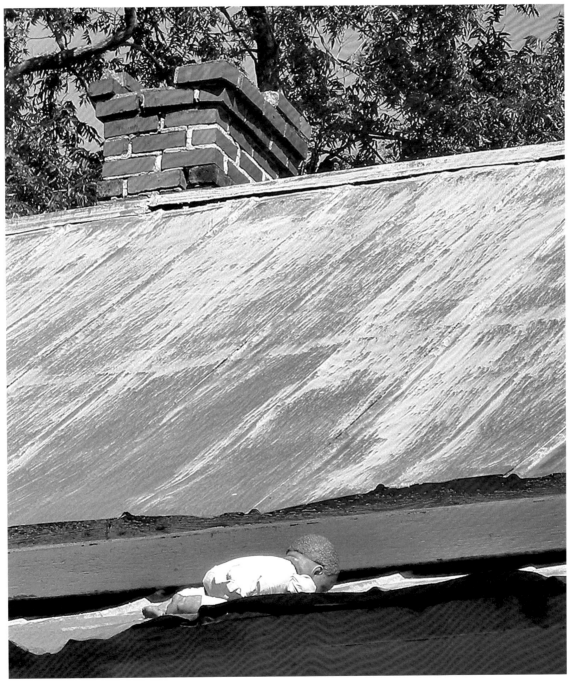

A long-forgotten baby doll has been tossed onto the porch roof, Manning, S.C.

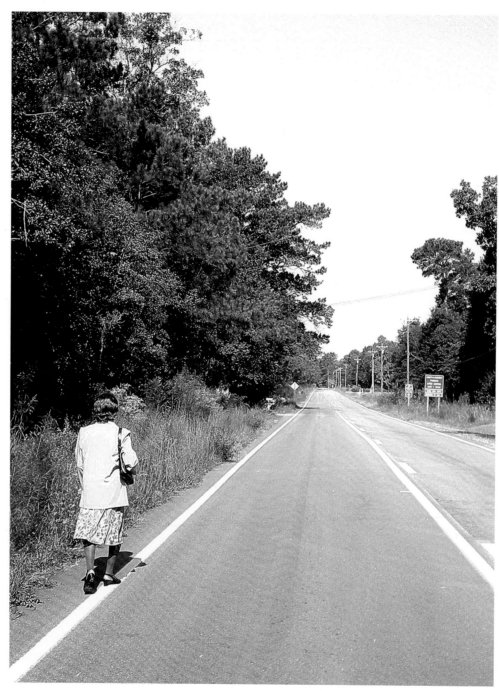

A quiet walk to church on a bright Sunday morning, Huger, S.C.

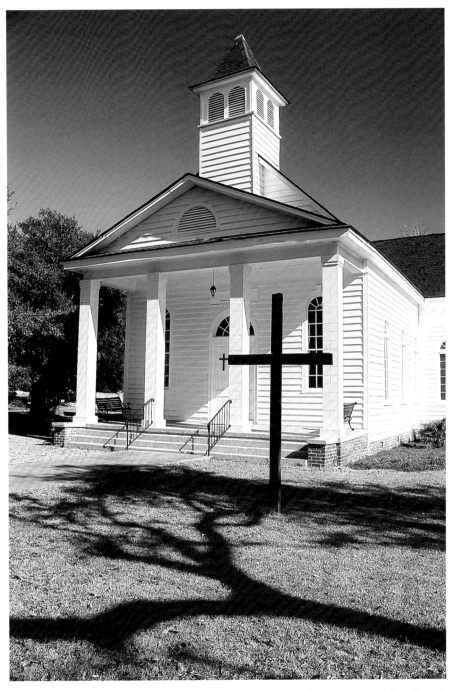

Wooden cross and shadows at McClellanville United Methodist Church, McClellanville, S.C.

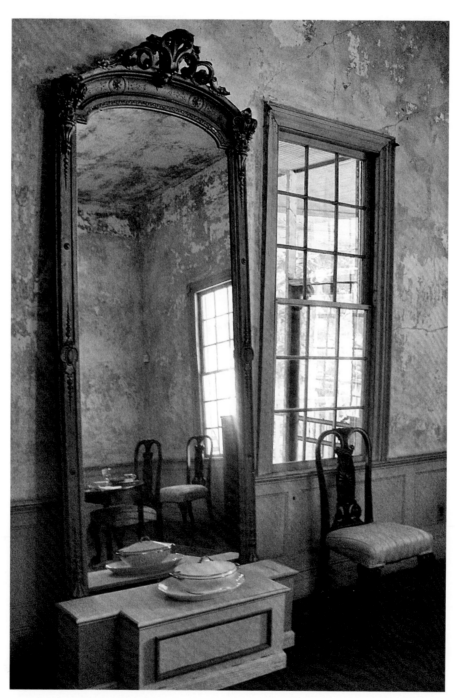

Mirror and console, the Bedon-Lucas House, Walterboro, S.C.

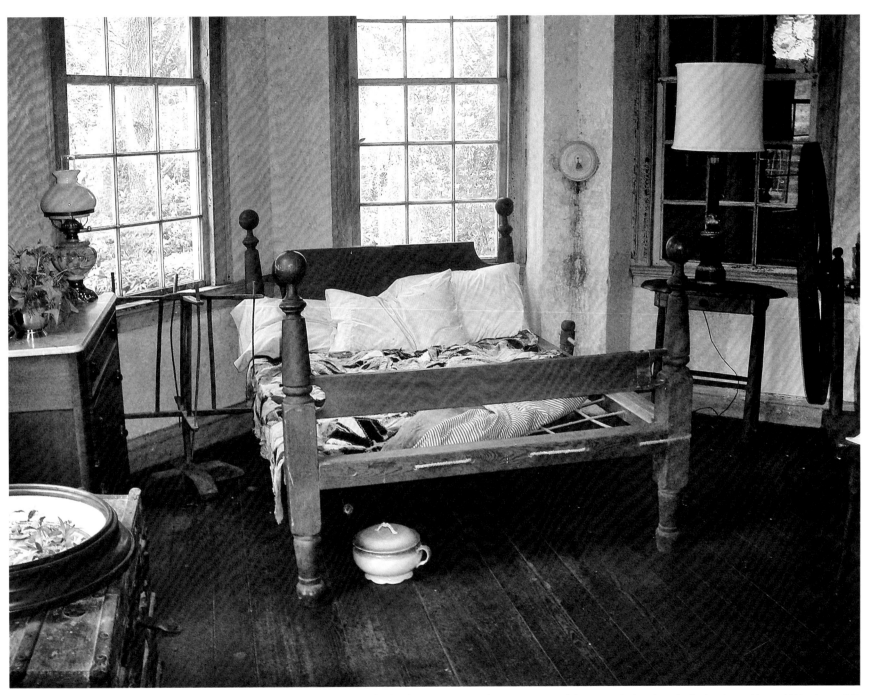

A classic poster bed with rope springs is the center point of the master's chamber, the Bedon-Lucas House, Walterboro, S.C.

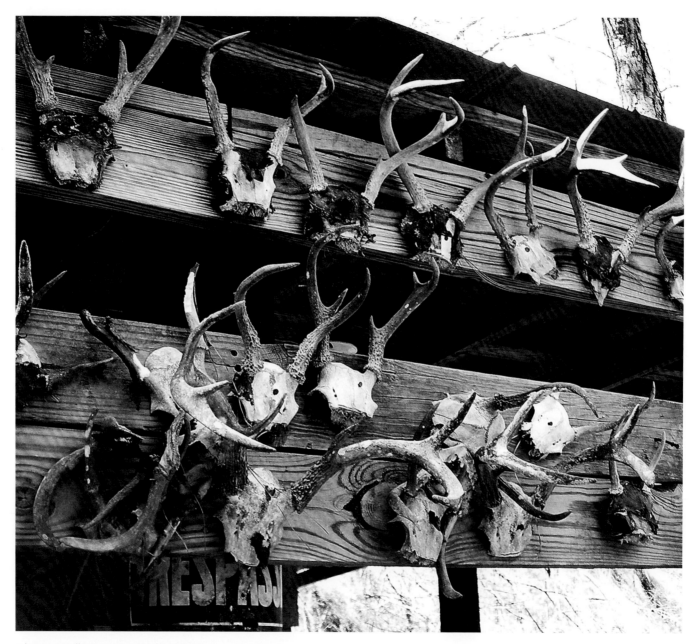

A hunter's collection, near Honey Hill, S.C.

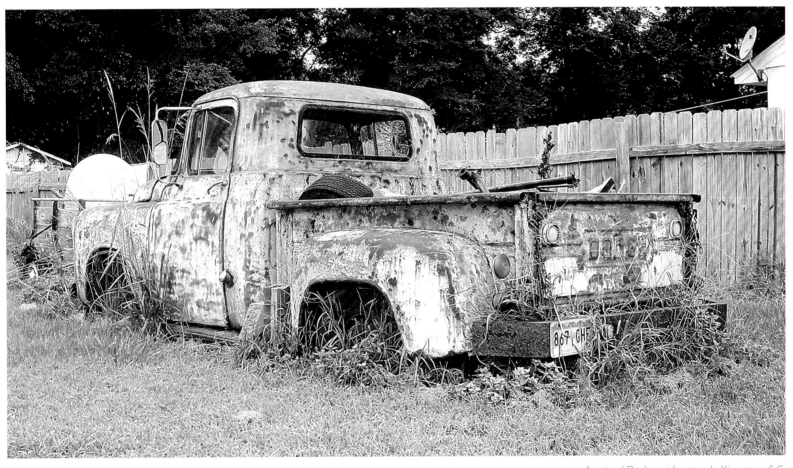

A retired Dodge pickup truck, Kingstree, S.C.

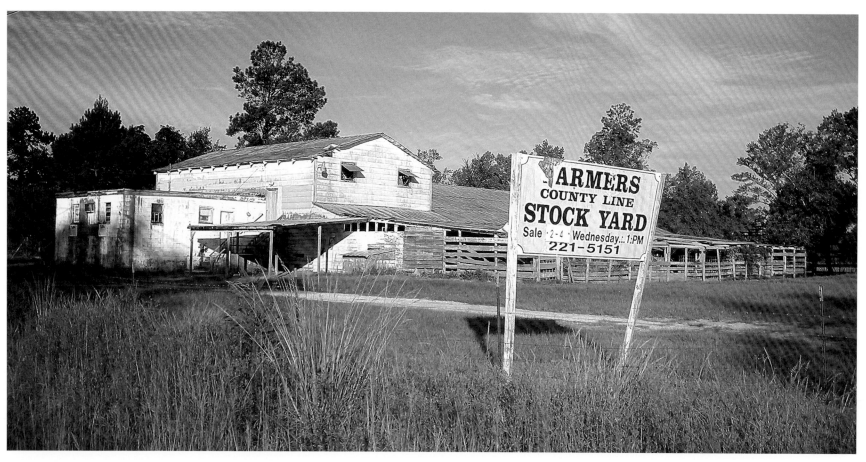

Farmers gather each Wednesday to buy and sell, Andrews, S.C.

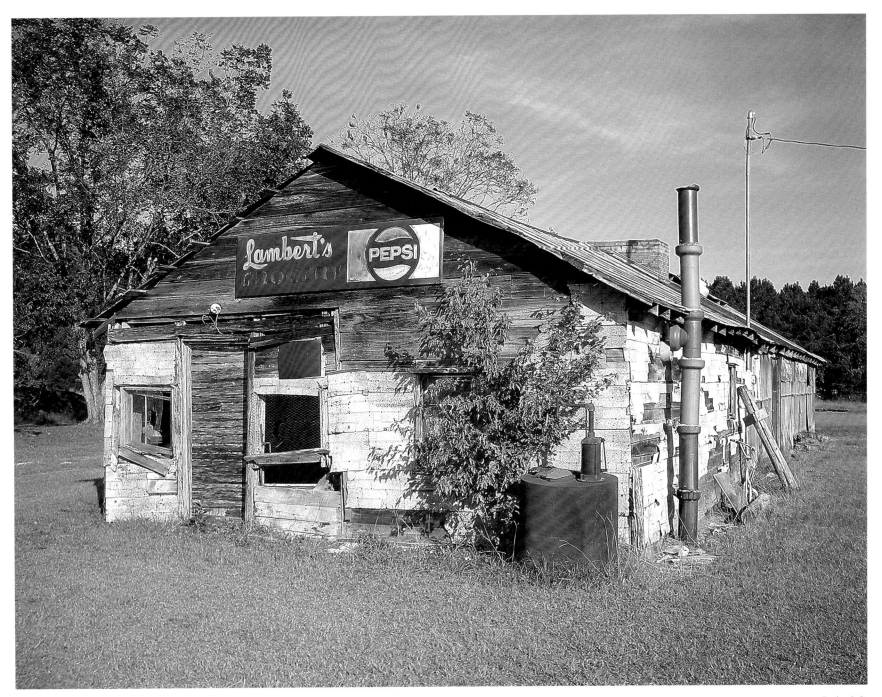

Vacant grocery store, near Earle, S.C.

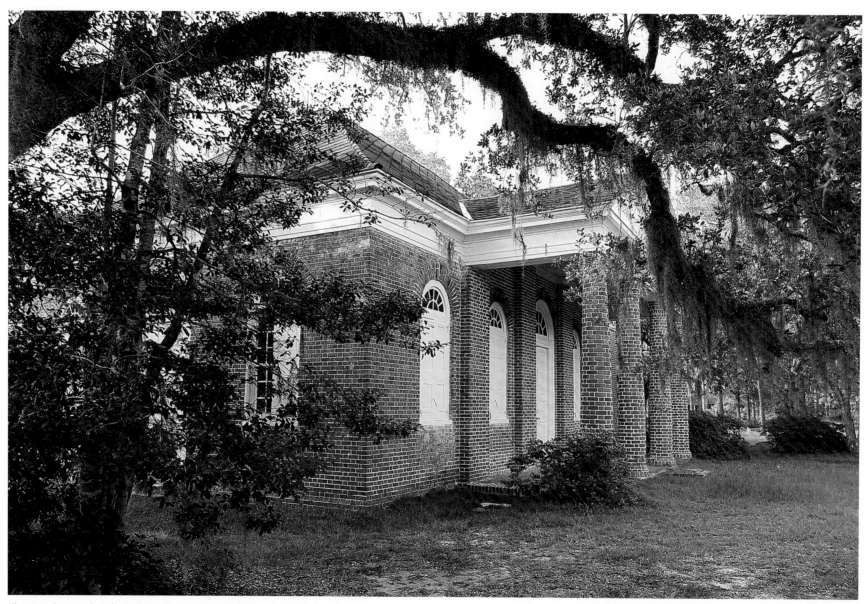

The rice planters church: St. James-Santee Episcopal Church, McClellanville, S.C.

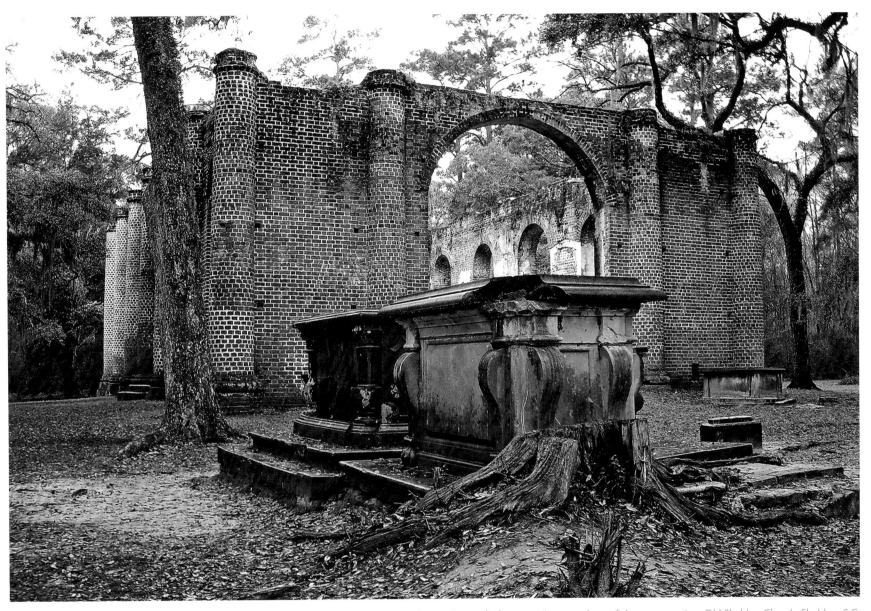

Impressive tombs honor ancient members of the congregation, Old Sheldon Church, Sheldon, S.C.

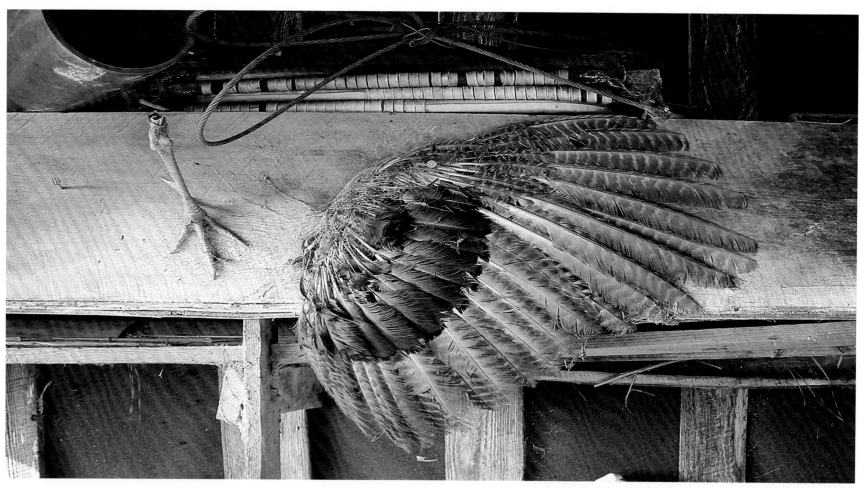

Hunting trophies: a turkey foot and wing, Ridgeland, S.C.

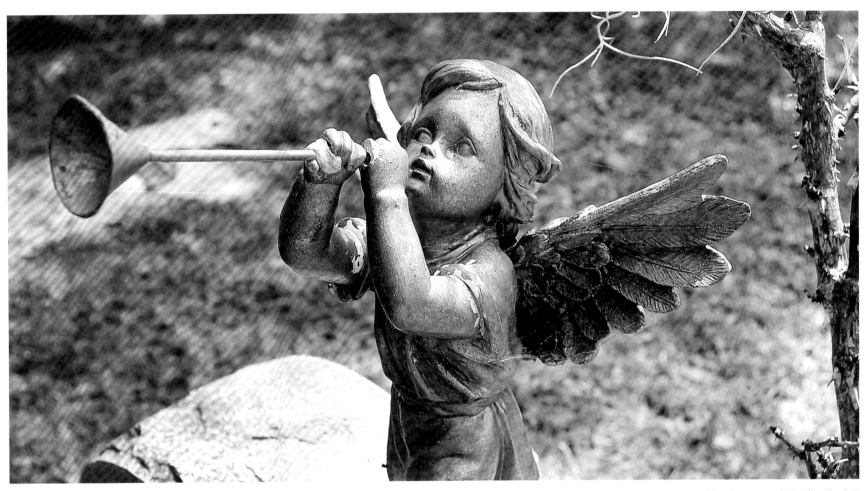

Little trumpeter, Taveau Church graveyard, Cordesville, S.C.

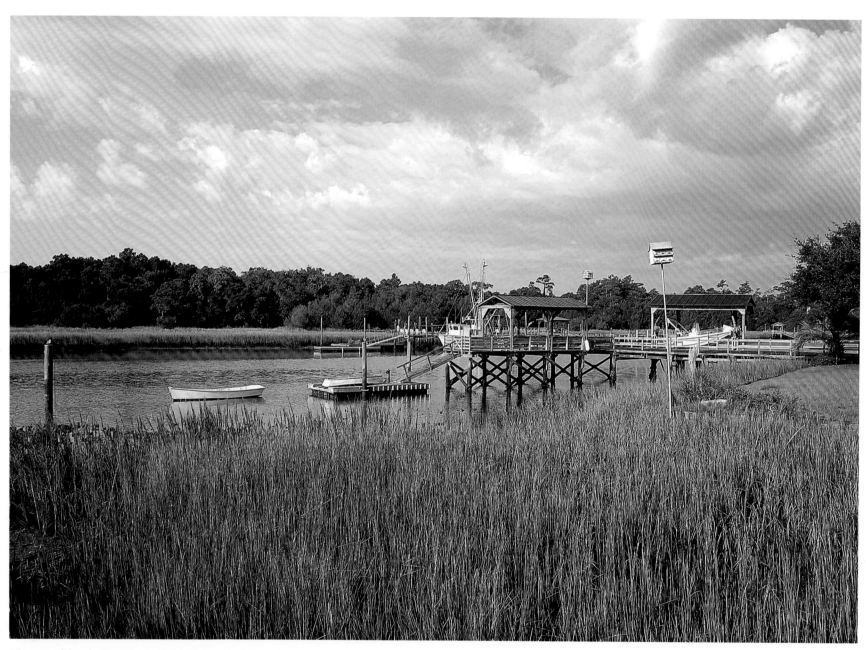

All is peaceful and still on the creek, McClellanville, S.C.

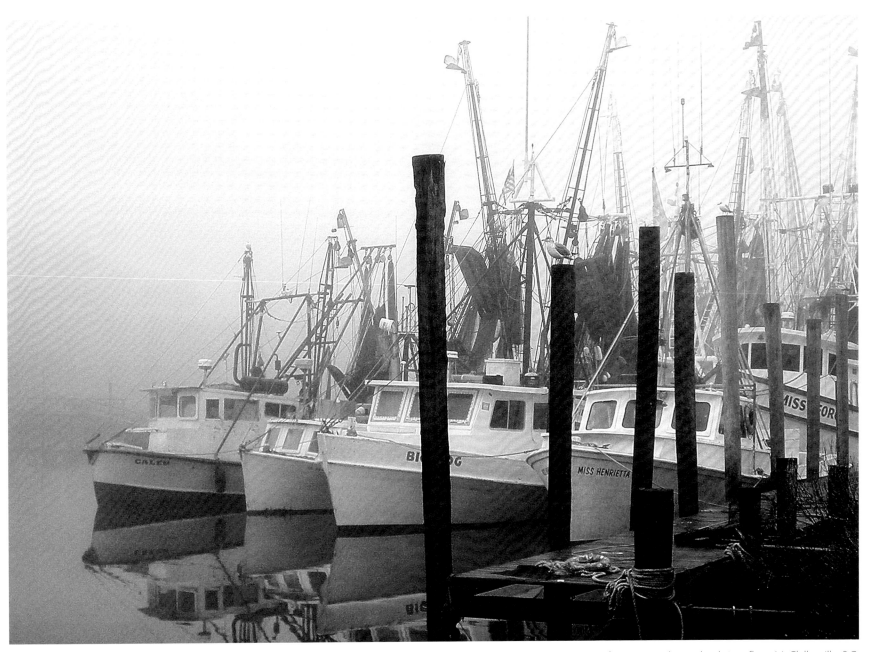

Dense fog casts a veil over the shrimp fleet, McClellanville, S.C.

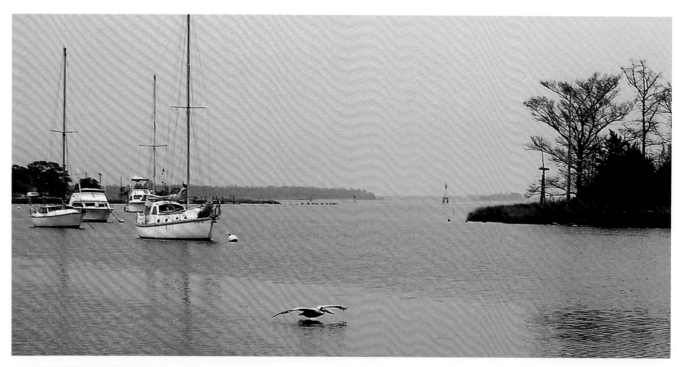

A pelican glides inches above the water, Georgetown, S.C.

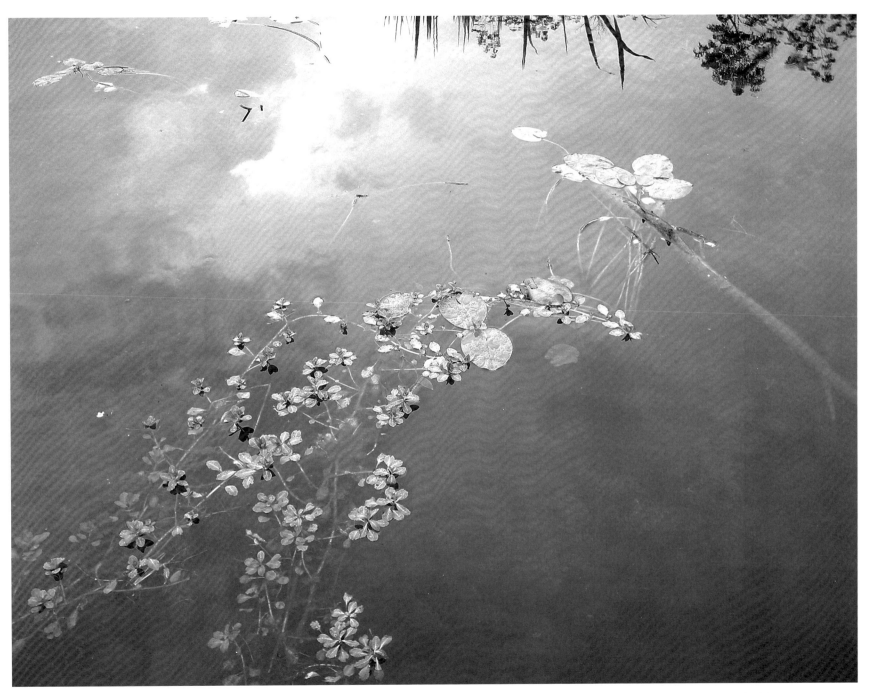

Lily pads and the reflection of clouds float on the lake, Davis Station, S.C.

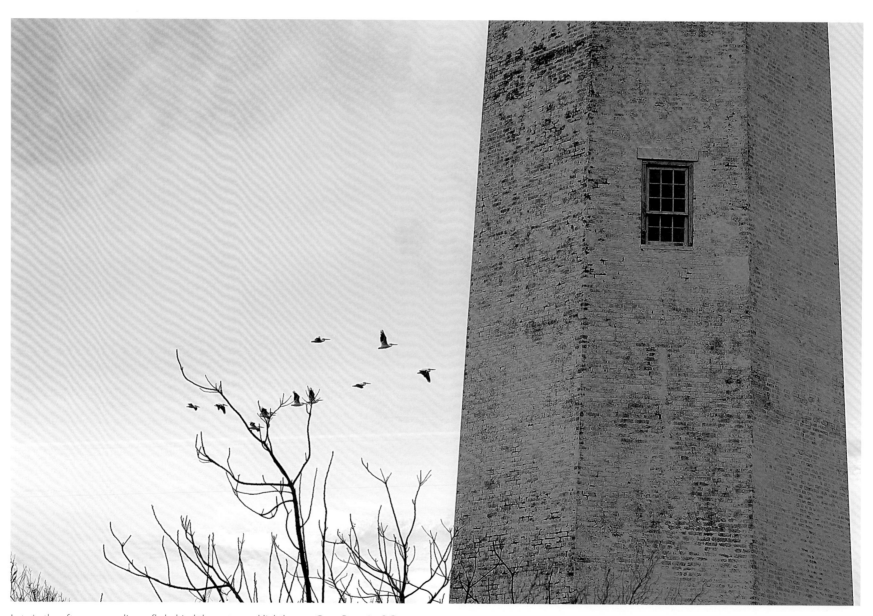

Late in the afternoon, pelicans fly behind the octagonal lighthouse, Cape Romain, S.C.

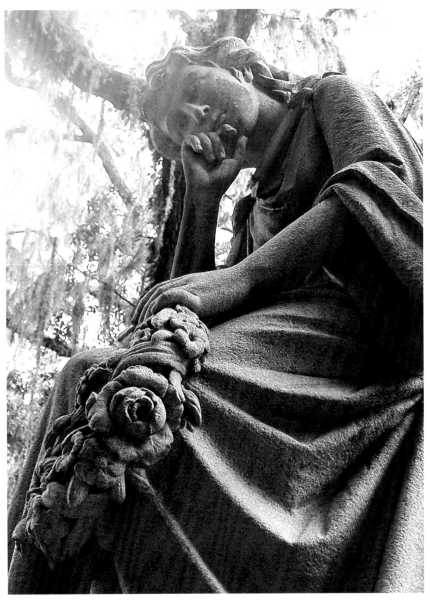

Laurels and reflection, Bonaventure Cemetery, Savannah, Ga.

The PHOTOGRAPHS of
SHARON CUMBEE

The POEMS of
WILLIAM P. BALDWIN

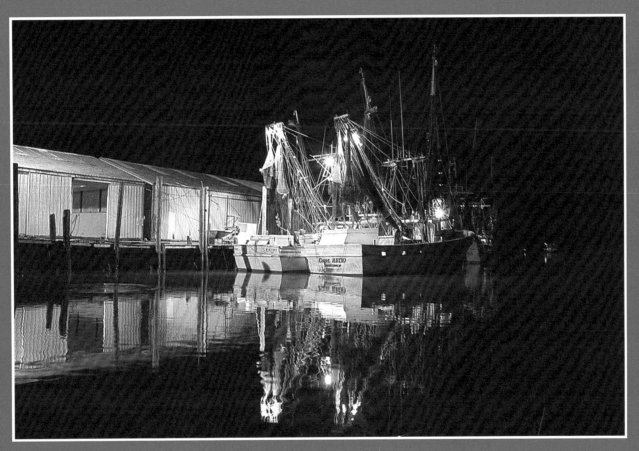

Jeremy Creek at eight o'clock in the evening, McClellanville, S.C.

THE TREE BEHIND THE OIL HOUSE

Going back a while
Back to being a certain child
Climbing a certain tree
And telling a certain sister
From there I could see
England's green hills
Most of Portugal, and a
Corner of the Barbary Coast,
And having her sing, *Doodle bug,*
Doodle bug, come out of your hole,
To the sandy cone of an ant lion's home
That was the first revelation.
And the second was her smile
And how it stalled the dreaming miles,
Sank Portugal, set adrift
Even the white cliffs of Dover,
And left the Corsair pirates
Rowing in a circle.

RETREAT: FOR MY WIFE

It'd be good to put things back the way they were.
Resend time,
Restore the Appalachians to their former majesty
And then I, shining in my angel infancy,
Could court both you and world, anew.
Smile and with reassembled language,
Sing songs of grander Niagaras
And bluer seas.
Retreat further, even.
Lay my head upon your breast
And simply listen.

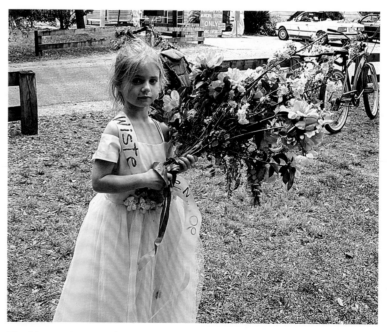

The Wisteria Queen on her big day, McClellanville, S.C.

SUMMER SOLSTICE

A streak of apple green in evening sky
And seen, too, the blue hydrangeas pasted
Deep within the live oak's warm shadow.
Azaleas gone, wisteria, the lilies all in waste,
With gaudy spring displaced
What fruition might I find
Here in summer night. As a child I swam
With tina phor, scraps of phosphorous
Tagging skinny arms, chest, and sun-worn hair—
While monstrous moon spread across the salt sweet creek
A pale but broader light. Brown shrimp, fresh caught,
Big spoon of grits, tomato slice, but still a child
Could live on rice. That was known. A fact of life,
Korean orphans had no choice. And already
We have lost the better part of June.

THE CLEAN UP

There beneath the Prince Eugene Napoleon
(Oh, she does like it best. Blossoms clean and
Molded), see the pile of fallen petals.
Yes, that's mystery. And by the
 Incinerator, the teetering stack
Of soul-wrecking jimcracks
Reaching to the sky, that's the rest
—what they're coming to collect
With a truck 'most big as the world.

A pile of petals, Shulerville, S.C.

HORIZON

In tired place
With tired face
She slipped on tired shoes,
Took a biscuit from the bin,
And walked down to the sea.
She fed some gulls that spoke of love,
Suckled baby at her breast,
With crooning lips sailed tired ships
Beyond the world's obliging crest.

DON'T TURN

Don't turn around, don't turn around,
Don't turn around, he goes.
The bear will dance, the white tail prance,
The otters dive caflooy.
Just paddle 'round this bend, he said.
Just paddle 'round this bend ahead
And put your hand in mine.
We'll lay our heads together,
Tip kayaks chime to chime,
And drift until a magic made
Of time and tangled muscadines
Turns us into turtles
Sunning side by side.
And so they did. Their boats are hid,
But that's them right ahead.

Morning stroll, Pawley's Island, S.C.

ACROSS

A brown-eyed burden of pure trust,
My little sister follows close.
Stepping slow and close, close, close,
As from plank to plank we go,
The night beyond our fingertips,
Below our feet the waves in rows.
There at the slough
Quick tides flow through.
Endless stars, a rind of moon,
Let promise grow and sea wind blow
And porpoise rise to play. How soon
The daylight comes
And when it comes, it stays.

LAWS

What makes the laws of science so nice
Is we don't think twice
About what we need to believe in,
And the laws of human longing
Are put where they belong:
In dusty tomes of poetry, drifting
cloud banks, and onto slobbered sticks
The dog brings.

CHASING BEAUTY

Don't say I didn't warn you.
What's a Greek urn
And how far to temporary?
Oh, we who yearn
For time to slam on brakes,
Back up, veering left and right
Down that mud hole of a road
We claim with shouts to be our life
And somehow snag that dog we took to walk.
Once unleashed he (or she) runs and runs
And what's to be done but chase her (or him)
In the car (the truck)
With head stretched out the window
Shouting Beauty! Beauty! Beauty.

VISION: FOR E.S. AND FOR CLAU

In a sensible world
What shape would women have?
And pleated linen 'round her hips
And *on her shoulders mantel green and gold?*
What's the point of all that fuss?
 Keep her simple. Cone, column, sphere,
And if you must, dress her in a tissue shift.
Plus that face, reflected in the store front glass
Along with live oak trunk and Ford across the street,
Let the flickered sadness
Be replaced with a happy smile,
The first is just reflection
Spun by a noon day sun.

Sad-eyed beauty, McClellanville, S.C.

LAMENT

Tonight the dog spoke of you.
The cat, too. She hummed with
Sad affection. The jays have chattered
And at dusk the curlews flew low in close
Inspection of that hollow place you left.
On the dike there at marsh edge, was then,
I saw in cloaking of the sun that deception.
We, cat, dog, and birds train ourselves
To call the truth. We, cat, dog,
And birds have seen and share that emptiness.
I alone have mopped the kitchen vinyl clean
And put the kettle on.

"Frankly My Dear!" Shulerville, S.C.

IN THE MANNER OF
In a better world
I'd be the kind of poet
Who rhymed things metaphysical,
And time would fly
On wings of gossamer
Instead of fins of plastic.
Our sphere and all her train
Would hurl instead of tumble
Half-deflated down this
Village sidewalk,
Bed sheets would smell of roses,
Peacocks strut and holler,
And your love, constant only
In its debateablity,
Would slip into the category
Labeled pure fantastic.

GONE WITH THE WIND
In combusting nations
What part do the resinous hearts of women
Play?
Helen did poor Troy in.
Scarlett watched Atlanta burn.
But why'd Rhett wait so long
To frankly say I don't give a damn?
Was it 'cause men and women want the same,
To build it up, burn it down, and build it up again.

OH, DEAR
Oh, Dear God above,
Pardon our offenses,
Longings of the heart
And efforts of the senses.
Move Mountains.
Feed the poor.
And end all war.
Then pardon our offenses.
Least among them
Longings of the heart
And efforts of the senses.

IF WE ARE

If we are to worship
Fire, water, air,
Women fierce and fair
And all other creatures miraculous,
Worship the quiet footfall
In the empty house
And know that time is still
And life is vast,
Love does not fall
Or hope decay.
We may still say
Most mournful
Most beautiful
Most likely to succeed.
But at what
When words we need
Have worn and wept themselves
Well past the burnish.

THE FLESH HAS

Knowing that the flesh has memories
Or echoes, anyway.
We step close on fingered feet
And shout the canyon raw.

AN ECHO POEM: FOR DAVID S.

Out on the highway trucks past by
And at the porch I hear, I feel,
Harsh echoes in the trickster air.
Oh, I know this low pearl sky,
This smooth cloud bend that flings out sound.
While picking oysters on the Keys,
Once I was trapped in traffic so.
From ten miles off the GMs whined.
And when the Bosch gears ground
A hundred recap tires whispered "come on, go,"
For it rises daily everywhere,
This tide in the affairs of men.

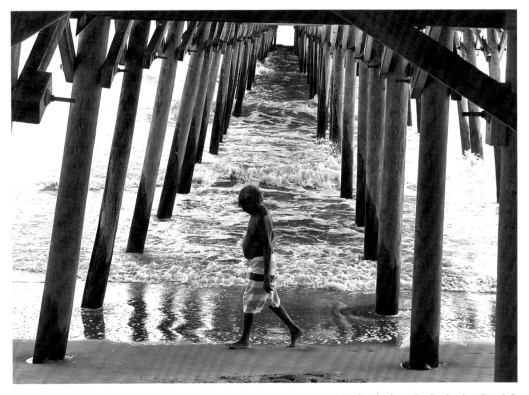

Under the boardwalk, Garden City, S.C.

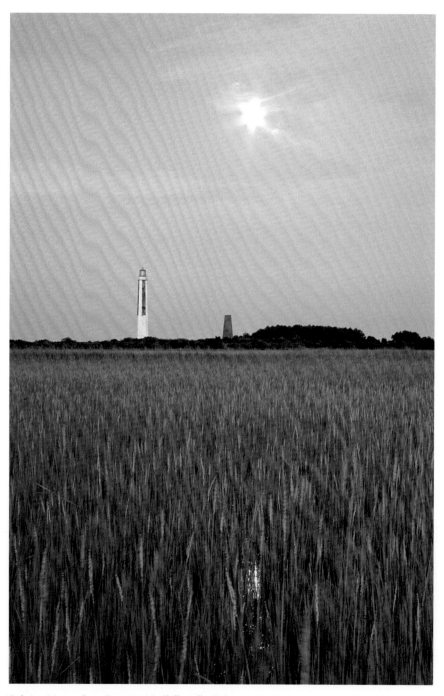

Solstice Moon, Cape Romain, McClellanville, S.C.

ISLAND ROMANCE

It's a thin blue dress she wears. And from a sun-bleached
Ribbon round her neck
Hangs a ruby ring. What, in truth, would
We remember,
Heads filled so with odd prescriptions and fears
Of sins commissioned?
But the stunted oak has not forgotten
All that was said on
The path through the dunes. Oak, sheared and bent
Beneath the wind's weight,
There between uplifting roots, she found
The woman,
Skull filled with crystal blue beads. Princess.
Indian princess,
No more or less than island royalty. And now a second,
She in thin blue dress
Wind pressed against thighs meant to forge
From poor man's flesh
Some noble linage. What she sees?
Cows so pestered
By the flies they go deep in the surf and stand with only
Nose exposed.
Terns so thick they rise above her head
In feathered storms.
That turtle in laborious crawl from sea to sand
To lay her eggs, to form
While weeping turtle tears, a turtle linage,
Then go back to sea again.
All this she sees and tells the oak. Speaks to tree of
Him, her suitor, bent at oars.

Him in her daddy's house, him smiling at her mother,
Him
Teasing at her sister—sister who in season sings to butterflies.
Marry that one. Not me.
She says that to his face.
But no. It's her he's come for.

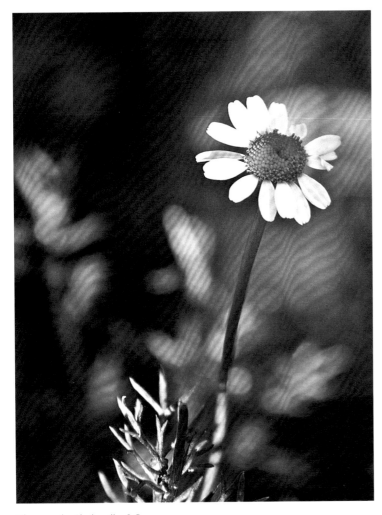

Chamomile, Shulerville, S.C.

LUNCH
I hardly hear the heron's cry
And see the moon with daylight's eye,
That you are there beside the truck
Talking to the dog of luck,
Of how when we are rich
We will make a grand picnic,
But for now cheese, saltines,
And seeped in slippery mess, sardines.

I hardly hear the heron's cry
And see the moon with daylight's eye,
That I take remembered trip
And taste the mustard on your lips.
And hear the bark of odd tooth dog
Rousing 'round some rotted log,
And hear the laughter from your lips,
And taste far oceans on your lips.

TONIGHT
Luminant world
Bright moon
Who in rising
Buries even tips of marsh
And all breathing life
Beneath a salt-lipped hiss,
Cross me off that list
Of potential subscribers. I
Have given my last hooray,
And what's another sigh
To a rising moon like you?

"Cat"templating, Shulerville, S.C.

WEDDING VOW: ALI & LOWRY

If he goes will you follow?
Climb Mount Ararat
And help him find that stone boat,
Pace out the cubits,
Say, "It will float." ?
Will you take him
In those strong arms
As Mrs. Noah did?

I will. I'll
Comfort, succor,
Even whisper, "It's okay.
We'll fit them in,
Yes, two of each.
Now close your eyes. Get some sleep."

THE MOON SONG

She wanted more of the ocean.
Something bigger, wetter too.
Her daddy's tales of Singapore,
Her mama singing Bali hai
Had wove bright spells
No wave would satisfy.
Another wistful adult,
An all-expectant child,
She still put the moon on her shoulder
And splashed around awhile.

HAMPTON 1952

We rowed today
Where wood storks stood
In solemn poses.
Talked today where roses, wild and pink,
Lost petals to a current where
You dipped a hand
And did not seem to care
When those two roses, wild and pink,
Slipped into your hair
Lost petals to a current where
You dipped your hand and laughed
At all the world's brief solemn poses.

ANNIE B.'S HAMPTON SONG

On that back path where Henry's laid,
Beneath a broken marble slab,
A shrine to heartache we have made
By praising only what is sad.

Rocked awhile in favorite chair.
What was mansion, what was wealth?
He yielded to love's grand despair.
Denied a bride he shot himself.

The branch is bent, the branch is bare.
The world is geared to such decay,
To winter storms and endless care
And gestures that defy delay.

The leaves lay thick upon his stone.
The leaves they mix with blossoms picked
And set to fade on Henry's stone.
Pale sun burns an earth that groans.

But what if Henry'd gone outside?
Thought let me celebrate myself.
Winter solstice has arrived.
Love's not dead and days are wealth.

For to that place no man goes
(Not me or you and Henry, too)
With knowledge of its bounds and woes
And best to see this gift world through.

That winter solstice sign above
Joy in life is not forbidden.
Henry should have smiled and shrugged,
And let the Spring then mend his heart.

Wave dancer, Pawley's Island, S.C.

Rose garden, Shulerville, S.C.

DON'T

Don't take the sun, the moon or wind from out the west,
That soft wind that rises with the tide. You may keep the rest.
The gold ship with three well-crafted silver masts,
That and the silken cow who comes
At night with clinking halter jewels,
Comes with sea-riven mist to haunt the Jack's Creek path.
Take ship and cow and all else
You now confuse with wealth.
You will wake.
'Til then I will take
The gull that stands one legged and the rest,
Who spread their wings, shake off the land,
'Til then hold both sun and moon,
Thoughts of you and wind from out the west.

LITTLE, LITTLE GIDDING

If Elliot had had his way.
Then time could freeze and melt away.
What's the use of all that thought?
An altered course,
An altered clock,
An altar boy
In altered smock.
Light savings time is here today.
Hooray!
With fresh expressions of delight.
Another hour is slipped from night.
And Christ on Easter morn' may raise
Our tired hearts from tired ways
An hour later. God be praised.
Yet still and all I know it's true.
My inside clock is beating fast
Easter present, Easters past.
 (A selfish thought but let me say)
It can't come too soon for me,
The visceral wrench of Easter day.

ROMANCE

Tie the belt of madras dress,
The memory of some tenderness.
Take the dog and walk the shore.
There was a man who reasons wore
Down to a stub, a scour, a scar,
A man who drew the mermaids in
To sing to you of sorrow,
Who laced the air with salty hands
And built tomorrow's castle.
Here the moat, towers tall,
Crenellated Bastille wall,
And in the floor a secret door.
Ah, such a gift. He held the tide 'til
You had gained the beach,
Stood ankle deep in melting sands
And learned what beaches teach.

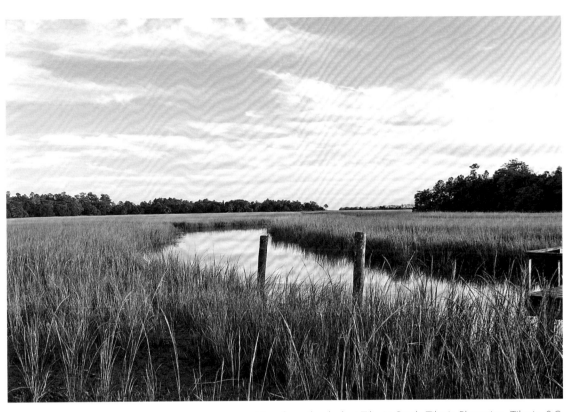

View from the dock at Tibwin Creek, Tibwin Plantation, Tibwin, S.C.

Zinnia, Shulerville, S.C

FOLLY BEACH '32

Folly's sweet country for a poet.
DuBose here where he belongs
And with Dorothy's in his arms, birds in trees,
And those dying generations still at their songs.
Roads laid with shell, a trout-crowded sea,
Fish, flesh, or fowl, commend all summer long
Whatever is begotten, born, and dies.
And DuBose hums soft and tries:
Summer time, living easy.
Daddy rich, Mama's pretty,
Hush, baby, hush.

Hush.
Fish jump, cotton high.
See. He's found a quiet alibi,
The last and best of lullabies.
And I who lifted, turned, and bent
Shifted script until it meant
Now, this moment,
I and you who heard your part
Step light into this opera of the heart.

I WAS WAVING

I was waving not drowning.
It's easy to confuse the two,
Especially at that distance.
And with those reports of killer whales
Moving down from their Iceland killing grounds—
They come in pods, like peas, but with a bloody minded
Aggression not found in some Le Sueur can—
You likely feared the worse.

Still, I was waving not drowning.
Yes. Yes. Over my head. Head and heels over.
Again, as in every morning since my arrival,
I watched you jogging down the beach,
Arms, legs piston perfect,
And asked myself, for once in my dull life,
Should I muscle up my courage, wave to her?
Make this Monday different from every other.

Oh, oh, on the beach you come and go,
Bronzing as you run in the sun.
I scuttle like a speckled sand crab,
Trousers rolled above knot knees.
Except today, when for reasons,
That rising from the heart have no reasons,
I donned my suit and swam far out,
Waved and gave a shout.
You slowed, slowmo, as in the movies.

Elvira Madigan. Remember how
They went and ate the dandelions,
And starved to death in that graceful
Way that movies have of slowing
Down the action, puking grass stems,
And no one seems to think it strange
That lovers went to such extremes as
The movie people did it slow and in a glow of pastel color.

Anyway, you may have smiled.
I cannot say for certain what expression came.
You stopped and raised a palm to shield your eyes,
I waved away as a man will in those circumstances,
And you, misunderstanding,
Came bounding through the surf, calling out the comforts
Of your saving kind:
Stay calm, stay calm.

I heard that much and thought
To drink the ocean and thus avoid,
The embarrassment that went with
Such a wild mistake. I was waving, not drowning,
Daring myself, wrestling with a mordant conscience.
But I see.
What can it matter? We dance in seas of platitudes,
Splash and sputter all manner of intent.

I should relax.
I am expected to relax.
Yes.
Relax.
Take me under your strong bronze arm,
Press my bobble head against your spandexed breast
And pull for shore.
I may yet be saved.

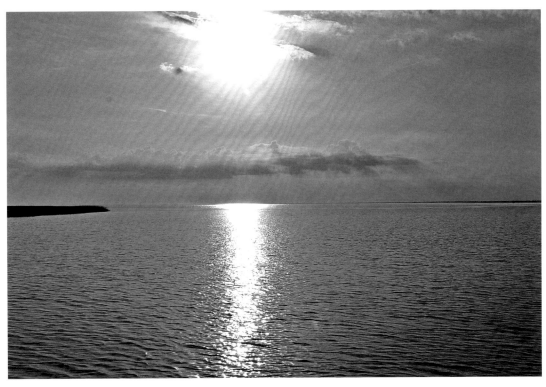

The sun sets, Cape Romain, S.C.

SONNET 3

The waves came not high and riotous,
Not foaming thunder, tumbling, grit clenched.
No. We had only a gentle scour
Which seemed to hesitate, then rinsed
Away that indention that marked our
Brief embrace or should I say surrender
To the forces of love's eroding power.
Taking, too, that folded sandwich wrapper
The one you threw as if a bottle sent
With message to some distant shore.
And what condemnation or lament
Did you post script to that nodding consent?
I did not think marriage to me so grim
An undertaking. Wait. Is that a grin?

PAWLEY'S

The swallows warring in the eves,
The rattling oleander leaves,
While peace he brings in that bent can,
Sweet corn and trout, fresh and cleaned
To you who stands behind the screen,
Raising now your sun-worn hand.
He and you, a battle hymn,
In night seas where dark things swim.
Conch shell, conch shell, whirly gig,
Best it is on land we live,
But what's below we find above,
Turtle skull—of love it sings
While on this porch the dark things swim.

OCTOBER

What's been done before
's been done before.
That expression she wore
Climbing the steps to where
He'd left the Tom Machan's shoe box
Half filled with shelled pecans
(golden apples or an Emmy)
That smile's been smiled before.
Don't you know
When Cleopatra went to see Rome's Anthony
She rose just so?
The gray cat's indifferent yawn
Yawned so since time's dawn,
Enacted all before on that porch swing
Or divan,
Depending on the man,
The cat, the century, or time of day.
Must they dine with silver tines?
This is where ham sandwiches belong
And sweet tea with lemon slices
Embedded in the rims of jelly glasses.
A plain dress of plain cotton, plain pearly white,
She touches that St. Christopher her Mama gave her
She says, I wouldn't want to live forever.

THAT'S ME: FOR STEPH

There's you.
 Beauty born of chaos.
Sea bird as woman, legs, shapely bare, thighs
Full and bound around with an emerald cloth of
Woven weeds. Breasts the perfect feathered
Compliment, downy soft, the shade of alabaster,
Arms the same but for the hands of *phosphorescent* flesh, finely fingered
And intent upon the braiding of a single thick braid.
Hair of gold or black as jaded night.
I cannot say with certainty,
The light being bright but of an inconstant quality.
Still your face, it seems a marvel of compositry,
Beauty's bits and pieces laid in purest harmony.
I've seen that smile before,
Seen it someplace back on shore.
Coming out the St. James Church?
Or crossing Broad Street?
Maybe both?
Me?
That's me just off from you.
The white boat floating low on this ocean
Large and blue.
See. Bailing with my hat.
That's me with sopping wet
Broad-brimmed hat in hand
And way beyond the sight of land.
I've stopped to wave
But just at you.

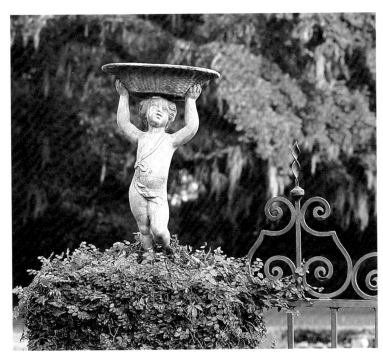

Garden statuary, Harrietta Plantation, McClellanville, S.C

FOR VIRGINIA S.: A LYRIC

Would seem that time's a river scheming,
Seems that I'm grown old with dreaming.
Wonder that they don't break through
These frail vessels treading blue,
'Neath the flesh of my wrist,
Wrist you press against your lips
A kiss you slip to memory's breasts,
And I also dreamt, which pleased me best,
That you lov'd me still the same.

THOUGHTS ON A GARDEN

I've been to the beach.
It's like here but wider and hotter, too.
No live oak there to give this blue-green shade.
No apple slice, no New Yorker. Right,
No iced tea pitcher either. I won't go back.
She's tried her damndest. Flipped the hammock
Sicced the dog on me. Last time she made
Up some excuse, walk that same dog, some rock
Solid reason to be standing on the shore,
A violent ocean laying calm, sun bright delight, a trap.
Wade out, Wade out, she cried.
Trousers rolled, shoes in hand, I took a step,
Be a man, she cried, Oh, be a man.
Knee deep now.
Wade out she cried.
Now mid thigh,
Looking back, intent on your approval,
(The she is you, no use to hide)
No. That won't do at all.
You, with hair pinned high,
You waved the tip of parasol. Wade out, you cried, wade out.
Me now chest deep, salt spray in eyes, salt spray on lips.
Wider, hotter, wetter, air ballooning beneath seersucker lapels,
Dog yipping, you with free hand on handsome, bustled hip,
Waving with the tip of parasol. Be a man, you cried.
I tried.
In one hand, shoes, the other pressing straw boater
Near down to my ears, and here the shark's fin, crisp sea incision,
Gray, fiendish, dorsal, and silver tracked. Wade out, you cried.
A shark, I cried. And as now the creature wallowed between me and shore,

Rolled half onto his side and spread his raw shark-toothed mouth wide
Enough to swallow you and Pekinese with still room left for me,
The lover lost at sea,
You chose to flee
To higher ground. Parasol in one hand, pet in other, yet fingers free
Enough to grab great handfuls of flowing skirts,
Off you hoofed on dainty feet with no look back
Until the trolley tracks were reached.
And where am I in all of this? Taken by a shark I've spun
From just your summons "to the beach."
Oh, yes, the ocean's fine, at least that one we call the mind.
There all semblance of a fact
May burn beneath a tropic sun,
Wash and roll in surf's soft surge,
While I here in garden made, in hammock hung
In blue-green shade compose a world where smiles don't fade.

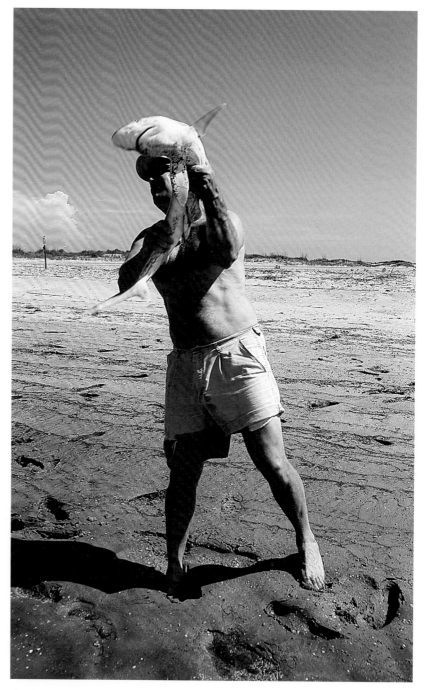

The shark dance, Cape Romain, S.C.

Susan, Jeremy Island, McClellanville, S.C.

THE BIRTH OF VENUS
My mama held me close and sang,
"How sweet she is, how sweet,"
Then placed me in a woven sling
That round her neck did reach.

She pulled the thread and bit the thread
And made a shroud of lace.
I keep it in the coffin box.
As all things have a place.

"When you were got," my mama claimed,
"I heard the sea gulls scream.
I spied upon my thigh
The sea foam glistening sheen."

"He went away. Away he stayed."
Her breasts were soft as silk.
She fed me there on nectar
And silver pearls of milk.

"You were a tiny babe,
Two hand widths and no more."
My mama sat me down
And this is what she swore:

"I dreamed a sword came falling
When I was brought to bed.
I know that was my token
For love they do forbid."

My uncle built a coffin small
No wider than two hands.
That's where I keep reminders
And wonder at men's plans.

How can they speak of longing,
Of beauty and desire?
The world is made by women
With whom the gods conspire.

THE THEOLOGY LESSON

I place her there as in a game of chess
With garden as the squareless board.
A single Eve stripped bare,
She reaches for the garden's pear,
Beneath her arm a patch of hair,
Yes, she goes unshaved the way French
Women dare for French men
Are not in such matters driven
By the hygienic slick tending
Of what God has placed here and there
To avoid friction.
Anyway, on tip toes with finger tips
Extended full she still can't reach the pear.
(God does not specify. Apple? Quince?
It's knowledge that's at stake.)
And she may, in game, lean there
Unspoiled, naked, and not falling
For all the ticking minutes of eternity.
With rules unwritten, who's to say?
Didn't Adam take delight in such a sight?
I do.

MY LOVE IS LIKE

My love is like a green, green apple or
More like the green, green apple core,
The green, green apple core chewed down
Until the mahogany dark seeds show through.
That's how much I need you.

No. Don't say no.
A colossal green, green apple core.
My need dwarf yours so
I've chewed it down myself
And appetized
On the apple seeds of need.

GIVEN

I could do worse
And given half a chance I would
Build my house on sand
And not of brick,
But wood
Or even straw, some mixture
Done with mud.
I'd whistle up the wind,
Beg a hurricane
And reveling in the rain's disdain,
Watch it melt and fly away
Into the sky a ways.
So listen while I say:
I said it then.
I say it still.
Say it 'til you get my point.
I could do worse
But with you around I won't.

Goose and gander, Shulerville, S.C.

IN THE MANNER OF ADDONIZIO
Something happens to El Niño or
Maybe in Morocco there's
A pigeon flaps her wings.
Doesn't matter how, just
Bring it on.
Storm of the century,
Make that millennium.
Bring it. Bring it. Bring it.
A hurricane of the heart
That leaves parts and parcel,
Panties and those red suspenders
Santa brought draped in trees
Still bent double from your love.
Yes. Absolutely.
A wild and wrecking cyclone
And make it soon. What?
All right. All right.
Since you've started supper
I'll settle for a kiss.
What?
Okay. If you got to
You can blow it 'cross the room.

METAPHYSICAL RIFF
Now smooth, now thin,
The nickel remembers
Both buffalo and Indian.
Nothing's lost or gained.
Atoms just get pushed around
Spread out, rearranged.
As a love remembers
Though smoothed, unnamed.

Palm frond, Santee Coastal Reserve, South Santee, S.C.

WHAT CAN

What can be more certain
Than the earth's decay and renovation.
Silt and sorrow,
Gravel, sand, and clay,
It's all a piece, another day
To bend and crack and mend again.

Now we lay us down to sleep
Pray our souls the Lord to keep.
Imperfect globe then circles round
And start to wear away again.
To grind, collapse, at least delay
Small spheres in which our hearts hold sway.

A TUESDAY POEM

White pelicans in single file
Ride a surf's rough draft.
As if that wind complains
She hears a sorrow's laugh.
And stepping quiet through the dunes
Comes on such a sight.
Laced in faded wedding garb,
Lithesome women in the marsh
Bend low to scratch
Where shackles once attached
Raw ankle to raw ankle.
Do you know what madness is?
A sea wolf's breath upon her
Neck, followed by a

Rise of tide, and there
A string of pearls grows wild.
Who can name tomorrow's fears?
These darkling maids, what will they
wear?
What will they say?
Modeled on eternity,
Mother of us all, the sea,
At dawn a pink white stretch on
blue,
Lithesome women in the marsh
Whisper to the sun "I do."
And as the rest is mystery.
What sunken man will she take
As husband, friend, and lover?

RICHARD'S SONG

Adrift in sun suspended dust
A sailfish with broken bill
Arches high above an ocean attic wave,
Fierce concoction of fish parts, papier-mâché
And large, yellow glass eyes,
Animal of pure ocean-bound appetites
Landed, taxidermed, and stranded, at sea among
Six unstrung tennis rackets and two packet trunks
Brimming full with tuxedoes worn last in the Grand Depression,
All gifted to my grandfather by a grateful employer,
A Philadelphia lawyer of nostalgic bend,
Hoping to lend this sober Southern pipe-smoking man
A past of civilized dimension, to kick-start Pap's untraveled Methodism,
Show a world unrolled, pressed back, four corners tacked.
At the wandering age of six did I glimpse in that fish's golden eye,
Babel's streets, and sea-trimmed foreign skies?

PADDLING WITH SHERRY

What will take the place of ancient dreaming,
Fasten darkness on the broad Cape marsh
And this expand with stars and moon, then
Incant a sun to brighten golden beauty back?
Tell me. What supplants these timeless intuitions,
These willful claims that sprang from out of chaos
To form the order of a day,
Secure the seeds of men in women, teach herons
How to fly, make mullet jump, and on certain mornings
Draw the ocean up and flood in consternation
'til only tips of grass extend above a silver surface?
Who's job will that be—to leave
The snails dangling here exposed
So small crabs climbing out the water find them,
And where is there safety?

Farmer and his reliable John Deere harvester, Shulerville, S.C

WHAT WE KNOW

Now let's consider the fiddler crab.
He fiddles wide but not so loud.
His mighty claw he waves around,
Sliding up and taking down
To orchestrate these four:
Her love of him,
The rise of tides, the flight of geese,
And in part at least,
The spreading of the Universe.
He motions quick.
He motions slow, slices salt air to and fro
Does she hear him? We can't say.
Miss China Back ignores it all,
Keeps piling sand in little balls,
But what does man know of sand
Or of the heart's tempo?

BLESSING ON MY WIFE

All hail, and bless the happy plan
That formed your thigh
Just for my hand.
And what does Darwin know
To say it isn't so,
To call in doubt a sweet design
That only God could bring about?

THE DEER HEAD OAK

Every blessed animal that swims
In air around the oak
Or scurries up a limb
Or laughs while leaping roots
And swings on tire swing,
Wings, four legs or two, child or wild,
These creatures storm the heavens
To do what oak tree angels do.

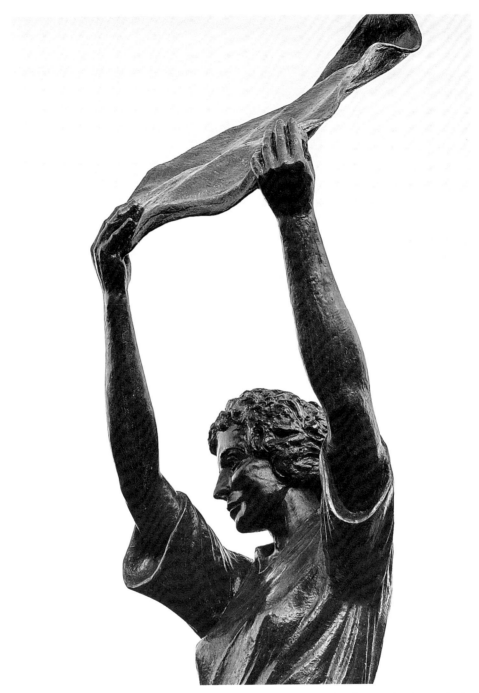

The "Waving Lady of Savannah", Savannah, Ga..

SHARON'S
Offerings

❦

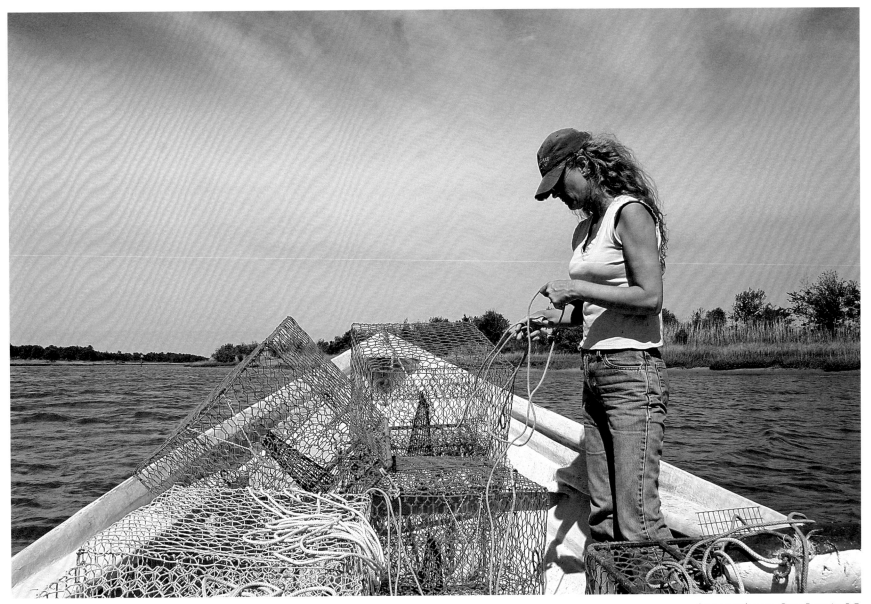

Setting crab pots, Cape Romain, S.C.

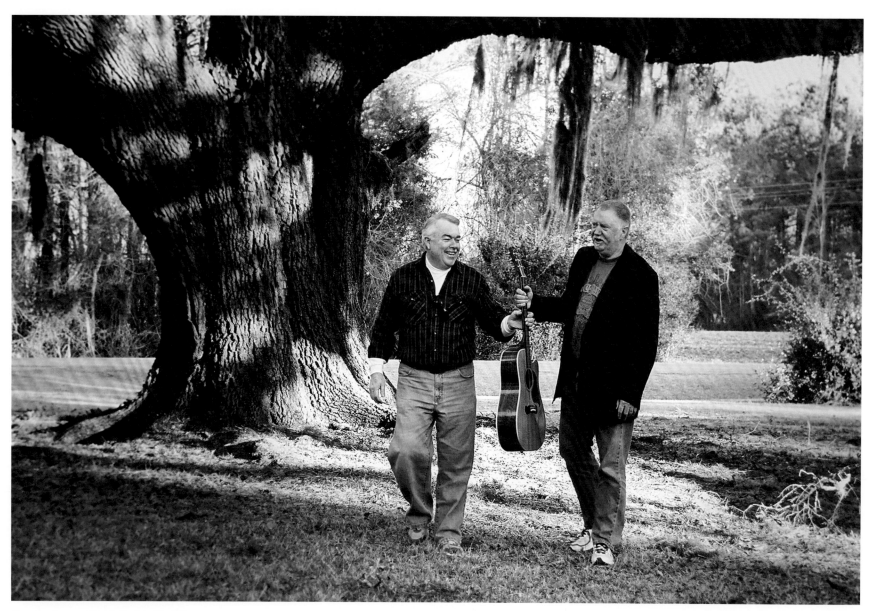

Play one for me, friend, Shulerville, S.C.

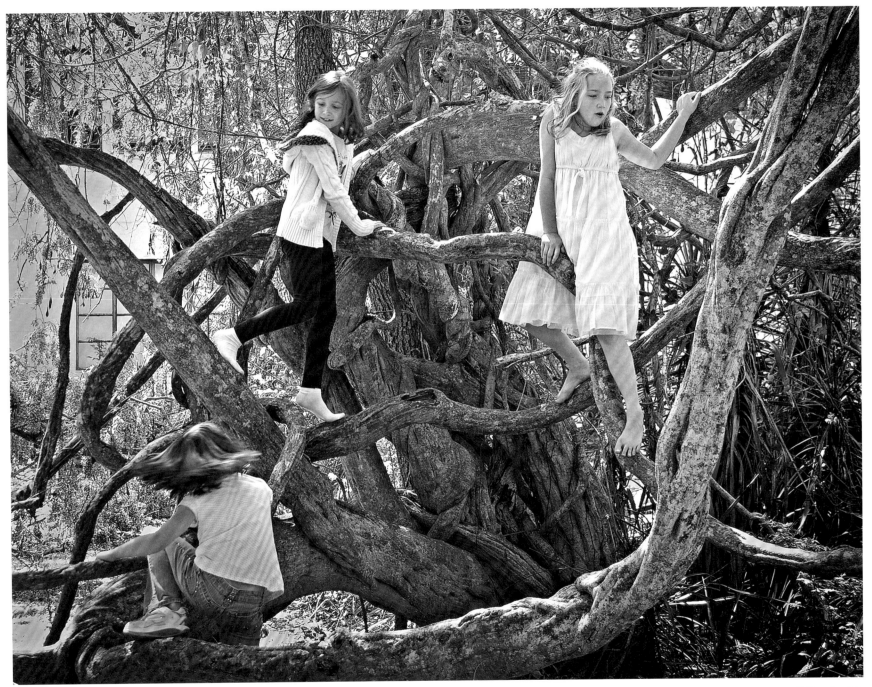

Children climb on nature's jungle gym, an ancient Wisteria vine, McClellanville, S.C.

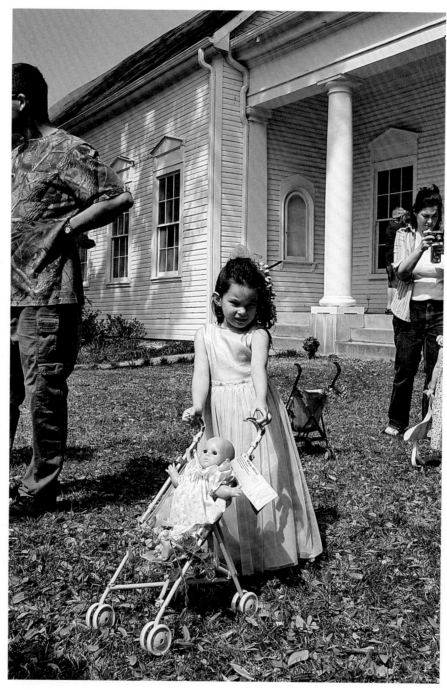

Ready for a stroll, annual Wisteria Parade, McClellanville, S.C.

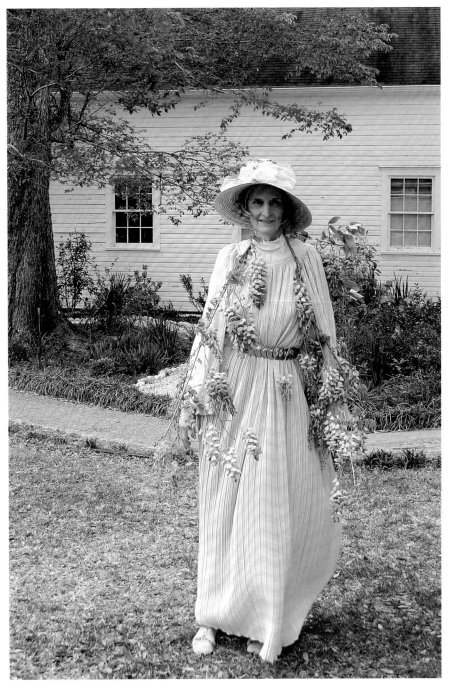

How do you like my gown? Wisteria Parade, McClellanville, S.C.

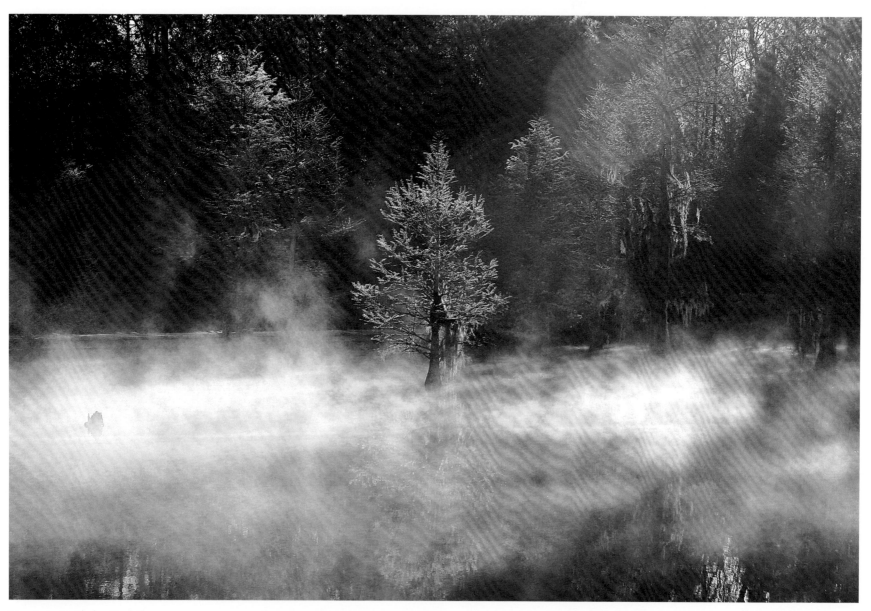

Morning mist, Shulerville, S.C.

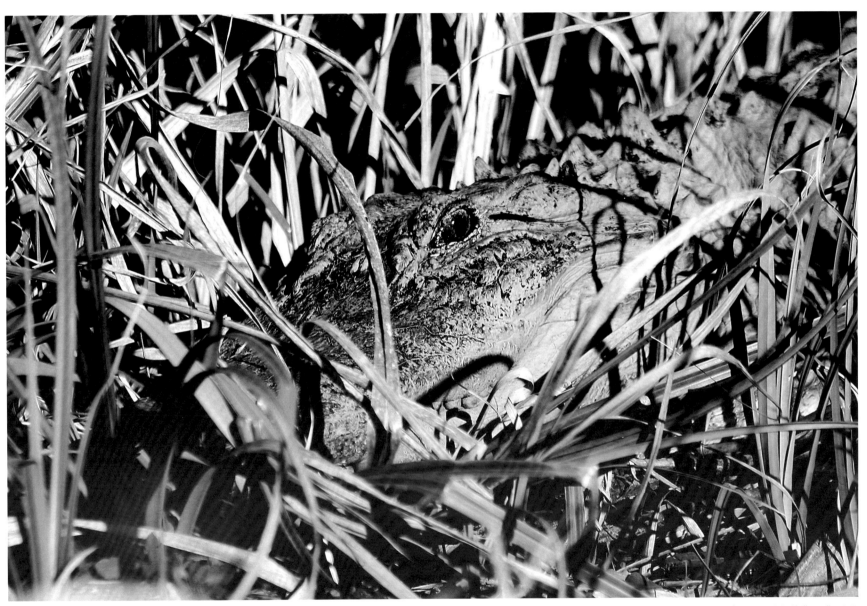

Gator in the grass, McClellanville, S.C.

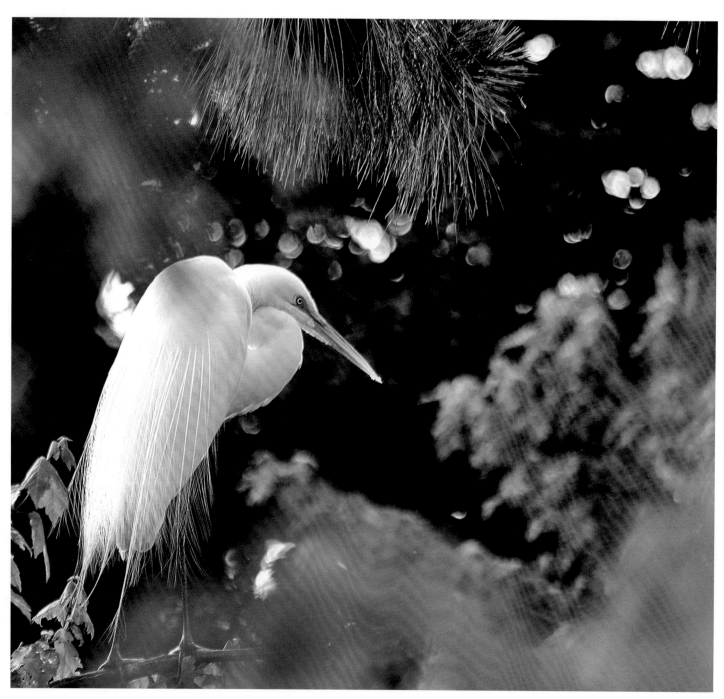

The egret, Awendaw, S.C.

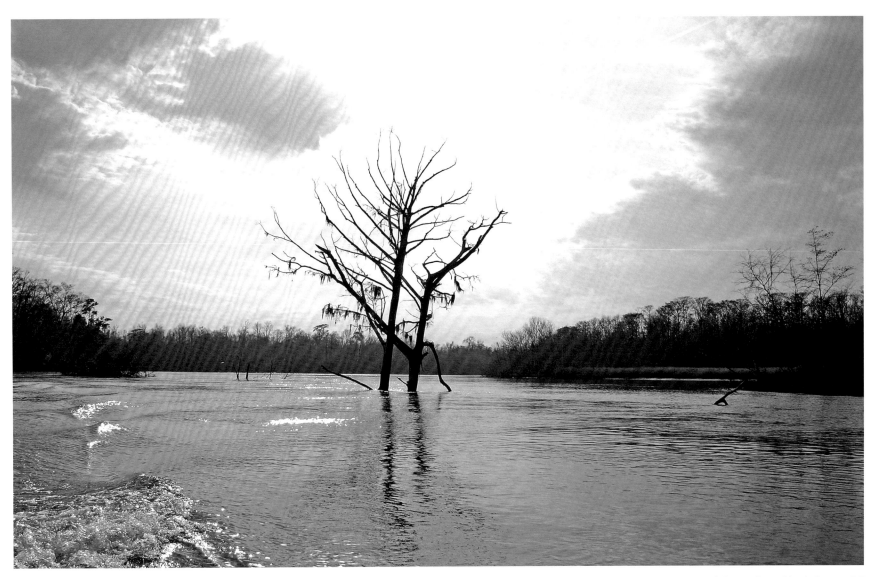

Evening, North Santee River, North Santee, S.C

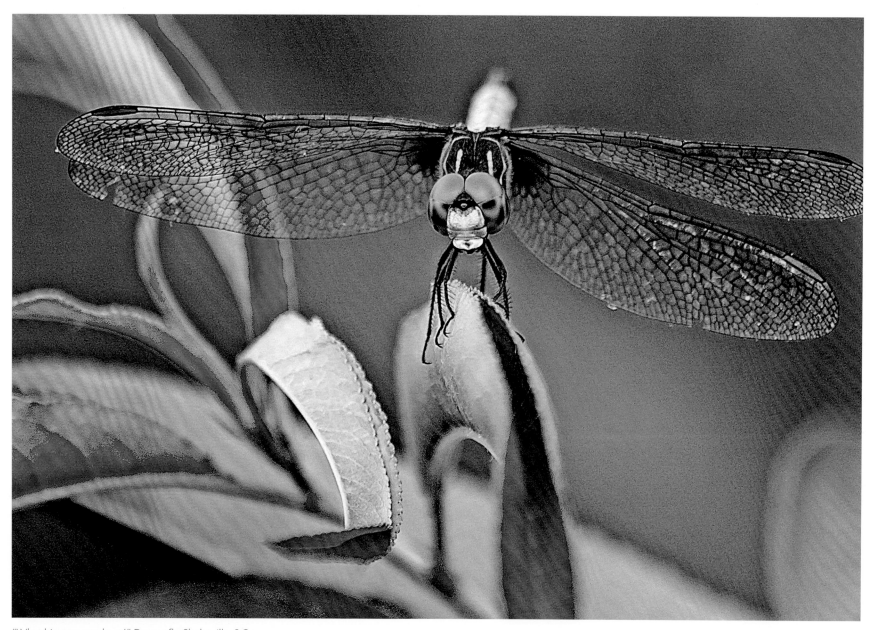

"What big eyes you have!" Dragonfly, Shulerville, S.C.

Daddy brings home my prince, Shulerville, S.C

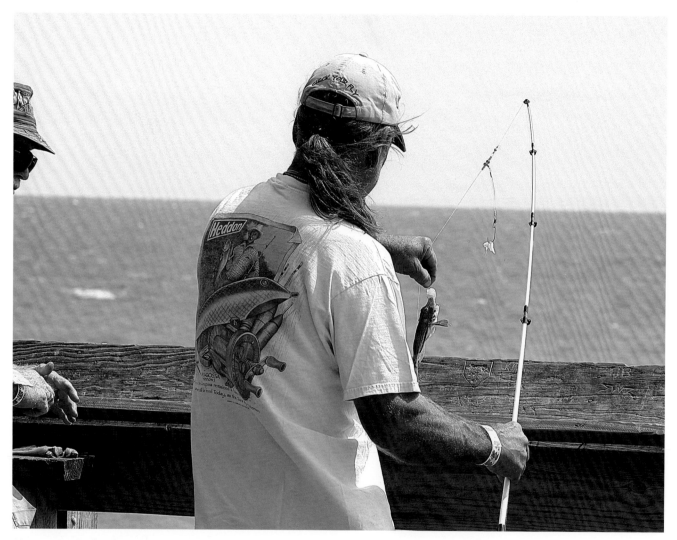

Man on pier, Garden City, S.C.

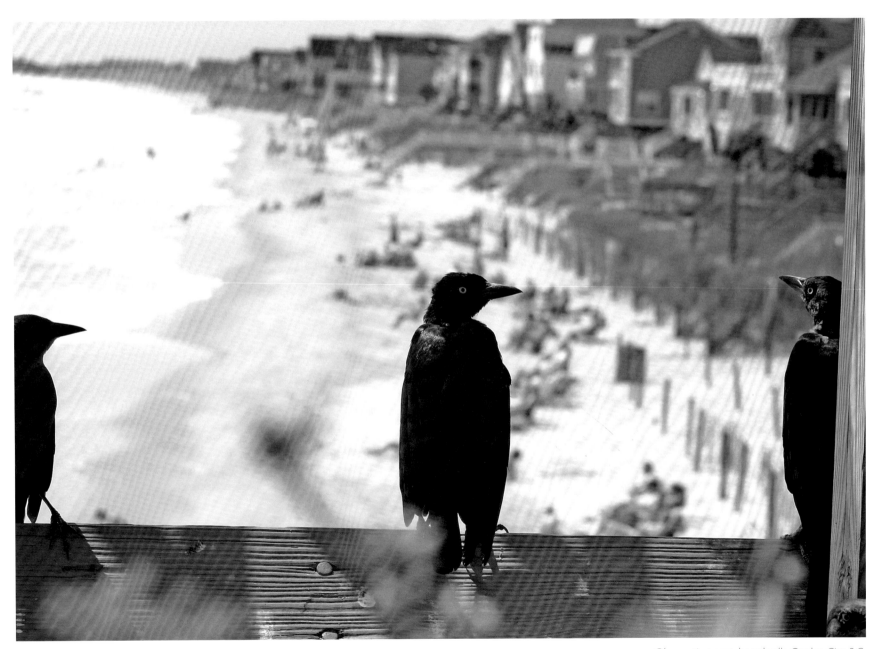

Observation post, boardwalk, Garden City, S.C.

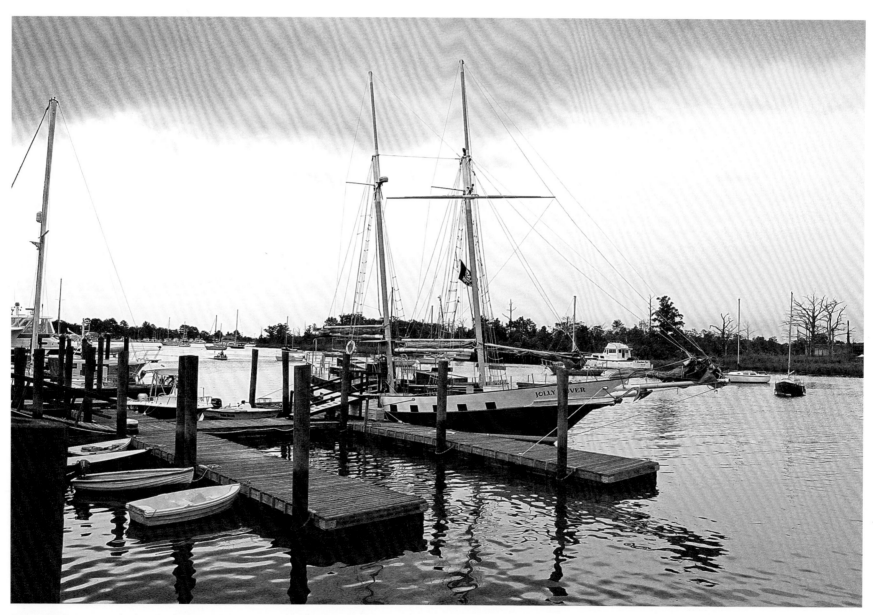

Riverwalk, Georgetown harbor, Georgetown, S.C.

Porch and rockers, Hampton Plantation, McClellanville, S.C.

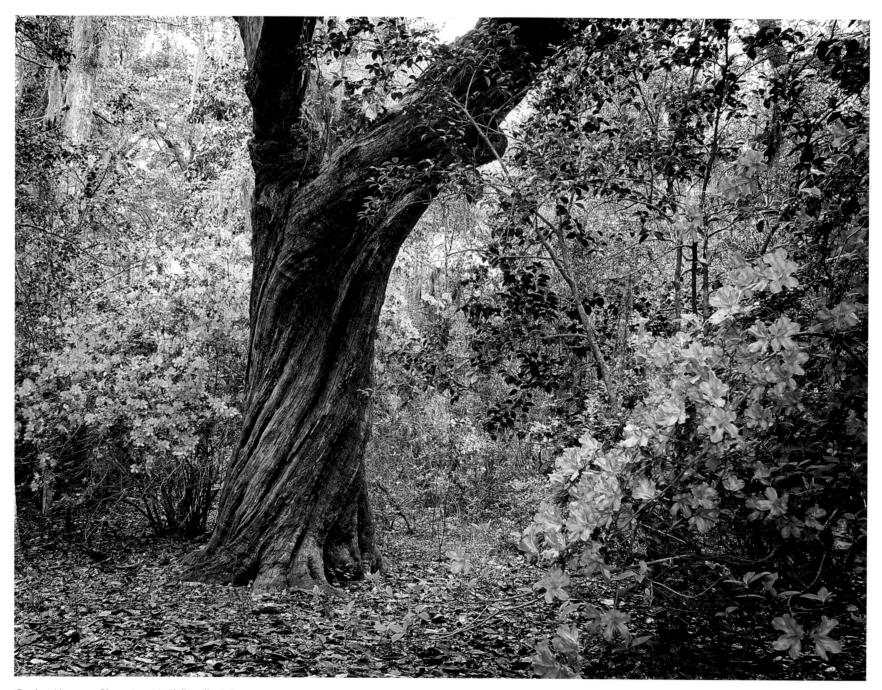

Garden, Hampton Plantation, McClellanville, S.C

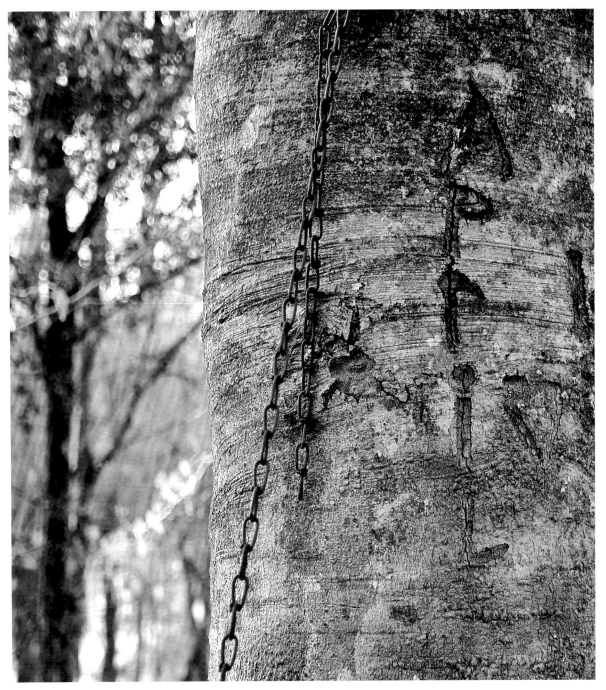

Tree trunk and link of chain, Echaw, Creek near Honey Hill, S.C.

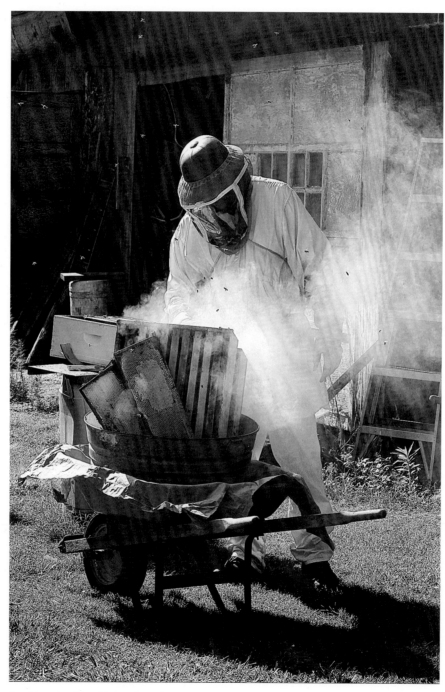

Smoking a beehive, Shulerville, S.C.

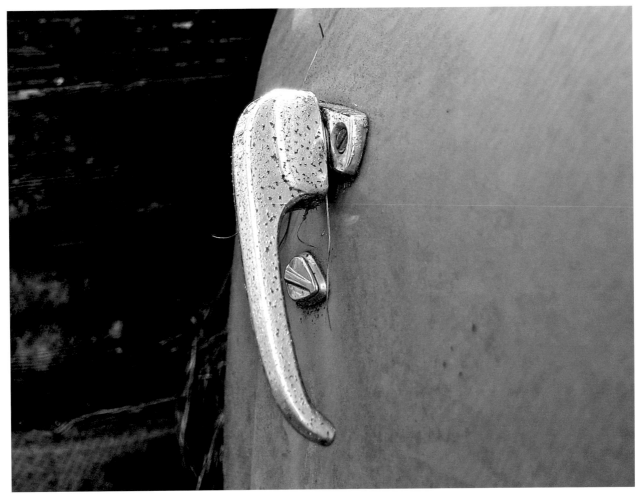

Handle, Honey Hill, S.C.

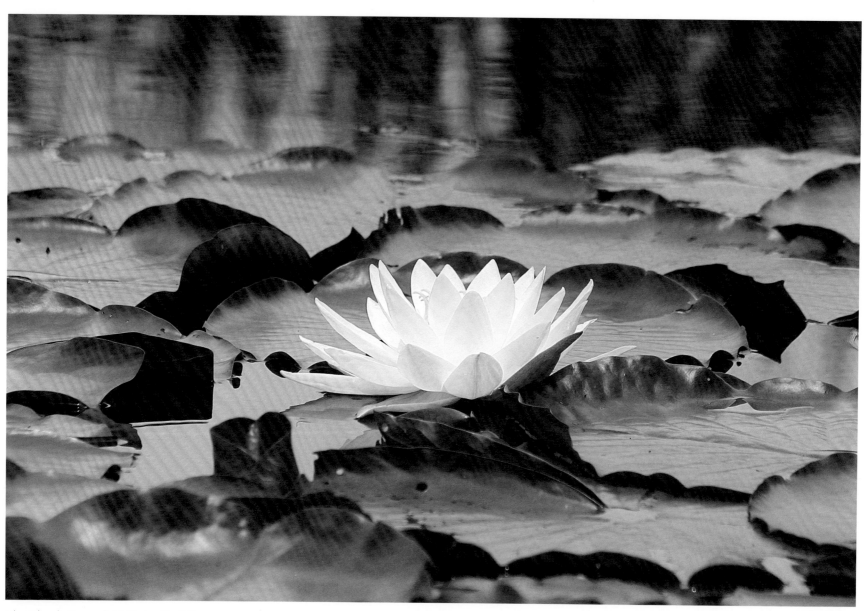

Lily and pads, Swampfield, Shulerville, S.C.

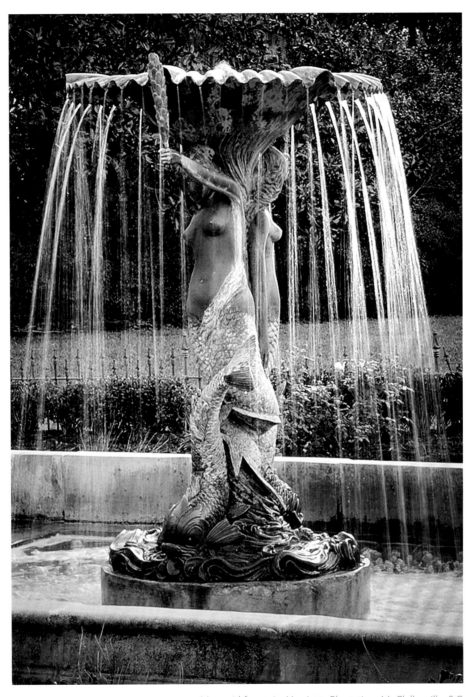

Mermaid fountain, Harrietta Plantation, McClellanville, S.C

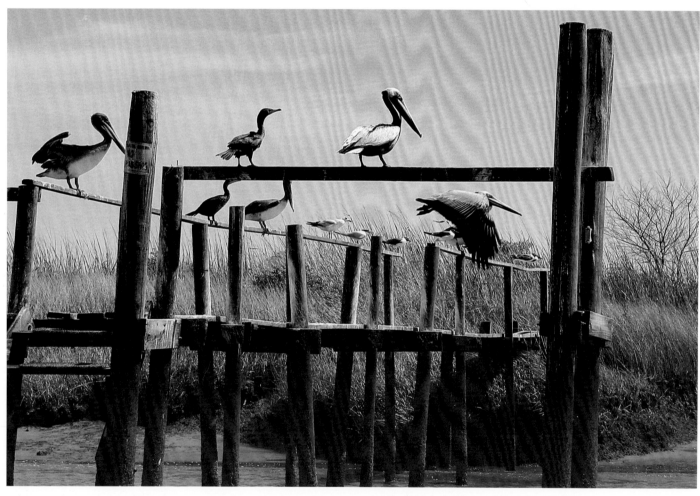

Pelican perch, Murphy Island, South Santee, S.C

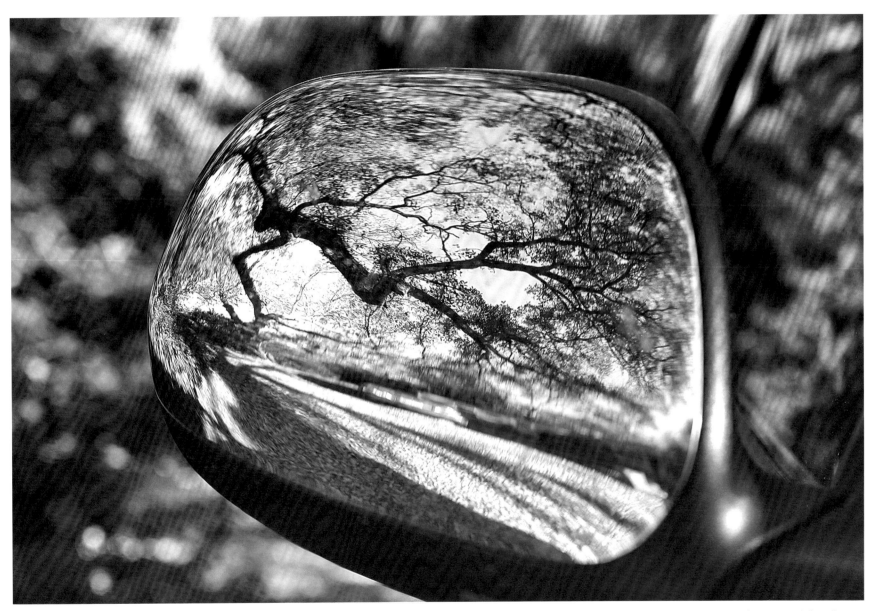

Reflection, Old Georgetown Road, near McClellanville, S.C.

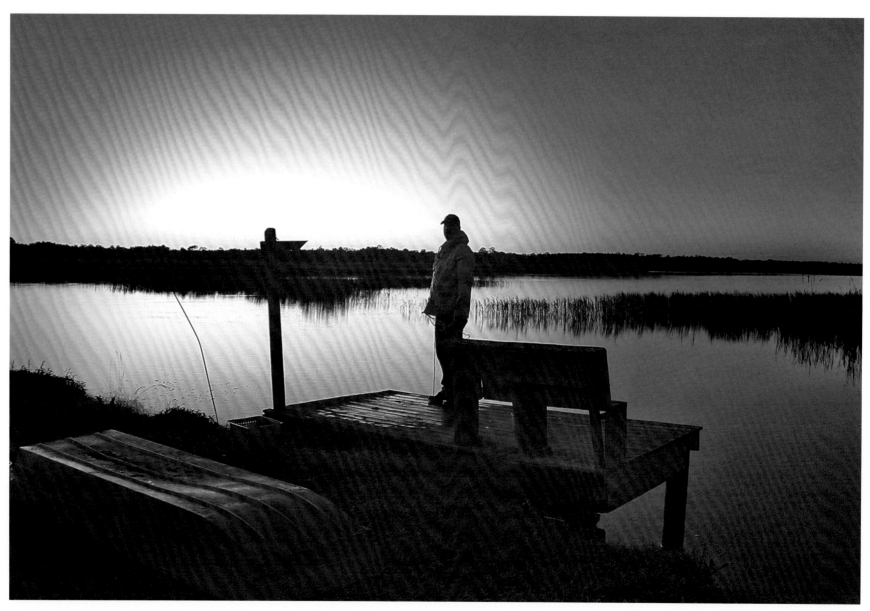

Evenings end on the Santee Delta, South Santee, S.C.

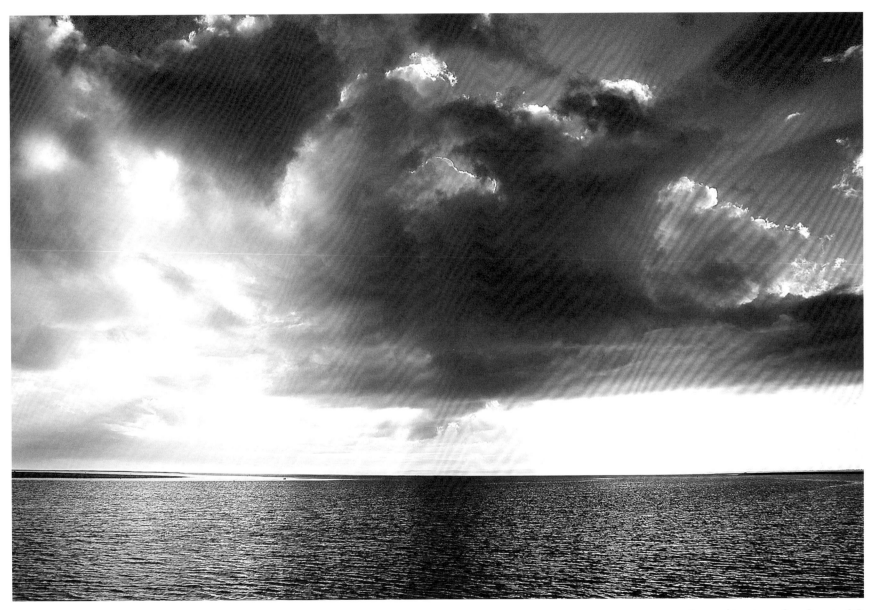

Approaching storm, Cape Romain, S.C.

The PHOTOGRAPHS *of*
ROBERT EPPS

The POEMS *of*
WILLIAM P. BALDWIN

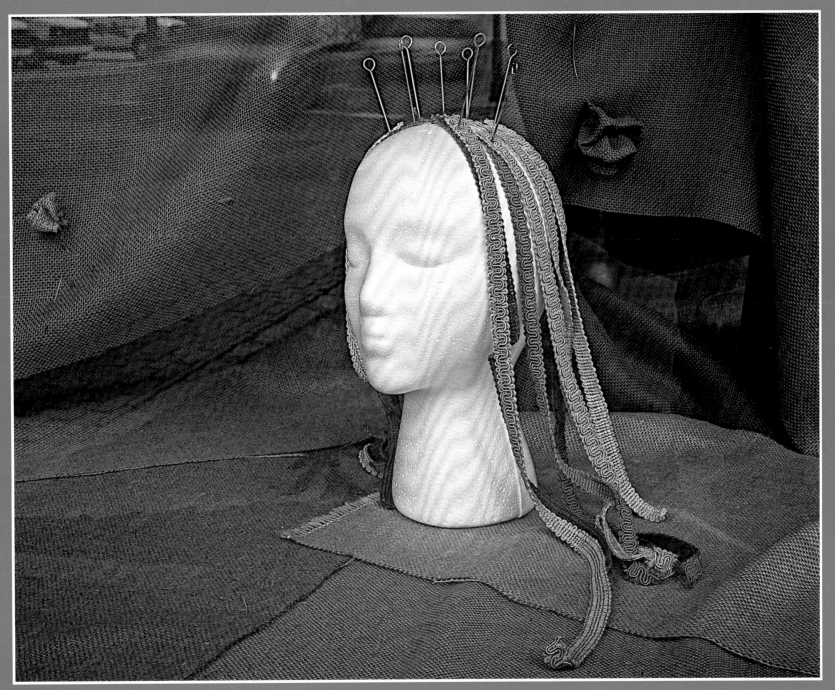

Pincushion beauty, Read Brothers store, Charleston, S.C.

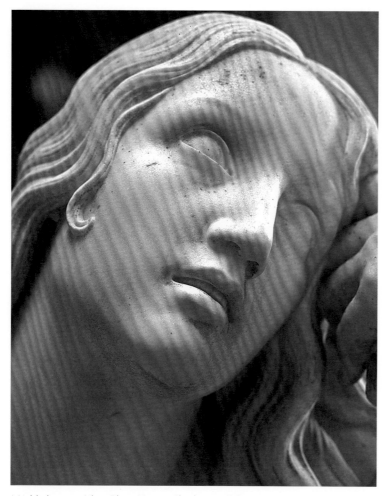

Marble beauty, Aiken Rhett House, Charleston, S.C.

Example me this:
What iron is wrought from roses?
Gates of pikes and arrows
Hang on pillars tricked in mortar.
I have not seen your garden,
But rumors of wars and end of wars abound
And all these things must be.
No. Fear not, for I am certain
A flower blooms in every moment
And you, serene and gateless,
Are a garden in disguise.
Sit. Run your thumb along the bench back.
What business is this of ours?

FORT SUMTER: ANOTHER FOR HARLAN

Oh, dirty little world
Run clean through with caves, rat holes,
And other breaches since repaired.
These are the rites of victory's house
And ours by the nation's seal:
The sound of grass, the taste of dirt.
Ours by the grave's repeal:
Flights of gulls, beer skimmed from moldy bread.
For sureties of staunch estate,
For undecaying cheer,
All proud things now gravitate to you.
The purple in the east has set, and in the North, the Star—

THE GARDEN TOUR

How tired are you?
Does all distance seem the same?
Here to there?
The moon and back?
Love declared in melodies
Old and oh, so familiar.

THE HEART AT EASTER

The heart is a house of hidden places,
The home of hidden gods,
Where uncreated light
Shines darkness on all sides.
At least that's how it seems
For we who host the dim-eyed king,
For we who find the truth of things,
Wrapped in what the UPS man brings.

Am I the inundation
The daughter of the Nile,
The master of the harbor light,
Or heavy-burdened child?
Of wants and wants and longings
There is no end in sight.
The body lies, the parrot cries,
The sound bites roam at night.
In chambers of deep waters

In wells of great renown,
Only on the crest of noon
Is light encircled found.
No, listen to the honored sing:
Forget the posture of the earth.
In the truth, light's found.
Just know the heart's a window,
And Love as King is crowned.

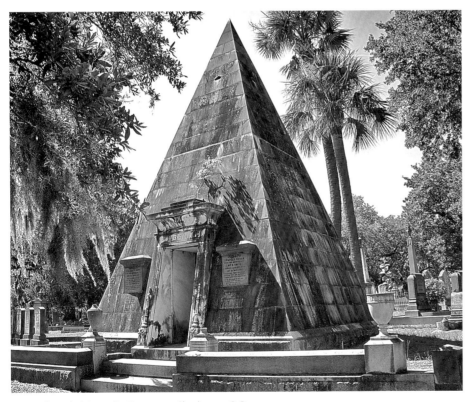

Pyramid tomb, Magnolia Cemetery, Charleston, S.C.

ATLANTIC AVENUE

The yard here is unkempt. Worn. Sad
Tonight beneath the street lamp all glows blue.
The August sun will bleach it white again.
Only the oleanders rebel, blooms piled on blooms, raving mad
With leaves renewing, bright green. But
By noon even these branches hang limp, the flowers faded.
Some blame the night gardeners.
Often enough I've seen them.
When dawn breaks off they go, in group,
Muttering their mild complaints,
Faint sounds, this African dialect
They insist on speaking among themselves.
Trowels, clippers, even hoes in hand,
They can't be stopped.
The joggers pause,
Dog walkers pause, all who rise early
Wait patiently as the night gardeners,
Wade into the sea, and looking neither left nor right,
Disappear beneath the soft waves.

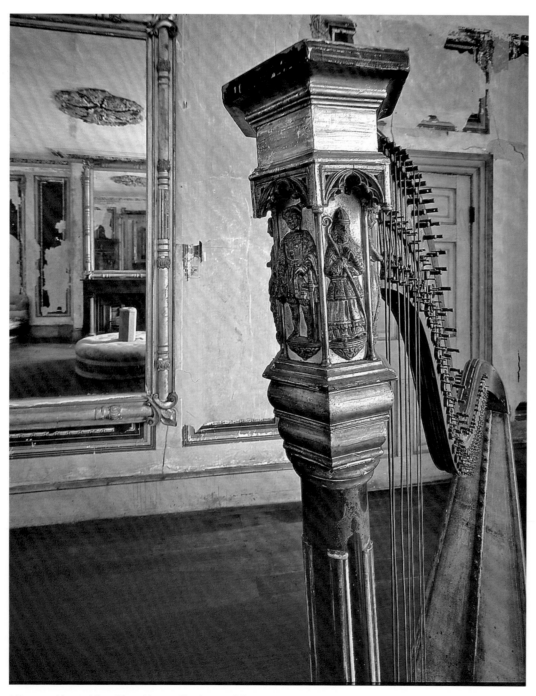

Mirror and harp, Aiken Rhett House, Charleston, S.C.

THE MATRON'S TALE

When the dead have given
What is due the living,
When St. Michael's rings that knell
Of *ding dong ding dong ding dong* bell,
And rustling at the window screen,
The brace of green palmetto fronds
Is seen again by shadows cast
Against the mirror's warbled glass,
While on the porch the wind clangs
Shell to spinning shell comes a spell that
Brings and brings and brings:
Once when I was young
And pedaling my bike along a foreign
Shore, I passed a bird
Wearing a turban of bright red
And coat of phosphoresced blue and some
Green, too,
And thought when I've grown old
Who will believe what I saw in Singapore
Or any other Shangri-La? For I was certain,
Even then, to end my days in Charleston
Pouring tea and calling no trump
And loving this man or that one.
"See! Here we are!" he shouted out in English
And spun upon the perch, red head down
Tropic tail flying high. "See! Here we are!"
Beneath my feet the pedals turn.
How odd. The tactile burn of memory
Held by rote.

THE CALIBRATION

If it's true that moths store rust
To spread on rainy days
And dust to fling
When dry decays
The borders of desire,
Then what thieving hours bring
Not what they bear away
Debases flesh's treasure.
A blow of such destructive force
Here hid among the moths,
And here I X the calendar
And light the nightly candles.

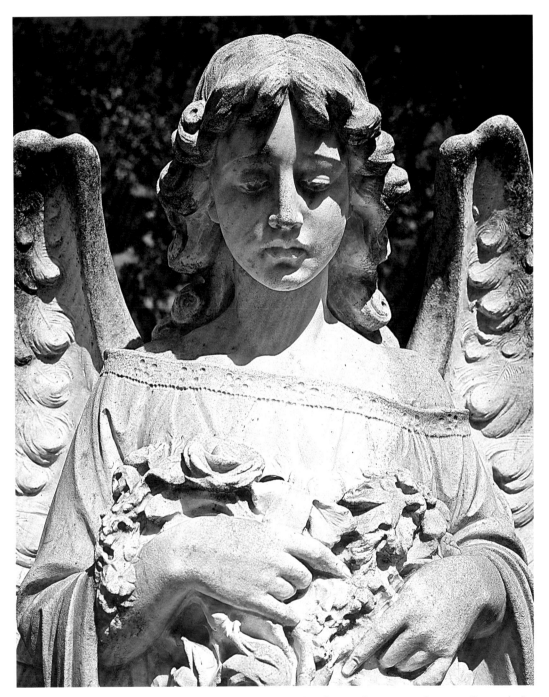

Angel statue, Bonaventure Cemetery, Savannah, Ga.

LINES FOR MARIA

Angels in decline.
Can't say fallen.
Leaves fall and apples, too
And women of a certain reputation.
Why, any one of us
Might fall on
Harder times.
So Angels must decline.
No more pitching
Head and heels,
No howl of grief,
Frantic grasping,
Wings collapsing
In that passing
From Heaven into Hell.
Say goodbye to tribulation.
There she points in designation.
Now a simple slide from station
And that could take eternity.

EVERY BOY: FOR PETE

Every boy's a digger.
Hands, shovel, sharp stick or silver
Serving spoon.
Earth allowing, they plumb the depth,
Plunge lower and lower still,
Waist deep, shoulders, dirt piled higher
Than dirt-circled eyes,
They slip Savannah's surly bounds,
Say goodbye to Victory Drive,
And soar beneath the sand-spurred surface.
They dig and dig and dig
Until they hear it clear—the speaking of Chinese,
A thin, high, and quick clicking tongue
That calls to mind the dangers of a foreign clime,
Waterlines, bones of dead dogs,
And all we know that's buried there.

THE CIRCUS

Even ten rows up,
What child in their right mind
Wasn't frightened by the clowns.
Like watching drunks from ten rows up
Scream and run and pound
Each other. Remember? Feelings for
That boxed lion pacing spaces
Hardly wider than a human being needs
To hunch before his blue computer screen,
Cubicles of rusted steel on painted gypsy wheels.
Spotlights, spotlights on the high
Flying trapeze girl and guy.
Sparkling people flying high.
They could die. One slip. One slip is all it took,
And ooh, and ah, and I don't want to look.
Cotton candy smeared around both eyes
And across the nose and even in the hair.
You can't run away from here.
Not *from* the circus.
Once you join you can't go home.
No. From then on, you got ambition, plans
To leave 'em laughing, gasping, coming back for more.
Me, my sister, one for each hand and
It's Daddy walk us through slate gray night. Savannah.
1949. Here's the world adults have built from canvas,
Paint, and wails of pure delight.
Yeah. I'll show you fear
In a handful of peanut shells
Plus that cotton candy face I wear.
And hell. That's that giant drum

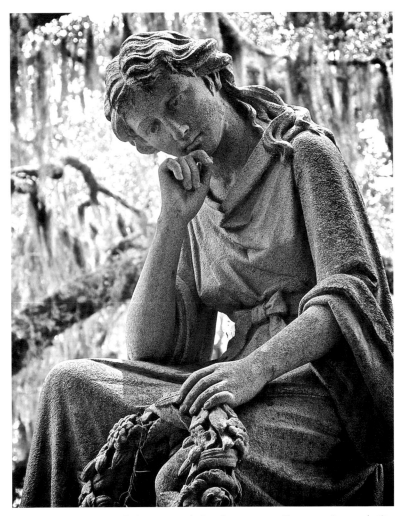

Quiet contemplation, Bonaventure Cemetery, Savannah, Ga.

Where the monkeys raced the roaring monkey motorcycles
'Round and 'round and 'round.
You want to know what keeps 'em going?
Ambition.
That's right. Dreaming of the jungle
And how they're going to win.

SHE
Sad eyes the gray of twilight blue,
Like twilight too, her dusky hair.
Not a face to bring delight
Or advertising dollars.
More like a woman Rembrandt drew,
Raw where raw was due
And grace where grace shone though.

He nodded and he offered:
Can I do that for you?
She went on pumping gas;
He turned away.
And then she laughed.
And when she spoke
Words broke, like waves
Upon a winter shore.
Don't say, I'm beautiful.
Don't say it, not tonight.
Nor am I a perfect woman, planned
To warn, to comfort,
Or command.
I'm none of that. You understand?

He says I do. Now let me ask,
Are you a spirit sent?
An angel supplement?
Part of their machine?
And again she laughed
Succubus, you mean?
Yes. A traveler
Between life and death,
Stealer of a man's breath.
She says, With sex, you mean?
No. No. I'm thinking, maybe coffee.
Something quite serene
That leads us
Back to praise, blame, tears, and smiles.
I'll think about it, husband.
Maybe in a while.

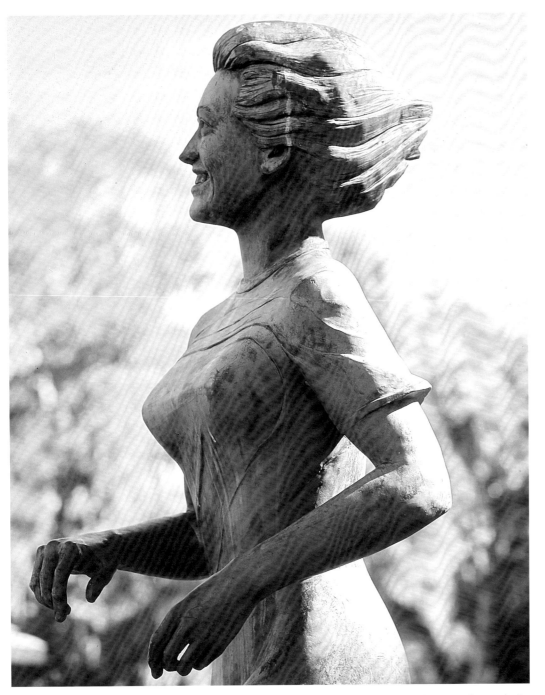

"The Jogging Lady," Bonaventure Cemetery, Savannah, Ga.

LOST IN THE CITY

I won't tell you
How to live your life
I'll only say for me
The bear suit
Was a big mistake.
Yeah, you might think here's
A grand idea whose time has come.
You'll miss the bald spots.
After all, they're small,
But soon
The dogs will maul your flank.
You'll hide up in that alley
And learn it's true:
In the dark of night
Moths consume.

WHEN

When carnivorous thought
Has split the last bone to the marrow,
When time has throbbed a new tomorrow
And rose the sun on all that's sorrow,
I'll stop then, pull into an Amoco
And ask directions of my heart.

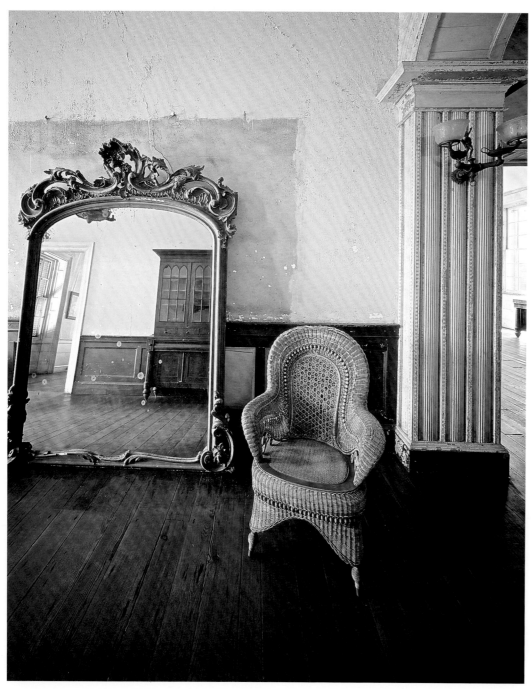

Two views of a room, Aiken Rhett House, Charleston, S.C.

ANTEBELLUM: FOR HARLAN

In these halls of sad and loss,
Mount the steps
And count the glory.
Captain, Massa,
Boss Man, Boss.
Are these blacks
Predisposed to joy
And waxing floors?
Whites
To singing songs off key
And telling of "The Woor"
When the Yankees stole
Harry Belafonte?
Thiefed the best and brightest
And still won't give him back.

Take double steps
Counting twelve by twos
And tell me what you see,
The cracked but gilded mirror there.
Is that the light from '61?
You caught it unaware,
The pride of hot-blood boredom
Bouncing off the glass?
Or is that something darker
Our savage other half?

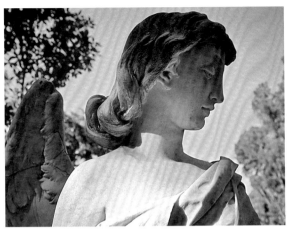

Statuary, Bonaventure Cemetery, Savannah, Ga.

THE GRAND TOUR

From the wall French paper slips
And here and there a statue's nicked
(Those risqué marbles he bought in Rome),
And visitors come
And visitors go,
Whispering as they pass below
Chandeliers she found in Venice
A hundred and sixty six years ago.
The harp has half its strings, and everywhere,
Though gilt is chipped, the mirrors glow.
Earphones in place, gaze encased by audio
Instructions, I heard them once, a husband, wife:
"...1857...we're...wait!...What happened?...Wait!..
Drawing room...no...outside...domestic life...
the kitchen...no, can't be the kitchen...the Aikens...."
He took her hand or she took his hand, and
Thus having lived long together they reached the piazza.
And all the while I'm thinking, Ah marriage.

THE LAST EVER

Oh, Lord, I'm looking straight into the surveillance camera.
That Howdy Doody mask isn't going to fool her.
I should have come as Nixon,
All plastic jowls and sinister intent.
Has love robbed it's last convenience store,
Waved that BB pistol
And shouted give me, give me, give me
For the final time?
Apparently so.
She's laughing.
She's called the other girl over
And the blind man who used to make the roses
From folded newspaper,
He's clutching at his side,
About to bust a gut.
Oh, great. There's the guy who drives the Pepsi truck.
Blanche or Beatrice?
Where's Flora? Echo?
Heloise?
A Joan of Arc would do.
Can't they see I'm dying here?
In this land of air conditioning.
Mais où sont les neiges d'antan
Yeah, where? Where? Where?
Whither have fled the snows of yesteryear?

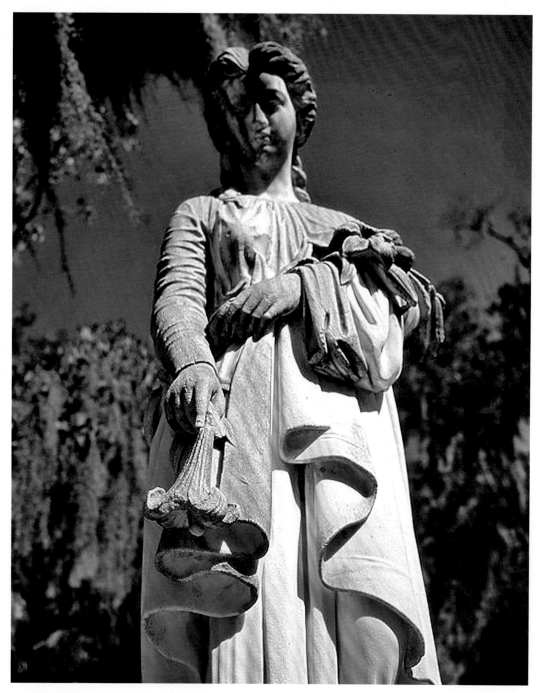

Lady and a lily, Bonaventure Cemetery, Savannah, Ga.

AT KRAMER'S DRUGSTORE

The soda jerk had hands that sang
As if he'd brought a symphony
From out a glockenspiel.
I hope when God does scoop me up,
He will feel the same.

MY OTHER NEW YORKER POEM

Together we
Went everywhere.
You, me, ubiquitous,
And like a fool I thought it'd
Always be that way with us.
But you and he
Had other plans.
The two of you.
Only one word comes to mind.
Iniquitous.
Actually two as in my absence I am
Conspicuous.
Innocuous?
Hippopotamus?
Actually, with all this struggle for a rhyme
It's come to matter less and less,
Unless you've changed your mind.

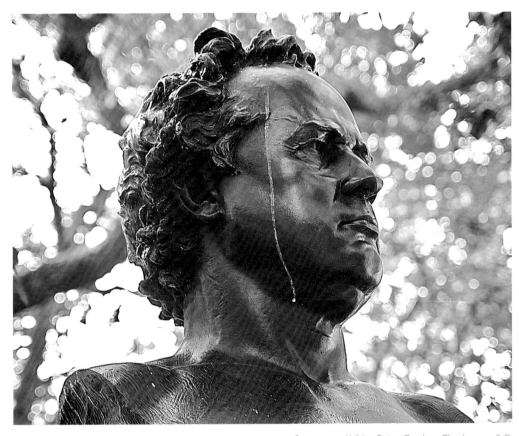

Statesman, White Point Garden, Charleston, S.C.

EASTER POEM

Where'd the monkey grinders go?
You know. Those dark, exotic few
Who cranked the box,
Ground the music out
And tapped a foot
While the monkey danced
And then went cup in hand
With just a touch of toxic spit
 On lower monkey lip
And beady Judas eyes
Dancing bright with pain.
Or is that me and you?
Or you and me?
Where's the Duncan yo-yo man?
Yeah, him who could spin
Fast and flying yoyos
One, two, three, and four—
All at one time going hither and yon,
Through the door,
Walking dogs and 'round the world
To see your Aunt Pearl.
Jesus, there was a man.
Mary Magdalene didn't
Know a good thing
When she saw it.
Or maybe she did.
Who's to say?
People come, then they go
And what's divine and what isn't?

BEEF MELT POEM

Plum moistened lips
They kiss the book
And tell the cats to stay.
The time has come to look
Beyond the door,
Beyond the yard,
Beyond the everyday,
She goes the length of Anson,
Then heads towards East Bay.

She's walking to the alley
Where the gray wolf lays.
How he dreads it when she picks
The fleas from out his pelt,
But then she'll whisper in his ear
Of chutney on beef melt
And other great things there to eat.
She knows best.
He'll let her choose
Among the neighbors who to meet.

129

ATLANTIS: A TALE OF MAGNOLIA
A full moon on the brain
And found here pyramid and
Other temples to lost gods,
Simm's fairies, Spanish knights,
And demons rising from the sea,
Majors, Generals, mothers, fathers,
Sons and daughters, saints and thieves.
In all a catalogue of muted eccentricities.
Still in that drift Atlantis left
There're stranger stones than these.
Still the song whispers in these oaks
Come here Brother, come here, we
Have found beneath this comet's course
A place where dreams in pockets bulge,
Where hats are worn on the back of your head.
And still at the cemetery station
The trolley turns and turns and turns again,
Two white horses, then two black,
And on that East Bay line there's always time
To call a greeting to the dull mortals left behind.

AND THIS TOO
Long ago when days were dark
And cannibals to be dreaded,
The young Spanish Captain
Halted there between St. Michael's
And this little park,
While strung behind him
The scurvyed crew of six
Collapsed onto the sand—
That done with a raising of his hand.
Yes, the men stank of fear.
But smell, too, the burning wicks
Of the matchlock muskets.
And down the way a woman calls,
An Indian maiden trimmed in softly minted deer skins
Saying to forget the King and come to live with her.
And you would have me step into the sandwichery,
Waste a lunch hour chewing to the marrow
Some fancied tale of when Broad Street too
Was a heart of darkness—before so many laws were passed
And, bearing parcels, pretty jaywalking secretaries
Cross as they do now.
No. Not today. How 'bout tomorrow?.

Color bearer, Magnolia Cemetery, Charleston, S.C

PHOTOGRAPHS BY SARAH MOON
Rhinoceroses.
They get a bad rap.
Like models in corsets
And two truck circuses.
You ask me they don't
Charge enough.
Well, the model might.
Who's to say what Sarah pays?
Not me. That's for sure.
The text is in Italian.

Bless my father. He'd often boast
No Baldwin ever read or even spoke
A foreign language,
No dancers, singers, musicians of any kind,
No soldiers, athletes, or financiers.
We Baldwins had our limits,
Walls that only mimes would mind.
I'll just have to wing it.

Anatomia. What is that? Anatomy?
Her handsome back turned to me
Corset laced like a giant zipper,
Yeah, I think I see.
Sextacular promisa of a dying planet.
Relax, Papa,
I got the picture.
I don't need to read it.

CONTRARY

So contrary to purist sensibilities,
Those photographs of Tichýs'.
Homemade cameras,
Cylinders of cardboard,
Backs carved and taped and tied,
Lenses ground from scraps
Of Plexiglas,
Then focused on the asses
Of unsuspecting bathers,
Czech women
Hungry for a touch of sun
And wholly indifferent
To Hegel's dream of history's run.

Next our hero made the prints,
Stepped on those,
Drew in frames,
Smudged and tore and said, This isn't art.
I'm Tichý.
It's what I do.
I'll leave it to the others
To raise the Iron Curtain
On Madonna and
Her traveling demon crew,
To bow down,
To stand on chairs,
To shout Hooray
And bathe in the unclorinated
Glories of sweet liberty.

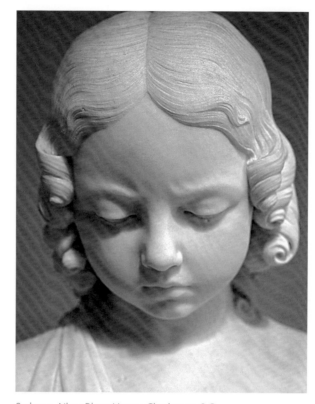
Sadness, Aiken Rhett House, Charleston, S.C.

Cropping the world's
Enough for me.

Oh, that poetry could do the same.
Fingers to thumb,
Make a lens,
Look through there.
Now tell me, tell me, tell me,
Who's insane?

BOOKS: FOR HANNAH

I've read of love and daring do
In places where the bugs chew through
To get at bindings' binding glue.
Antique dreams aren't so rare
That we won't find them leaning up
Against this latest thrift store pulp.
Knights of Malta, damsels, King,
Irish tales with fish that sing,
Popes who stoop to murdering
And love that's always conquering.
Outside in the sky is a pale sun's rind
And down from that, Wando-bound
Trailer trucks and electric lines.
Oh, dreamin' souls, look to me.
The cover's ripped along the spine
But *then* comes tumbling from each line.

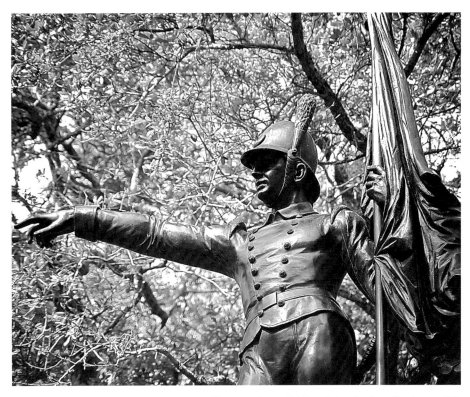

"Sargeant Jasper," White Point Garden, Charleston, S.C.

LINCOLN WALKS AT

He has seen the mice in moonlight play
And seen them file along a shadowed wall,
And in the spirit of liberty's license, he's been hung in effigy
On this street corner and that one over there.
Gone, gone, gone with the wind.
No one comes unfettered. Or free of fretting.
And the grander the inequity
The deeper is the murmur of disdainful delight.
Tourists, and some locals, they have seen him
On Broad Street or like this walking 'wards the Battery,
Stovepipe hat perched above that homely crag of face,
(firm commission of every penny lost between the seat cushions)
Shawl-draped frame of lank dimension and all in black,
A silhouette complete with palmetto tree and banners furled
And there is murder here and depravity all over the world
And when he sees far Fort Sumter glistening in the moonlight
Does he think, *At least this once we got it right?*

GEORGIA GIRL: FOR RUT

Like a blue mist were her eyes,
A thickening mist where good men die,
Like a sunset were her lips,
A stormy sunset on doomed ships,
And yellow gold gloomed in her hair.
She wasn't from just anywhere.
She was a Georgia girl, I fear,
From the unholy land of Tybee.
And time runs on, cries she,
Now out of charity
Come dance with me in Tybee.

One man, one man alone
In bright searsucker gear,
One solitary man
From Carolina's there
Had turned his stately head.
That is a long way off,
A long way off, he said. Plus
You Georgia girls are rough,
Your players are all thumbs,
Or the guitar strings are cursed,
The banjos and the mandolins
I hear they're even worse.
Maliciously he winked an eye,
Adds, Strike me down if I lie,
The singing's poorly done.

She did not seem to hear
Or did not seem to care.
Without a hint of smile,
Yes, time runs on, she cries,
Time runs on. And time runs on.
Indeed it does, he laughed,
And took a step away.
I'm headed back to Charleston
In just a little while.
She does not understand.
Now out of charity, cries she,
Come dance with me at Tybee

And No, no, no, no, no, he goes,
For she now holds his hand.
Time might run beneath the sun
But I am due at home.
And still she will not hear. Cries,
God is joy and joy is God,
And those that have grown sad are wicked,
And those that fear the coming dawn
With coming dawn's gray sorrow,
Have no need of heaven or of a bright tomorrow.

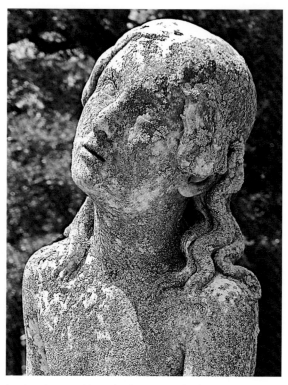

Look to heaven, Magnolia Cemetery, Charleston, S.C

He shook his head,
Pulled away and glanced toward the boat
So dim's the light of mortal shore.
Was then she touched well-tailored coat,
Stroked lapel and gazed on him
And laughed with murmur deep in throat.
I was a Georgia girl, but that was long ago.
Yes, time runs on, she sighs.
No, not from charity
He went to dance at Tybee.
For it was then, yes, it was then,
She gave the banshee's cry.

IN THE GALLERY
The imprint of divinity
Our breath upon the glass,
Our eyes the hands beauty demands
For taking back the world
From where gross want and reason hid it.
Denim vest, small silver skull,
Head is shaved to spell out love.
I passed her on the steps out there,
Chalking on the tiles that meet
The concrete waste.
Why does God do it?
Make us young first
And hope the rest will fall in place?

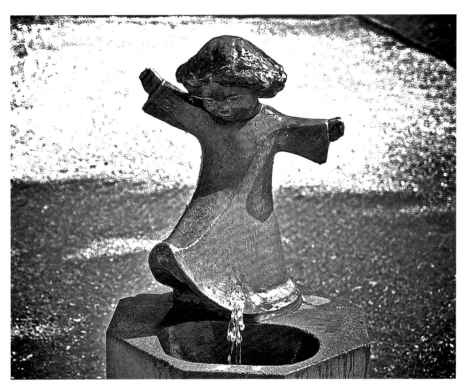

"The Angel Fountain," White Point Garden, Charleston, S.C.

ROBERT AT THE DOG PARK
This wolf in every forest
Boasts eyes that shimmer powder blue,
But for the moment they are closed,
As now he sleeps where dog park keeps
An ordered place of Frisbees tossed
And manicures all brindled lost. Still he yips
And stirs.
There where man can't trace a care.
He hunts the stag with horns like throne
While dreams of panting race embrace
Your need for scratching 'hind his ear.

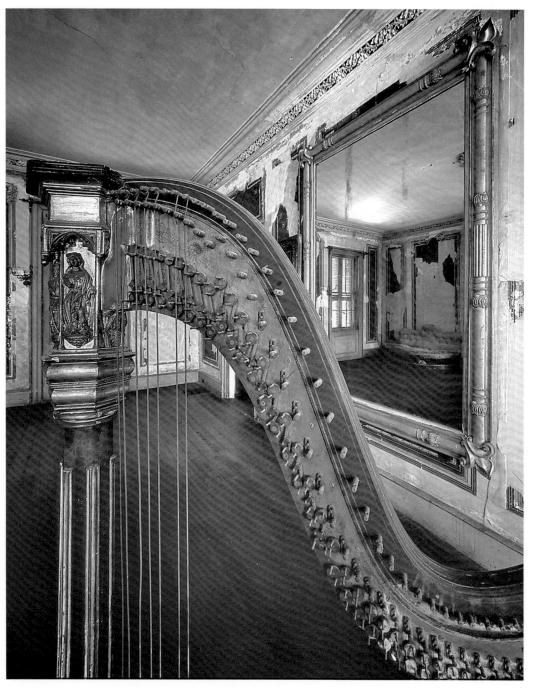

View through a harp, Aiken Rhett House, Charleston, S.C.

ON REFLECTION
When wandering sailors came to port
They'd say the truth is known.
A mermaid is half fish, half conjure both
And Charles Town is full sown
About with the dead men's bones.
Ring bells, ring,
Sound peace and rest to church,
Yet night ghosts from graves still come
For murder murder craves
And blood to blood is drawn
Until the empty vaults at dawn
Are filled again. Oh, brave men
Call Yankee preachers from the stalls
Let them run the race,
Saddled tight at waspish waists.
With vigorous use of quirts
And green gowns in the stands,
We'll set the goblins in their place
And tramp the old town pure
As any Yankee land.

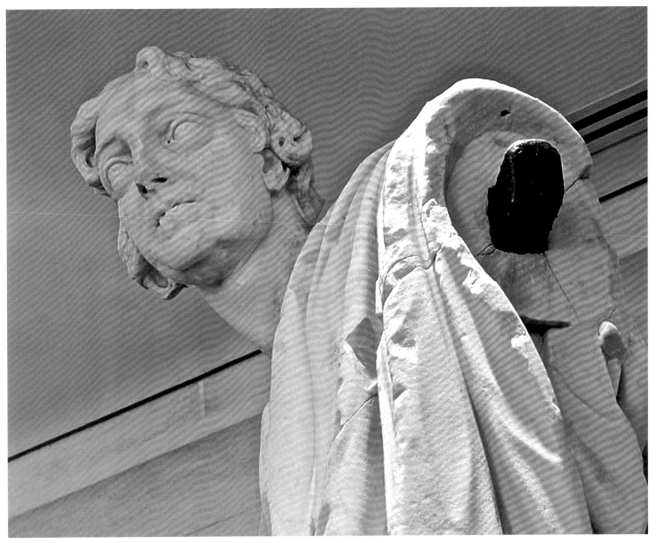

Statue, Charleston County Courthouse, Charleston, S.C.

ROBERT'S

Offerings

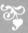

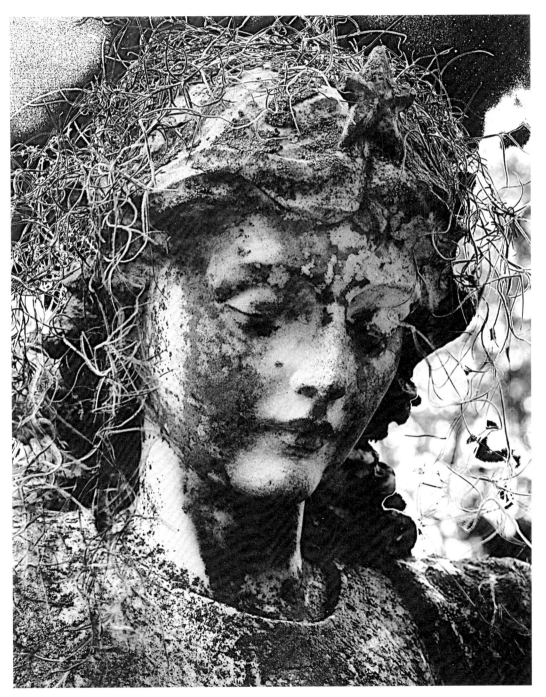

Moss-draped beauty, Bonaventure Cemetery, Savannah, Ga.

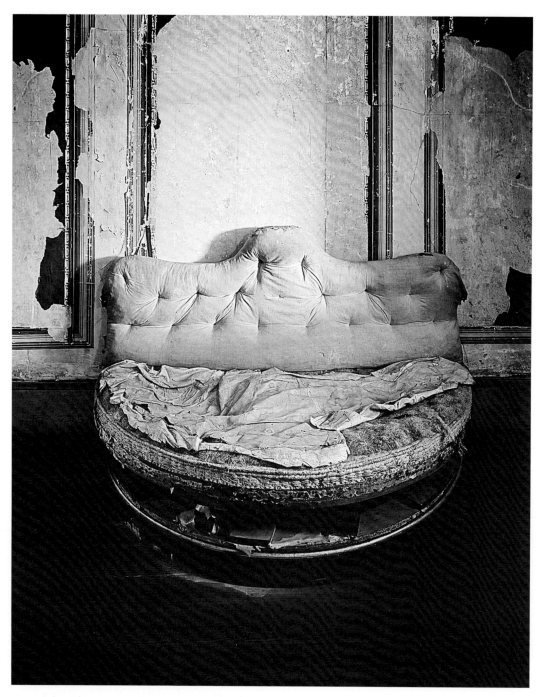

Divan, Aiken Rhett House, Charleston, S.C.

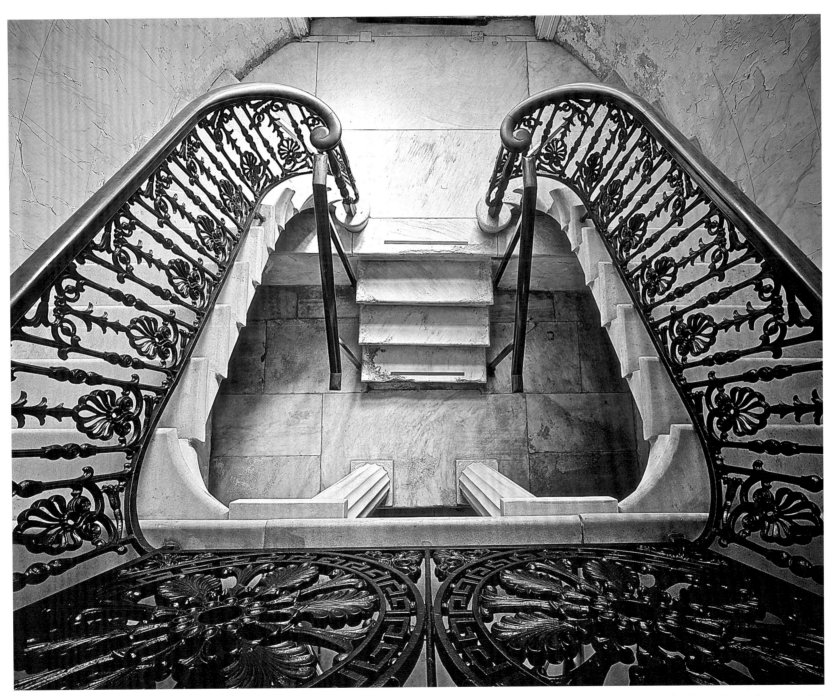

Staircase, Aiken Rhett House, Charleston, S.C.

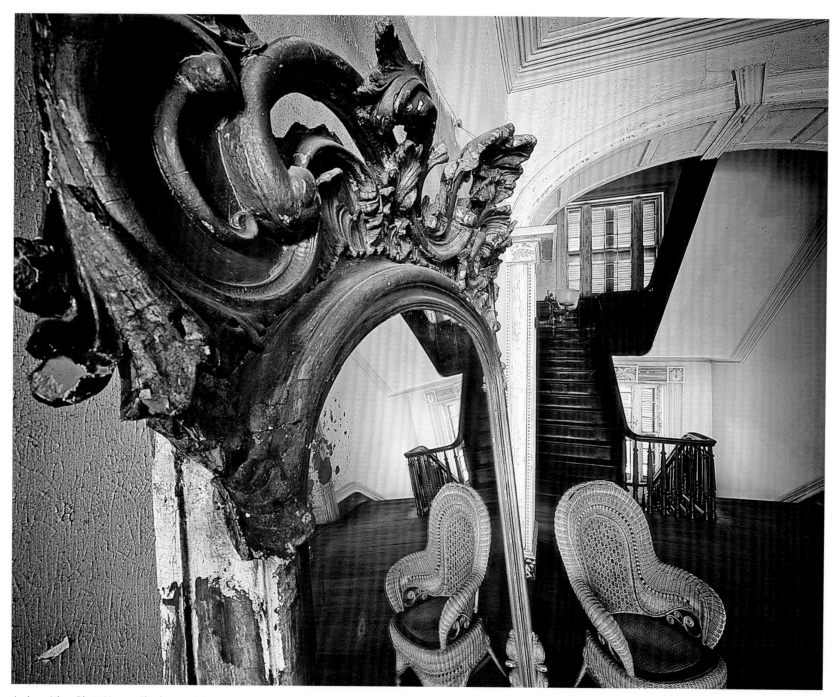

Arches, Aiken Rhett House, Charleston, S.C.

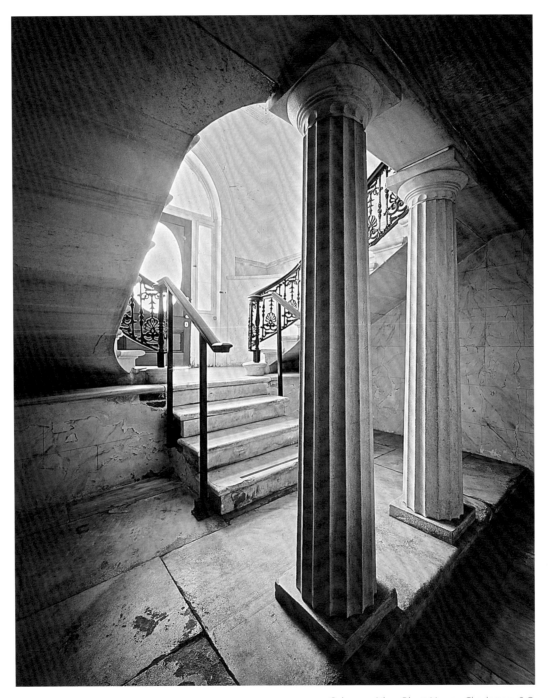

Columns, Aiken Rhett House, Charleston, S.C.

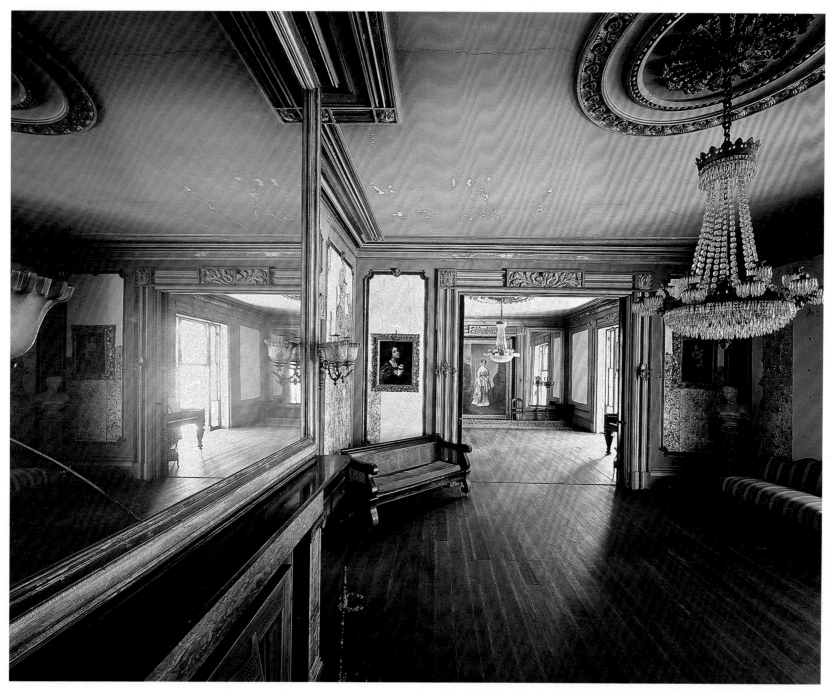

View from one room to another, Aiken Rhett House, Charleston, S.C.

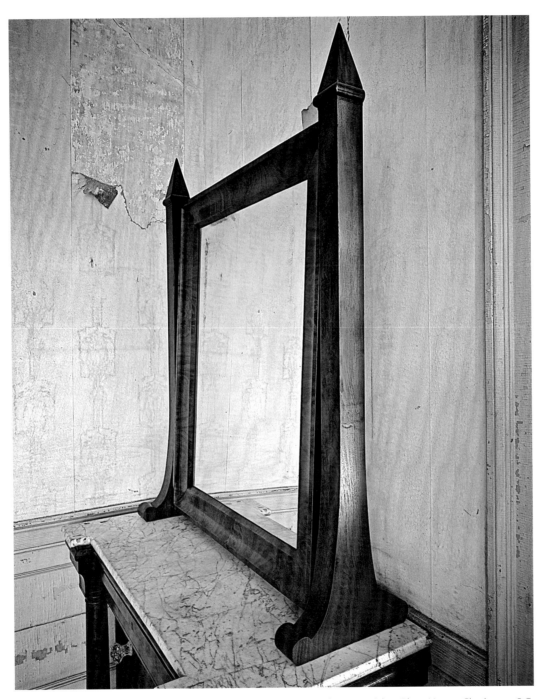

Console mirror, Aiken Rhett House, Charleston, S.C.

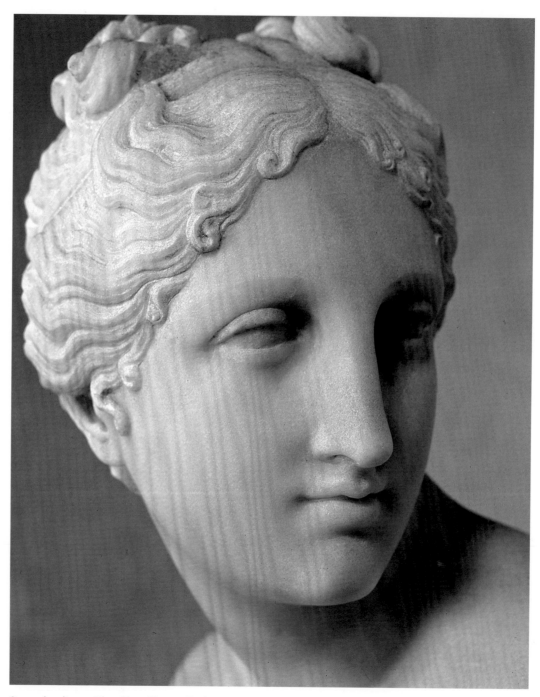

Serene loveliness, Aiken Rhett House, Charleston, S.C.

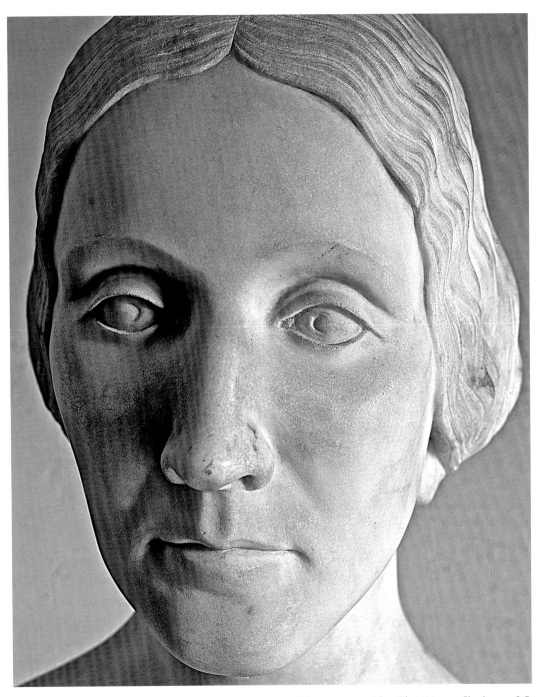

A far away gaze, Aiken Rhett House, Charleston, S.C.

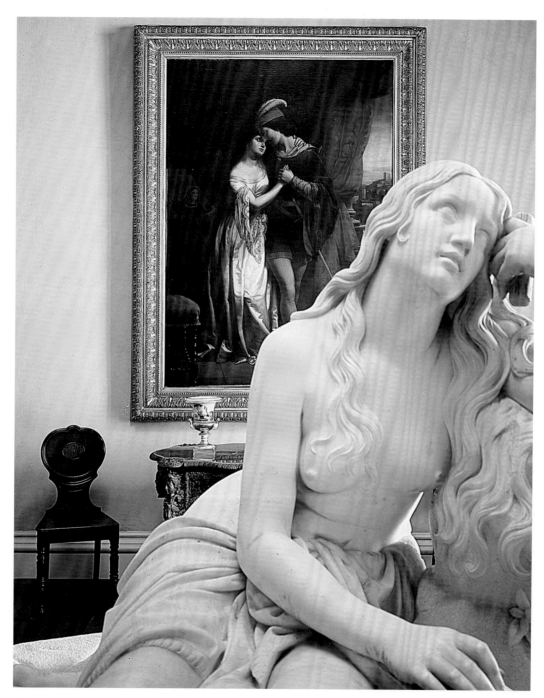

Charleston beauty, Aiken Rhett House, Charleston, S.C.

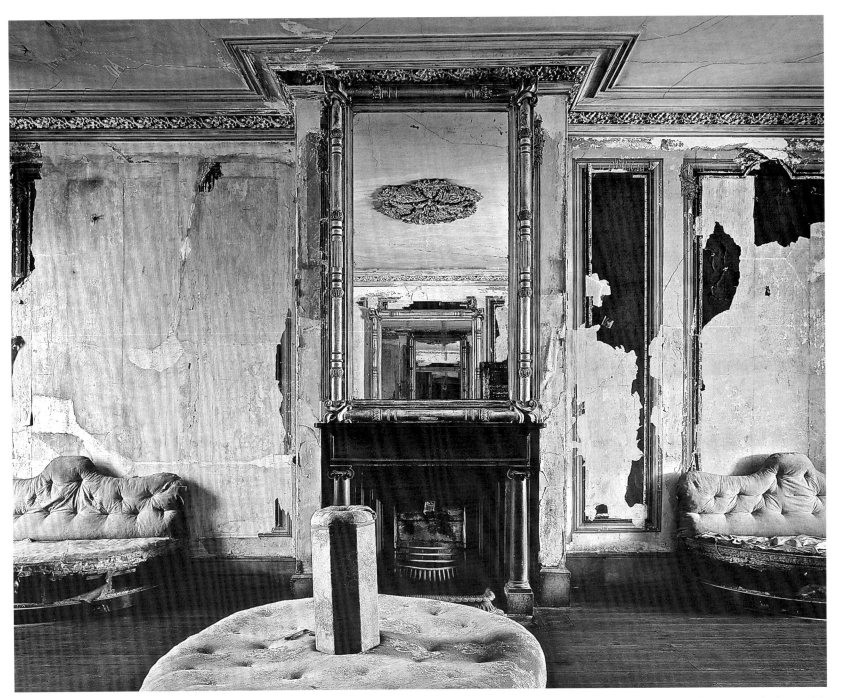

Parlor, Aiken Rhett House, Charleston, S.C.

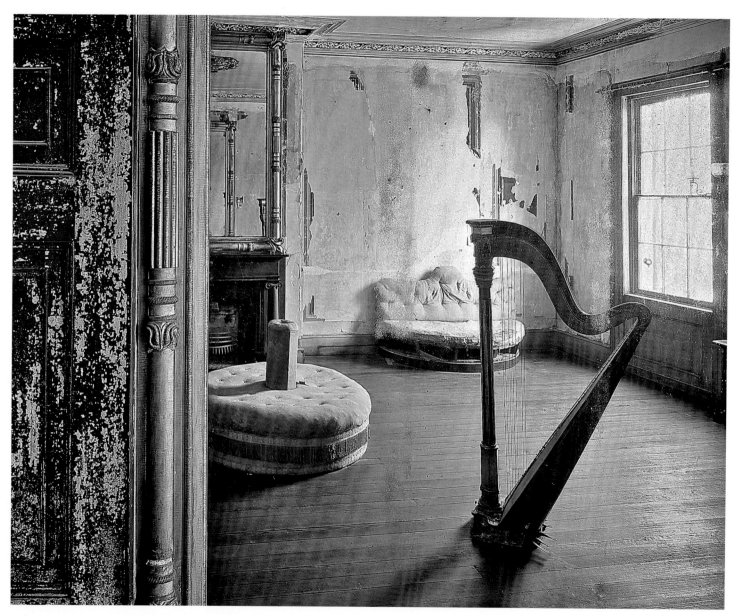

Soft music, Aiken Rhett House, Charleston, S.C.

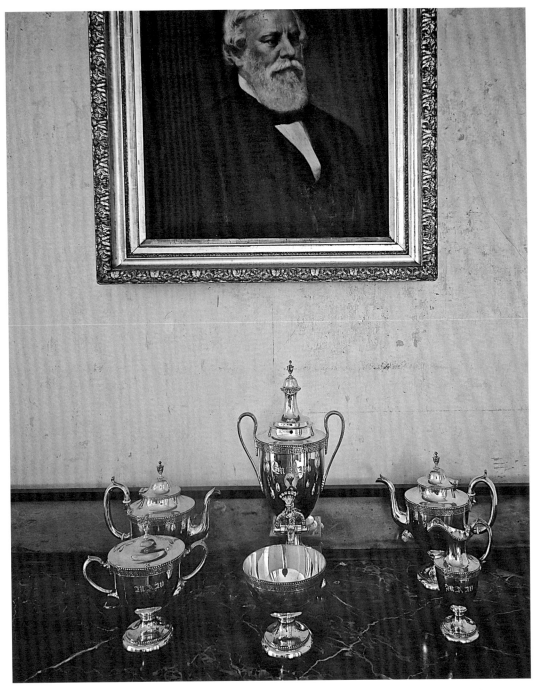

Watching over the silver, Aiken Rhett House, Charleston, S.C.

Banister, Aiken Rhett House, Charleston, S.C.

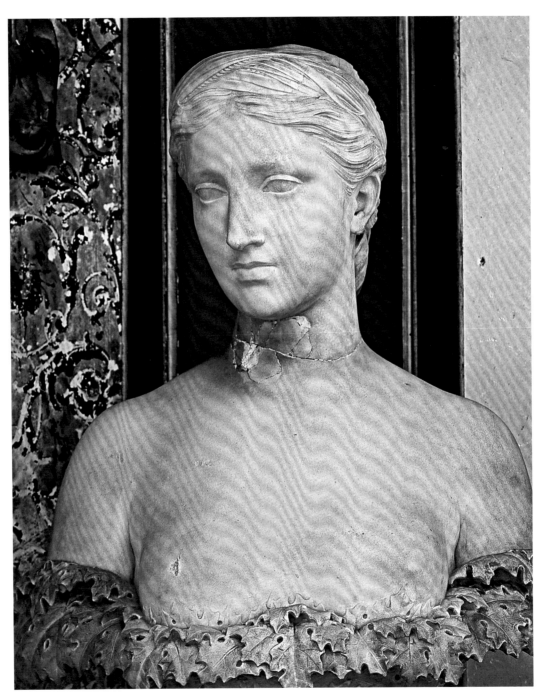

Restored beauty, Aiken Rhett House, Charleston, S.C.

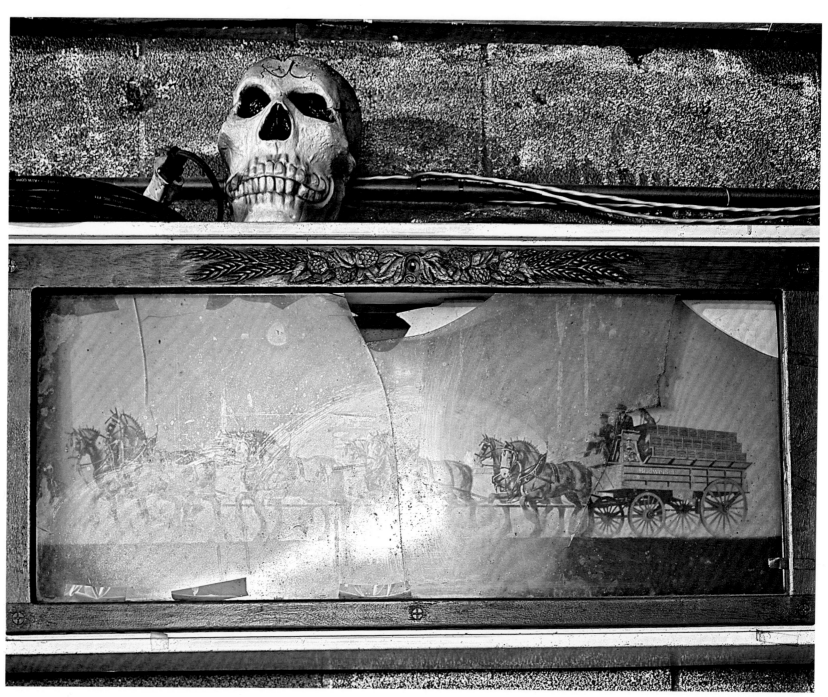

Bizarre decoration, Big John's Tavern, Charleston, S.C.

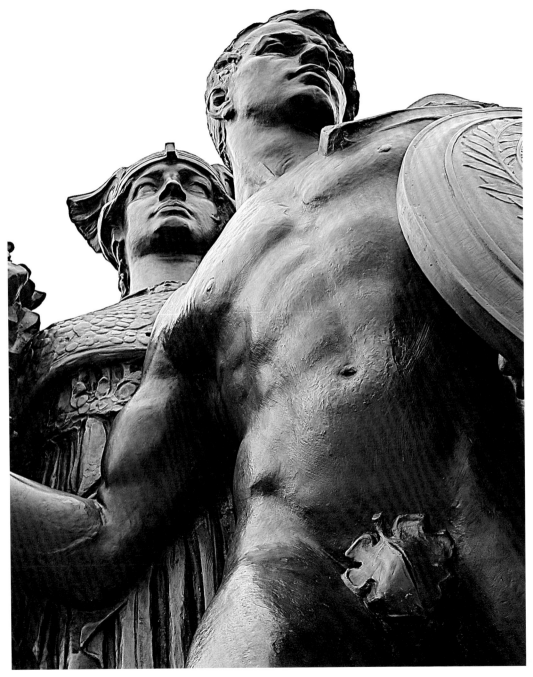

Classic statuary, White Point Garden, Charleston, S.C.

Empty room of the former Kerrison's Department Store, Charleston, S.C.

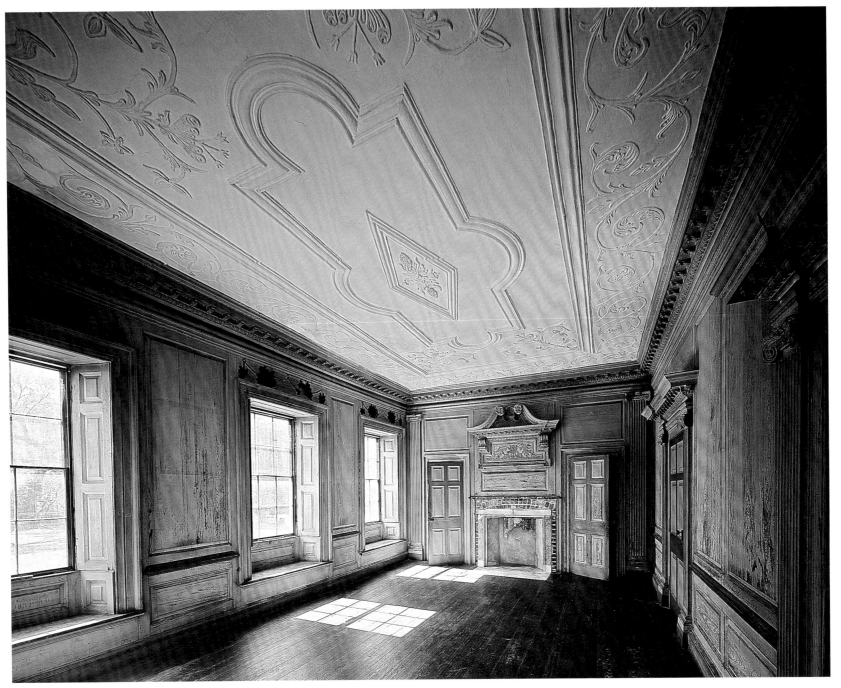

Majestic room, Drayton Hall, Charleston, S.C.

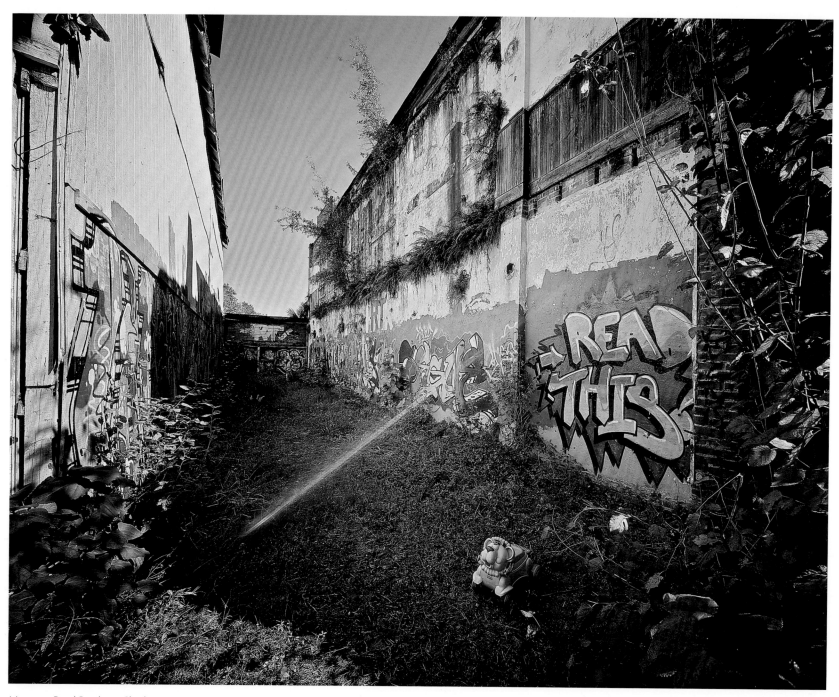

Message, Read Brothers, Charleston, S.C.

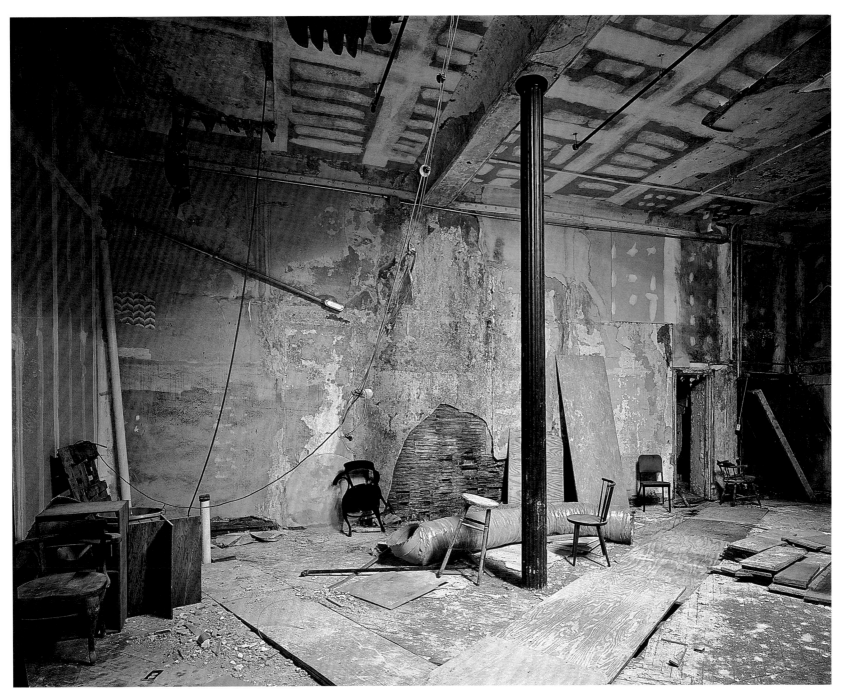

Vacant space, Kerrison's Department Store, Charleston, S.C.

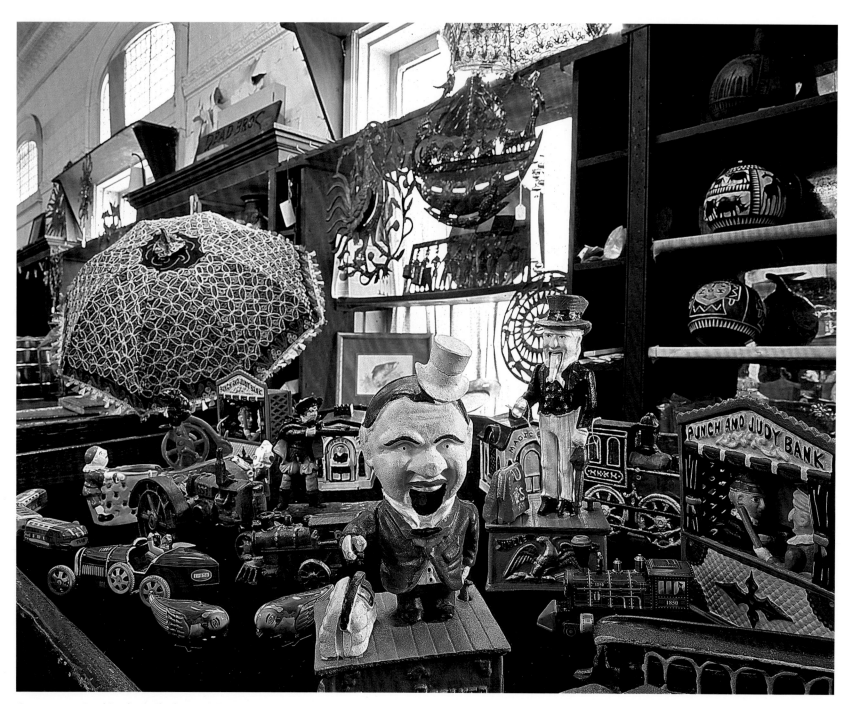

Cast iron toys, Read Brothers, Charleston, S.C.

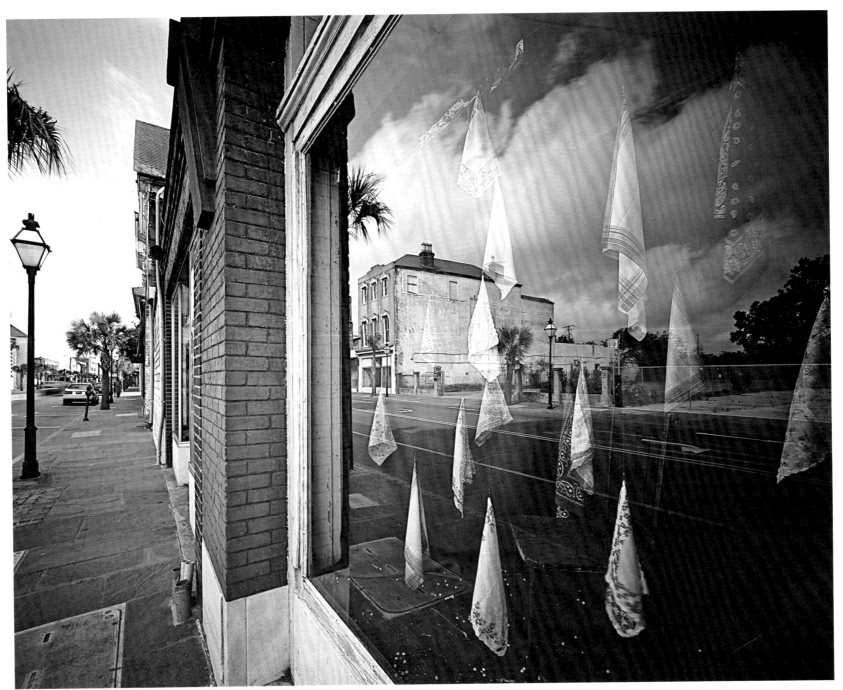

Reflection, Read Brothers, Charleston, S.C.

The PHOTOGRAPHS *of*
SELDEN B. HILL

SHARON CUMBEE

ROBERT EPPS

The POEMS *of*
WILLIAM P. BALDWIN

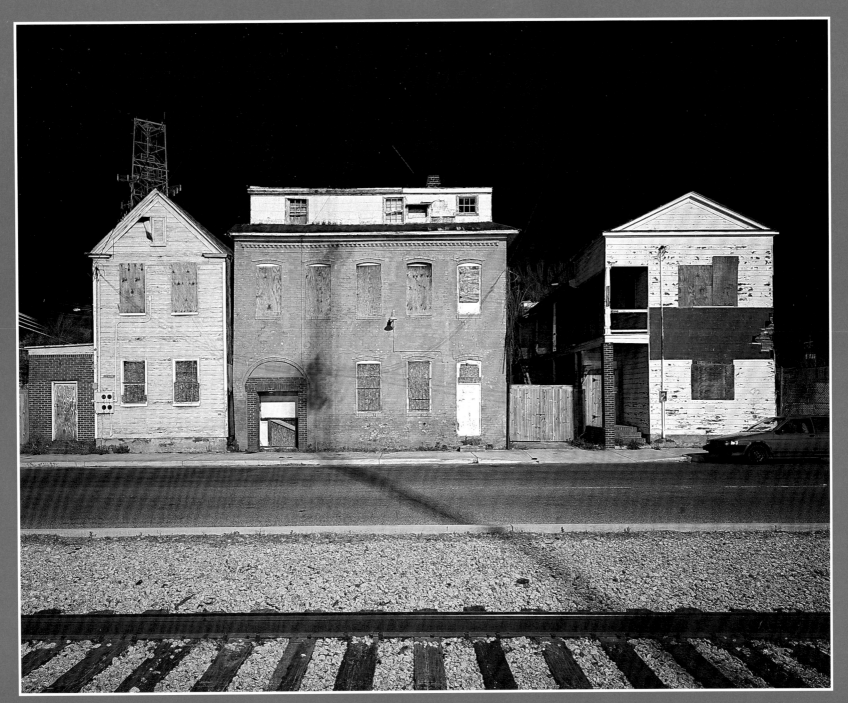

Streetscape, Charleston, S.C.

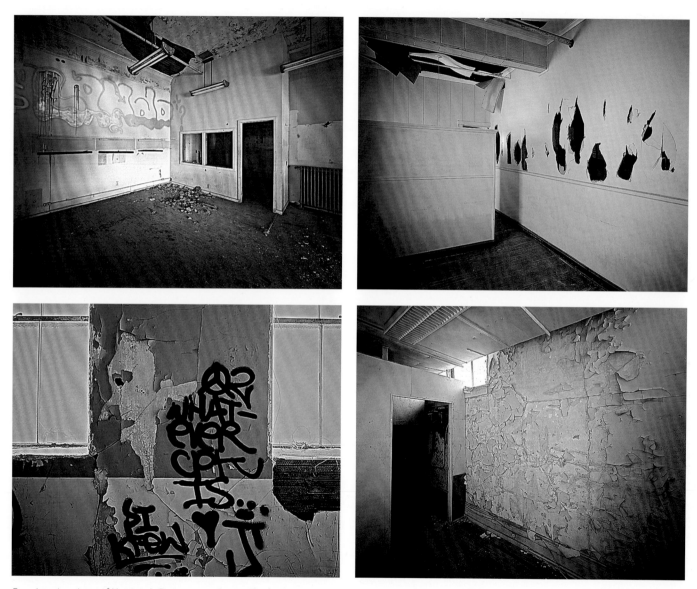

Four interior views of Kerrison's Department Store, Charleston, S.C.

SOME LINES FOR V

Ignore all else.
Read me first.
Every poem needs a home,
A silent place, a thin tome
Skinned in mock velum.
You know, an efficiency,
Just a folding bed,
For poems eat not, nor do they thirst.
Read me first.
I've waited here on your eye, your tongue.
Has the lark sung, the moon hung,
Or your dog barked
For less reason than this?
Say "Yes."

Door knob and spider-webbed key hole, Eutawville, S.C.

BRIGHT DEATH, BRIGHT DEATH

The bunting's flown.
The cedar'd grown
Into a prison bower.
The sky compelled
By wanderlust
Swelled wider by the hour.
I guess the feeder
Was old hat
And my delight no matter.
What other reason would he be
Flapping red and orange, yellow, blue
Or bronze and green?
Rose, apricot, chartreuse?
Why flying off to Florida
Or maybe even Cuba,
Unless it was to break my heart?
I really see no other.

MORNING POEM

Oh, fledgling empire of my soul
Wearing crowns inflicts a toll.
Six branches from the very top
In the pine that lightning struck,
A Great Horned Owl held court today—
At least he tried, but harsh
Partitioned by the crows,
Our owl was made to fly away.
I shouted, Wait!
What majesty is there in *Great*
When common feathers rule debate?
But as he'd left no answer came,
Except from crows who spoke in vain
Of victory over bruted death.

THE GHOST OF ALICE FLAGG

Her hair was gold, more gold than not,
Something there of goldilocks
With coils pressed soft against two cheeks
Where parlor into blush did creep,
Her eyes the blue that Mary wore
While fleeing into Egypt.
Her smile the wealth let none corrupt.
Her heart for one alone to keep.
She loved a man who owned no men,
Her brother owned two hundred ten.
For this was then before the War
When planters swore rebellion
And thought their sisters listened.
It seems they were mistaken.
In button shoes she walked the shore,
White dress with crinolines she wore.
In secret there between her breasts
Lay a ring that promised bliss,
Until in raging fever's speech,
She spoke of love and to her
Brother showed this token which he snatched,
He threw it in the ocean.
There swam a beast, two tails and scales
And jaws of such dimension

It might swallow mansion house
Cotton, dog, cow and wharf
Ships with sails and sailors rigged,
Whole battalions loosed for war
And all those things an angry man might fling.
A ring was but a little thing.
My ring, she cried, my ring, my ring
Scratched upon her breasts
Until blood was let. No need to bleed.
Fever's sweats scored trails
Through blush. And those blue eyes
Lost what little light there was.
When backs were turned, she spurned all else
And crawled into the ocean.
Angel of divine shore lines,
If this be true, come down
The South has need of you.
For now on stormy nights she goes
Pressed against the breakers,
And those who might just happen by
Will hear the poor girl's cry:
Oh Damn you, Brother, damn you.
To this creature of the sea
I gave my body and my soul so
He'd return my ring to me.

SOME SAY

Some say the death of your last parent
Brings a silence like the absence
Of a canyon echo. I cast my vote for
The perfect stillness coming with
The final note
The Devil plays on His Pandemonium.
Soundless.
Speechless.
And such a relief.

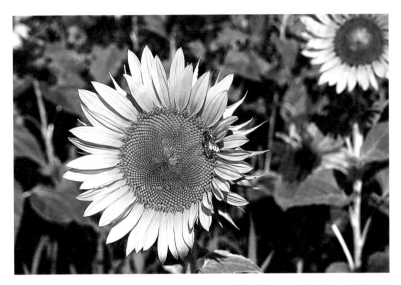

Sunflower patch, Honey Hill, S.C.

MY NEW YORKER POEM

A mad woman lives here.
Her dream is to run with wolves.
To pull off every stitch...Well,
Keep her Reeboks on and run...
Or at least walk with wolves.
Call them brother wolf and sister wolf,
And have stocks which hold their value.
And children that hold their mother
In reverent awe
Because she has this way with wolves
And does not feed her children to them.

SPARE US

Spare us those small deaths of pride,
That enfeeblement which stalks
The sidewalk and the supermarket aisle,
Waits trollish at
The bathroom door,
In bed
And out,
Waits upon the body's loss to time
And what the mind
Forgot to never mind.

FRANKENSTEIN AT CHRISTMAS

I compassion him
Wish to console
But he being only
My shadow self,
I feel revulsion.
A filthy moving, talking mass,
He has no ties to others,
No attentions paid him.
Hence the hatred cast
Of his communion.
Let angels bellow of a forfeit.
Being shy a manger, mother, fathcr,
Shepherds, star, and wise men
And knowing we believe
Affection to be its own prophet,
He rises, turns, then again turns,
Opens wide that great maw of need
And slouches toward Bethlehem.

IN THE WORLD

In the world before the flood,
Man and wolf still spoke,
The air was scented apricot
Until the heavens broke.
For forty nights and forty days
It rained and rained
And all the life that was before
Got washed away, except
What grounded on a flinty shore.
Held within that ark
All praise to man and animal,
Set six doves to soar.

Noah and wolf came down the plank
Sniffed in vain for apricot
And took their separate ways.
The wolf, a creature blood besot,
Went on to wolfish slaughters.
Noah got drunk and cursed his son.
Lot got drunk
And lay with both his daughters.
This is now and that was then
And no one seems the wiser.
There's only one change I can name.
Men still go as wolves
And wolves still go as men
But neither greets the other.

SAVE

Save for me those primitive joys.
Make me first among peers.
And while you're there, make him last.
The girl's smile. Yes,
When she brings the menu,
Smile for me alone.
Damn right.
A Pulitzer prize
And those fries they make
From sweet potatoes.
Have the buntings to my feeder.
Bright cardinals, blue birds.
Give grackles to my neighbors
Save the best for me.
Save for me primitive joys,
Those of old savannah days,
When, rearing back,
Man took his rock,
And threw it at the next one over.

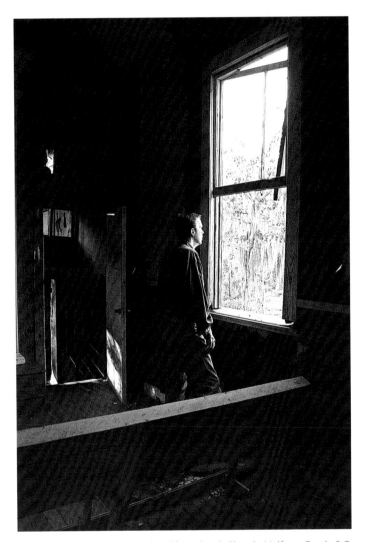

Glancing toward the graveyard, Halfway Creek Church, Halfway Creek, S.C.

THE BEACH
Along the King's Highway,
These inhabitants of sand hills and cypress swamps,
(Hills and swamps occupying sites
Better taken up with fertile fields)
These men, cautious of desire
And women, hardened by a lack of happy songs,
Still came and danced on the wide strand shores.
The sea is rich in minerals,
Salt mostly but tiny flecks of gold, as well,
And the soles of bare feet
Shown bright in the dance night light
Of fires built on fires of the week before.
Do I have to tell you?
Many a child conceived, girls dowered, boys empowered
By golden footprints leading to the dunes.
Is it true? The mermaids still come, and mermen, too,
Phosphorous trimmed but of grim aspect,
They float at night just beyond the surf,
And in that clicking language of the fishes,
Comment on this common age
Of caustic power and oh, so happy songs
And on the concrete curbs and neon signs
That click of sad decline.

A DOODLE FOR ELLEN

Spring unveils her latest line,
Scented sweet with jas-a-mine
See those marsh mink trimmed in fur—
Oh, furthest wilds of furthest calls,
Critter runways through it all—
Rock doves coo, the blue jay sneers,
A hide that's tanned goes anywhere.

IN HABITATION: FOR JANE O'B.

And it's old and it's old and it's old
And sadder than anyone knew,
This tale of the water moccasin
Who wanted to be a shoe.
He drew on his knowledge of Frogs
And all doubt in his fitness suspended.
He lay 'neath the bed,
And when all's done he said,
The world is a pond us upended.

Unhinged, Vance, S.C.

MY BOOK

Beige linen paper,
Inked, bound, and held.
I had a story to tell,
A man bites dog story
Where the man bites the dog,
Not the dog bites...well, you know.
But YouTube stepped in,
Made cannibal soup out of it.
Ate the dog and the man. Ate
the big iron pot and the fire, too.
Their version went viral and
Consumed the whole earth.
I've heard the story.
So have you.
Return to cinder.

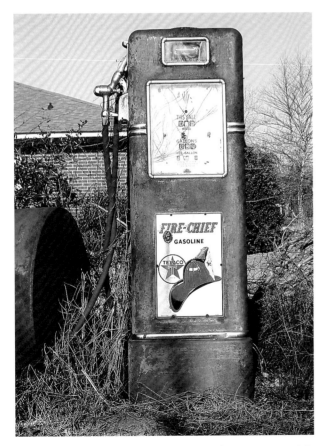

When gas was cheap, Kingstree, S.C.

LOST DAYS

Are you? Think you're all set.
Come here.
I'll teach you a lesson you won't forget.
Heel, ball, toe,
Jog, post, canter, do, re, me, my, bo
Hunk us.
There's not enough
Hours in the world's time collection
To fit them all in,
These lessons in the how to do
What's expected of you.
You think Eisenhower got to be President
Of this great country by just killing Germans?
No. It took practice, practice, practice.

MAKING FRIENDS

We've got Facebook, wine tastings,
And get-acquainted barbeques.
It isn't hard to make new
Friends. Not like in the old days,
1810 or so,
When they finally knew
Right to the miniscule
How blood circulates
And why we breathe.
Back then making friends
Took seeing someone for what
They might become plus a
Broad knowledge of chemistry.
Now we just want receptivity
Without responsibility
For what might happen
When you run a lightning bolt
Through your friend's
Nearly resurrected cranium.
That's all changed.
We've got this ease of a light switch
Companionship.
No guarantees that strife
Won't rend weak hearts asunder.
You don't get them now,
High voltage friends for life.

DOODLES
Narrow escape.
I came this close to saying
No, I won't
When all along
A barn they milk the
rattlesnakes in
Might just be where I belong.

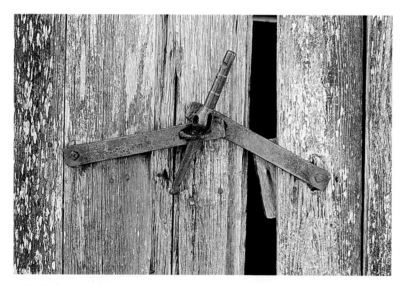

Make-shift latch, Elloree, S.C.

LYRIC
How do I explain
Seeing you again?
How?
No. Don't get up. Can't stay.
Just hand me down
My weary thought machine,
Yes, yes.
That scorched oven mitt of a brain,
The one you
Took to the stream where
The women gather
To pound their clothes clean
While the hippos (water buffalo,
flamingos, or caribou)
Trumpet their displeasure.
Remember?
The one you wrung by hand
And set to dry on the top step by
The geranium in the green pot.
Yes. Just toss it here. Or better yet,
I'll come to you.

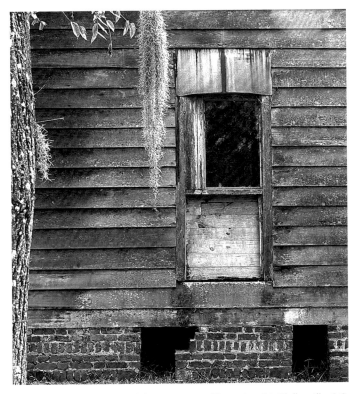

Door to kitchen building, Hampton Plantation, McClellanville, S.C.

HERE I STAND

Here I stand
As hungry as a paper nautilus,
Ship of pearl, with new coil
Of words to set me on a spinning course.
And there's an ocean boiling
With indifference.
Sail on, silver lad.
Sail on.

YOU THINK

You think no ocean's left
The dry has spread too far.
The concrete strip,
The metal lip,
The air-conditioned car,
But just across the dunes
The surf goes rumbling still.
The peopled sands of white-hot land
Hiss and grind, the children climb
In mother's arms, the kites take flight
And dogs from Frisbees flee,
For there vast oceans spill
And even lovers lack the will
To do what lovers will.

FEBRUARY

Maybe,
Some other time.
Suppose I put it first,
This last sad line,
Stick some lovely doveys in,
Then end with
Be my valentine?

IN THE GALLERY

That guard who watches from the door—
Do I match the profile?
Would I snatch the Rembrandt sketch
Or with sharp popsicle stick,
Deface the Virgin's lace-ringed face?
Or worst yet, rest finger tips
On these oneiric Gauguin breasts?

THE GAME

A smidgeon of affirmation.
Just the sound of one hand clapping.
No need to bring the A team.
Scrubs will do.
And those bobby-socked
cheerleaders,
Keep them on the bus.
This is between us.
Me and you.

BIRTHDAY GREETINGS

You could have stayed young,
Bailed forever.
But no, not oh, So clever you,
You with right foot on the
rocking boat,
Left one stepping to the dock.
Don't trust you'll end in dust.
This could go either way.

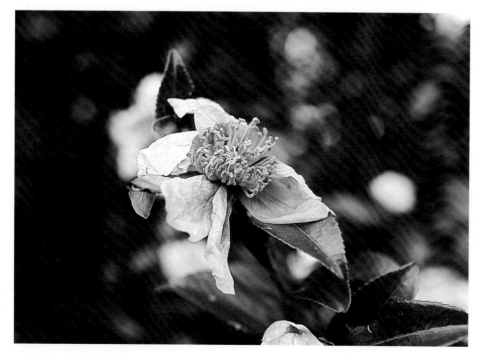

Faded flower, Shulerville, S.C.

SOMETHNG TO HUM

Something metabolic,
That rage in girded thighs,
Antiques that the woman found
She stripped them down with lye.
Crazed eyes they seared 'cross dark veneers,
Milk-based paints, all finish dear
To gauge attack for primal grain.
Scrapped with blade, scrubbed with brush.
Pustules on her hands, her face,
Sparrows flying overhead breathed the fumes
And fell down dead. All water pumped
Beneath her feet lost the precious label sweet.
Bare pine and oak, and bleached mahogany.
The fundamental signature
Of hell's velocity.

THE LAST OF APRIL

We purchase nature at a price
Blend the blush of roses, breed the cows,
Decaffeinate coffee, and in general
Bleed the world of far horizons
Yet still somehow, cling to plain old
Boy meets girl. That can't last.
Mark my words: there'll come a day
When April fails to sing
And May will be a month like any other.
In fact, and sad to say,
These few lines you're reading
Might be the last love song ever.

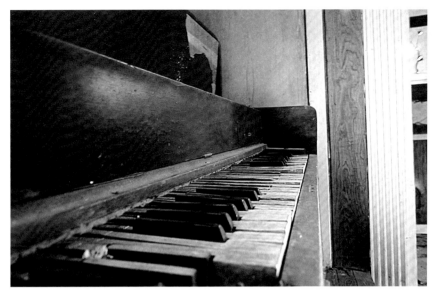

The last song, Halfway Creek Church, Halfway Creek, S.C

LINES COMPOSED ON A STORMY EVENING

Still, and despite myself, I must
Rhyme a dark woods, lace the branches overhead,
Place the owl's call at the disposal of not just owls
But demons of ghoulish intent, then have heard
A banshee's scream, and rear the horse beneath the hangman's limb
Where just last week I courted you with words
 Borrowed from a younger self, wove a bird nest out of black-ink print
And had the bluebird singing to his mate how next spring
He'd build one even better like maybe, *Wrap your arms around me, call me Honey pie*
But poems have borders just like women (or like men)
That stall divine alliance and hence demand an end.

MAKE ME YOUNG AGAIN

Just let me attach new lips
To this old face of mine,
Those red wax candy lip contraptions
Not seen since we were children
Laughing in that dead tongue time.
You know, back then,
Licorice laid in twisted strips, sold by the pound.
Wake me. Lace these legs with bright sinew.
And double quick I'll make them run
 Into that dusty cavern
Of a store. As dry to green,
Barefoot, homemade jeans, and nickel in my hand,
Right then, I'll make them speak,
If nothing else, those lips will shout my name.
Include me. Make me young again.

THE RAYBURN VINE

Because my old head's worn out,
Been tumbled and blown
By its own blind trying
And will likely believe that anything
That is bad enough to be true, is true,
About that my daddy had a theory.
Six, seven thousand years ago
There were people living in North America.
These were White people. T'wards Bethera
He showed me big dikes up in swamp.
No Indian could build what he showed me.
White people were here then and malaria
And typhoid fever completely killed 'em.
The Indians came later. Same in 1918.
Typhoid and malaria had weakened
The people. That's why the influenza could kill so many.
I had a brother, a sister, and an uncle all dead in seven days.
All over the country people died.
The flu, it was just a bad cold.
I was four or five years old.
I can remember watching the cow pen gap,
Minding the cows while my tall mother milked.
I saw my brother and sister dead, laid out on the bed.
You couldn't get a doctor.
You had to hitch up and drive to Mount Pleasant
And get him, and you had to have money to pay.
There were families up in Cotton Patch,
Three or four families.

And there was nobody to bury them.
They were just scattered out there dead,
Left for the hovering vultures to eat.
I went up there years later and there's nothing to say
Where they lived. Not a brick or thin board.
Just a windless sky and one wild bee hive.
No time now for the marriage bed.
And the hurry in their shoes. That's gone too.
The earth don't wither, it's us that wither.
And that's how come I got this Rayburn vine.
Hardly a leaf peeking through. No daylight shows.
See. Solid scuppernongs
You must figure to the square yard
Two ounces of aluminum sulphate.
The arbor is 16 feet by 16. And the weight...
Hanging up there are what...a ton of grapes?
Maybe. Bi-Lo stores will take them all.
I'll just spread sheets out underneath
And shake them down.
All that coming out the ground. Rayburns.
I dug that vine from their old place.
They left 'cause a wild cat kept squalling
Outside the window, endless crying like a baby.
No. Can't close your eyes when a sound like that won't end.
Went on for years and they left
And they never came back. Anyhow
I dug the vine up and brought it here.
Something to show what the Rayburns had done and where
I am now.

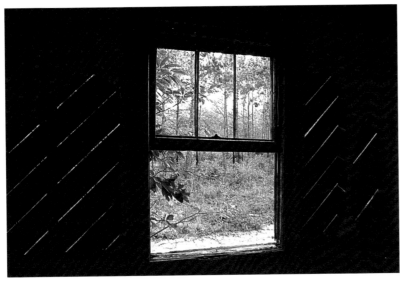

Light comes in, Halfway Creek Church, Halfway Creek, S.C

AS IT HAS BEEN

As it has been some time since
I set myself up as a poet,
A centennial might just
Be in order.
A hundred years of rhyming,
Of timing my arrivals and
Departures,
And waving at the masses
Has given me no little understanding
Of what passes for the spoken, written
Word of God.
Let hosannas ring, and when that's done
The nightingale will sing
Of loss.

SPRING

Save us from bent things,
Sharp objects, and purposeless desires,
Especially now,
In these final days before
Spring's confoundedness,
Especially now,
While leaves are still budding green
And hearts are still leaping
When confronted by magnesium
Blue skies,
Still leaping, leaping, leaping.
Especially now,
We should not confuse discontent's faint sighs
With their versified promises of star-sprinkled nights
Breaking into dawns of apricot shading into peach,
Confuse those
With our dreary mulling metaphors
Composed of miles to go and promises to keep.

TO THE GROWN WOMEN IN MY LIFE

I'm thinking every poem
Should have a built-in exit,
Like a screw-down hatch, one thick and retro
And bolted through the hull of the sinking sub,
Or a second rip cord for when the big chute fails—
You know, the poet's a lost cause, or at least that verse is—
But wait. From out his fanny pack
A strip of silk comes stealing,
Peeling, snapping to a saving white width.
And every poem should begin and end with
Just your name—except this poem
Which for reasons unknown starts
With *I'm thinking,* and as I now discover,
Comes with only a burlap sack tacked
Over that ragged hole hacked into the dry wall...
There, with some modicum of grace
I, by sliding sideways, will make my departure.
Now you see me, now you don't—or won't if
You go further down the page—No wait.
I've snagged the sleeve of my reindeer sweater
On that bent framing nail. I wore that old
V-neck back when I was twelve
And now the poor reindeer's head
Is stretched to moose dimensions,
And worse yet,
Though I call your name, it goes unsaid.

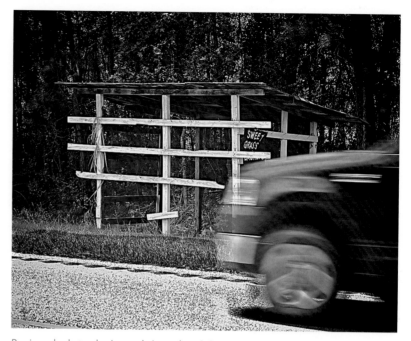

Passing a basketmaker's stand, Awendaw, S.C.

LOVE ITSELF

When I have finished blaming
This useless roof of stars
And the careless God who formed a shaped
But hollow man of newspaper and flour paste,
Then I will blame love itself.
This dough, fiercely but kindly kneaded,
Is poor stuff and those finger paints He used
Weep on contact with the night damp.
Hang me like a piñata from that tree limb
No need to take a swing.
Just a pat will do.
And may a candy kiss or two
Brush those wondering lips.

REMEMBERING

Remembering steps from left to right
Or right to left or both.
Thick legs of elephant
And camel's hump it boasts.

The antlers spread near 'cross a room
And snout for ants it waves.
Or so it seemed when I was young
And painted in the caves.

But now I've got a Kodak
With pixels pink to black.
And all the sharp bright colors
Can't bring the magic back.

You want to seal a moment
Then light that torch and come.
Some soot and deepest ochre
Will make the wild things run.

SONG OF THE HEART

In royal battle with a Ford's left rear-view mirror
A male cardinal just pecked himself silly,
While the female, in dull red coy dissimilitude,
Gossiped at the back fence, even smiled beneath
Her wing, for he, in male simplicity,
Mistook his own reflection for a rude and
Fiery rival. No. Pecking at this keyboard.
Couldn't match in any way. Well, maybe
If you smiled beneath your wing it would.

MEDITATION

Substituting love for fear
And estimating what goes where
Can take the better part of years.
So do the thing, start right now.
Clap your hands, take a bow,
Shout: I am one who, way back when,
Mistook that tire swing for wings
And flew to scary places.

SUSAN B. LANE

Beneath that bright balm
What needless shadows play.
Each pale confusion of the day
Takes light, a fistful, sometimes two,
Loses for us this and that until the night
Comes 'round to patch things up.
In vast silence the pine limbs sway
Stirring stars, stirring stars, stirring stars
And tender is the touch of breeze
On cheeks this verse has spun.
Must we fulminate another sun?
There. Carl's dog barks and down the way
An answer comes.

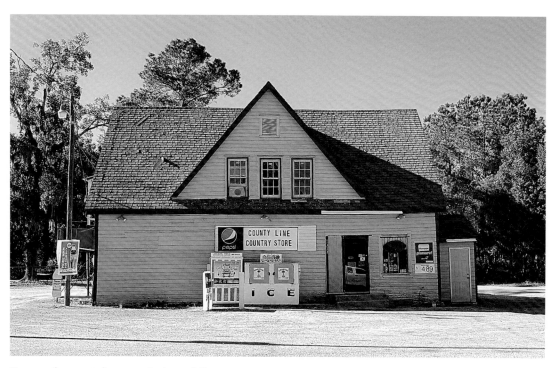

Store on the county line, near Andrews, S.C.

HOLY

Holy, holy, holy.
Son of God.
Disguised as wayward man.
Did Jesus Christ
Trod this strip of white-lined concrete,
Limp at dawn past the gamecock farm
Or 'cross Black Mingo, stop and have a beer
At that place by the county line where
They've pulled the gas pumps out
And left the rest behind?
Or did he drive,
Maybe in a Ford Fiesta
With the front right fender
Crumpled and rust festered,
Humming somethin',
Careless elbow resting on the window edge,
Tattooed forearm reading
Semper fi or *Cherokee Indian Nation*,
Drive along just so,
With no thoughts now of crucifixion,
Content to be redeeming
And lost like any other to springtime dreaming?

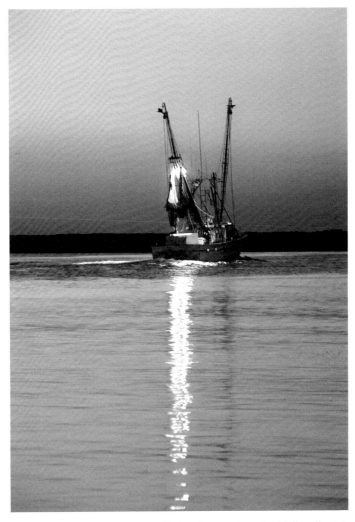

Shrimp boat at dawn, McClellanville, S.C.

SELDEN B. HILL

Essay

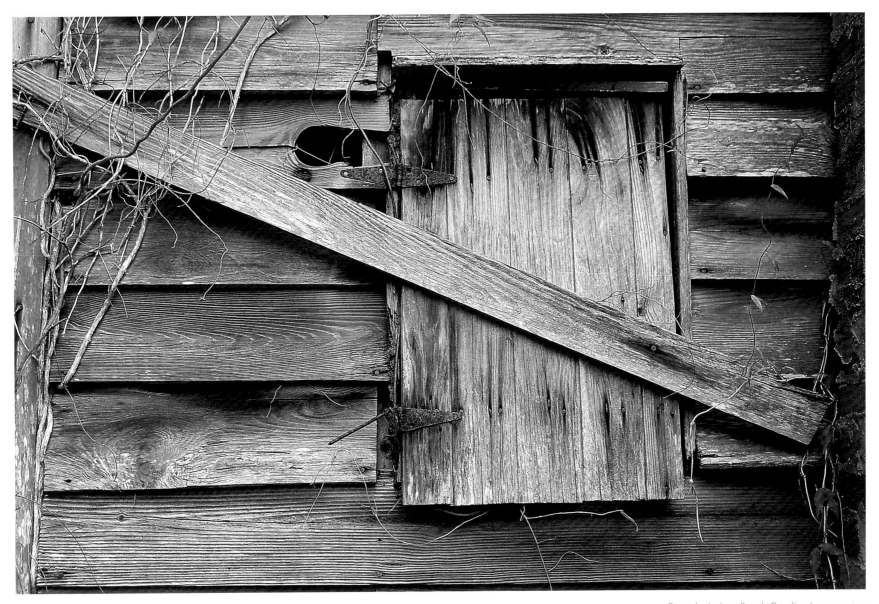

Barred window, South Carolina Lowcountry.

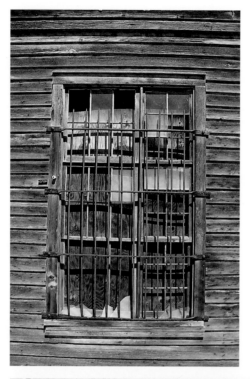
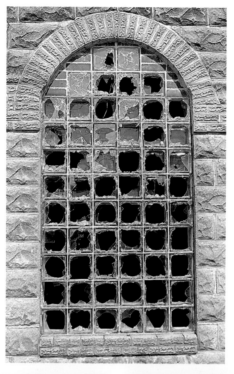

Collection of matted windows from across the Lowcountry.

Windows and doors: They make you want to peek inside.

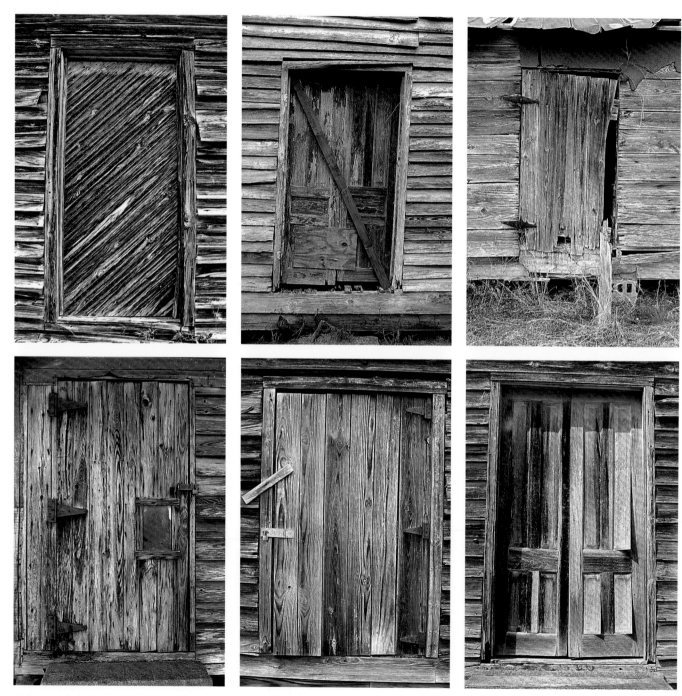

A door can lock you out or welcome you in.

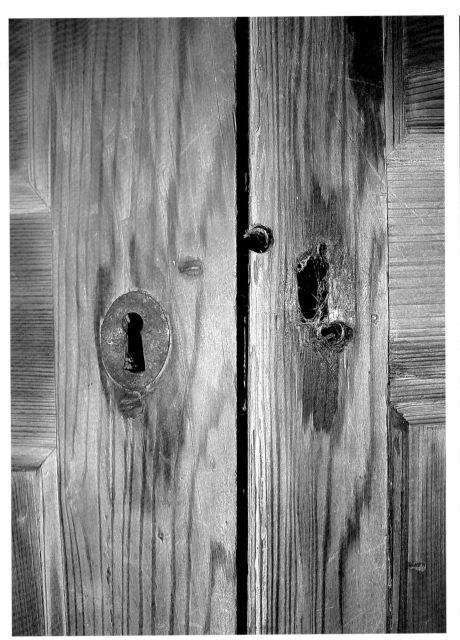
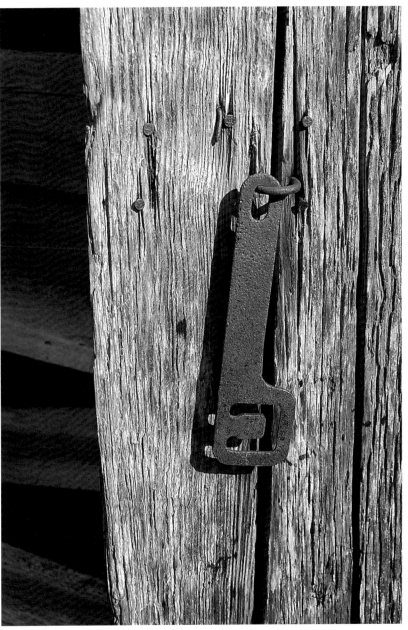

Ancient pew door and old barn door with latch.

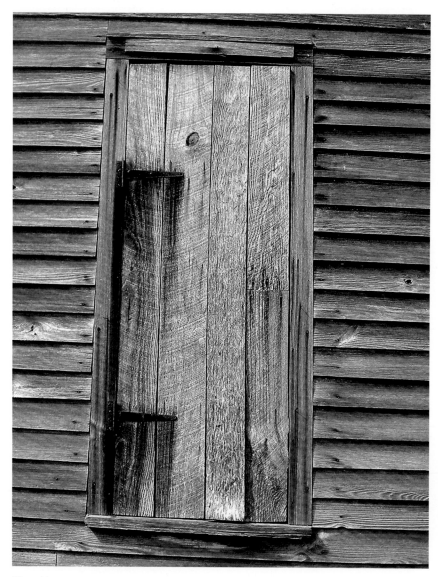

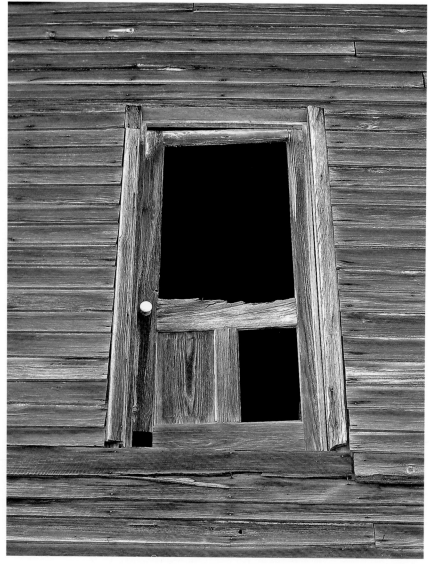

Closed but not secure.

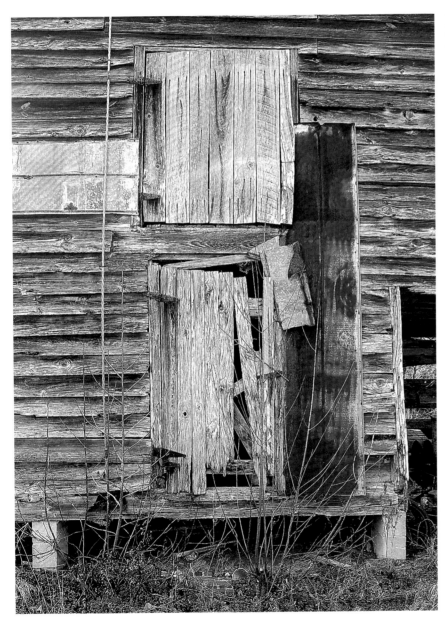

Weathered wood and metal siding.

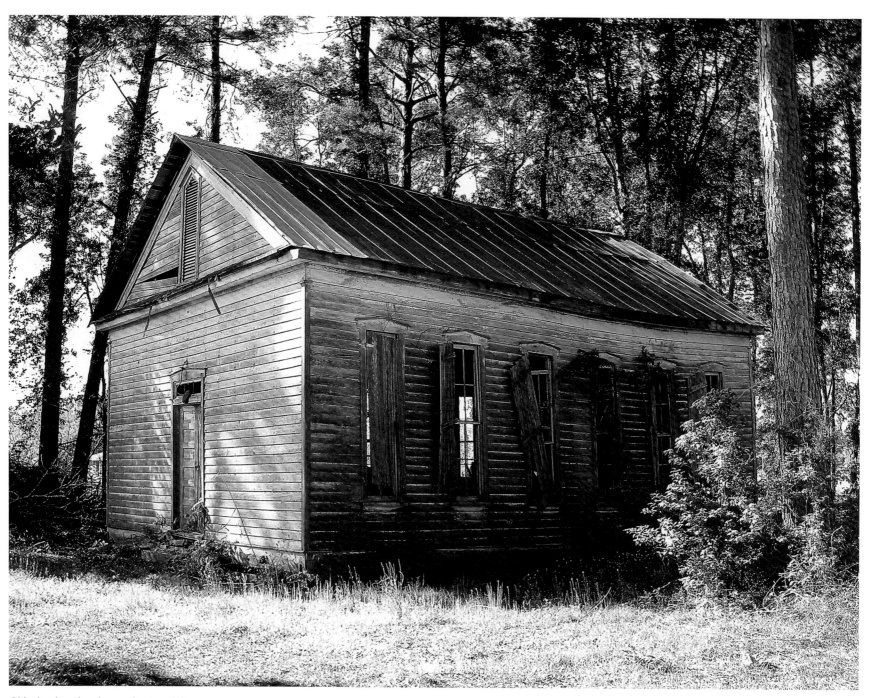

Old school or church, near Creston, S.C

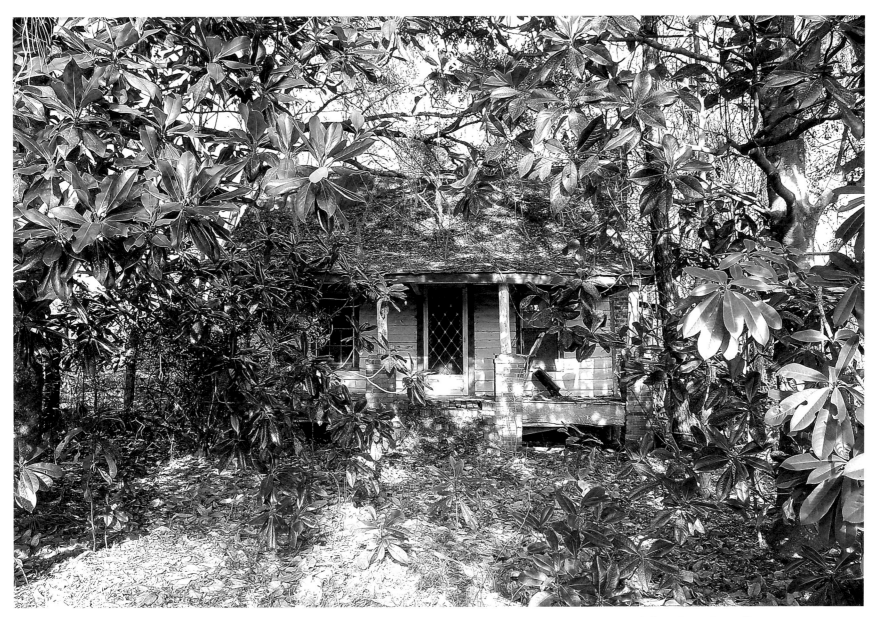

Magnolia bows frame this small cottage, Jamestown, S.C.

Early steam tractor, Elloree, S.C.

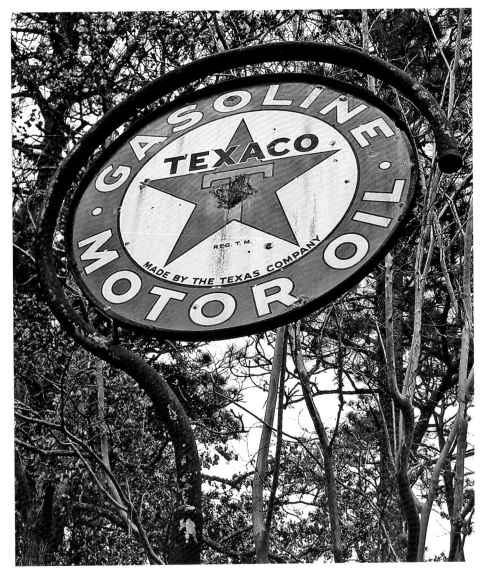

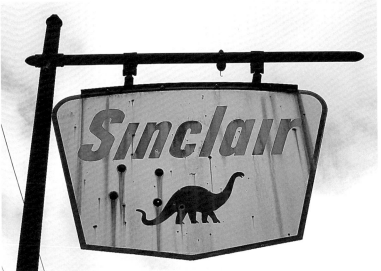

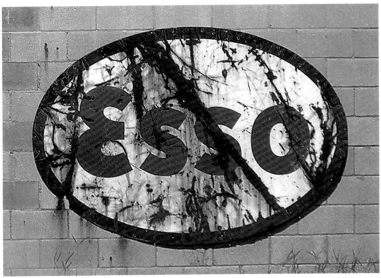

Signs, signs, everywhere signs.

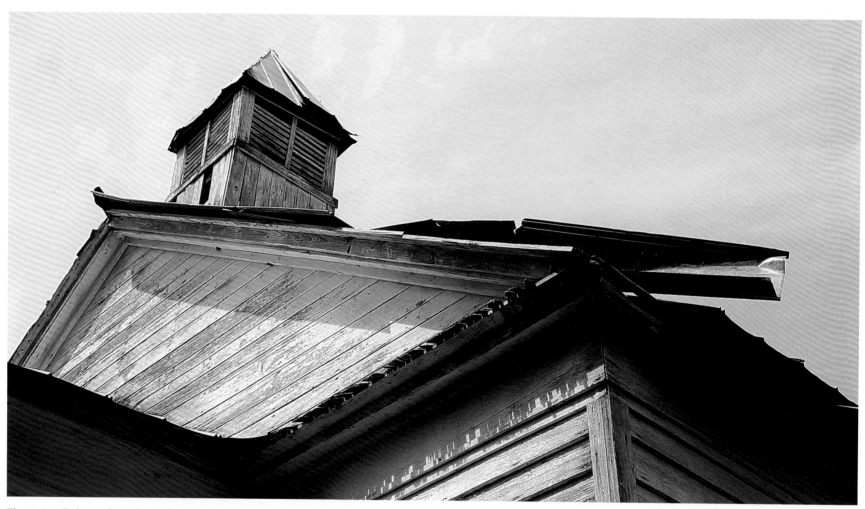

The tin is pulled away from the roof and steeple, Taveau Church, Cordesville, S.C.

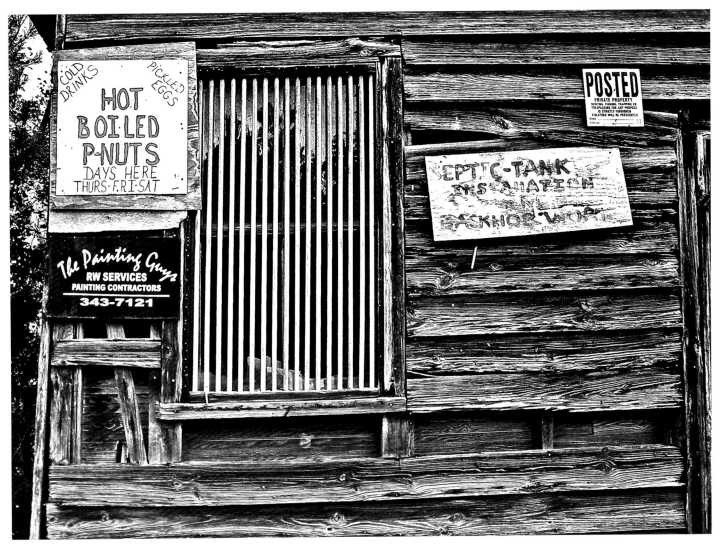

You used to purchase the official snack food of South Carolina here, near Cross, S.C.

The PHOTOGRAPHS and POEMS of
WILLIAM P. BALDWIN

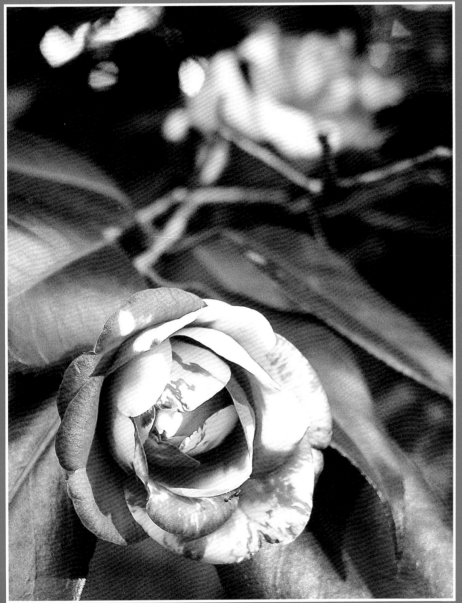

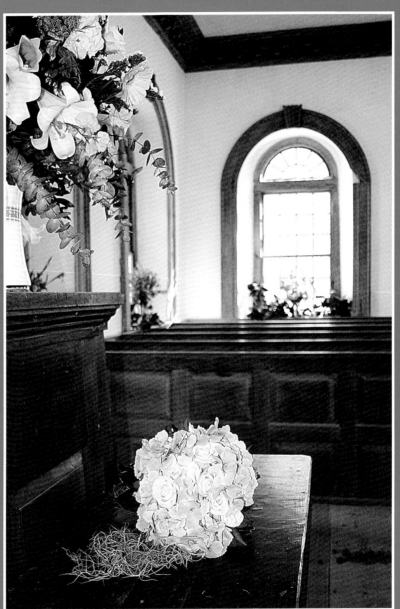

Camellia blossom, Hampton Plantation, McClellanville, S.C.

Floral decorations, Brick Church, McClellanville, S.C.

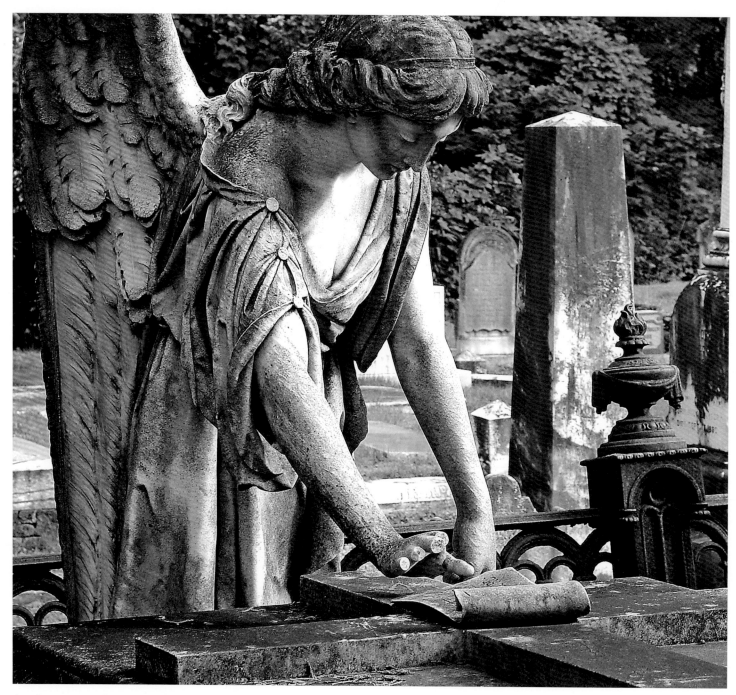

Angelic messenger, Bonaventure Cemetery, Savannah, Ga.

HAMPTON AT NIGHT

What caliber of night is this?
The wings of descension beat slow,
Hear? Above the holly comes a hiss.
If we connect the world with words,
Rope the dark roses into scented confusion
And scalp the sky of blue amazement,
What is left for love and songs?
Cat, dog, panther, house, seashell, stone,
Each we wrench with meaning's talon,
Tumble rabbit from his perch
And owlish tear among the bones.

PRIDE

A pride of the eye
Is the edge of the storm,
Grand purples and browns and green,
But I tell you the best I've seen
Was there in the water's edge.
A flounder was making his bed,
And he rose and he fell
In a bed of fine shells,
And settled himself unseen
Among purples and browns and green.

Richard and his treasure, McClellanville, S.C.

THE BROKEN SHORE

Beneath our feet earth's shelly core,
This half mile stretch of broken shore.
A night's blind rim, a surf's soft chime.
Forget the time and the tides,
The price of that, the needs of law,
Remember just that silver cloud anchored in the blue-black sky,
That light you saw beyond the bar where no light's meant to be,
And locked forever on their course, let moon and stars drift by,
While at the core of quickening, you fold a place for me.

DELTA

The Delta is a place of pagan gods,
Thick-barked oaken ones, who with just a nod
Draw from off a summer ocean tumbling clouds.
There: rough surfaced waters brimming light
And wind in gusts to flay the pitching grasses—
Until I am shrouded in a bristling rain.
Then to the right, left, front, back, come
Crackling spears of wild divinity,
 Each strike with its unknowable
Intent, ion burning, booming and all flung to and fro
By the twisting branch hands of un-thankable
Delta beings, pagan gods,
Who anchored firm on scraps of island
And on higher distant shore
Refuse our direction,
Cannot be prayed through.

OLD SONGS

I do remember, quite clearly, I do,
Deep in the night
The red-light radio
Brings a far off plea:
Boys at the jungle camp
Want to hear Peggy Lee sing her new song
Is That's All There Is?
Of all the promises we try to keep
Being there for her/for him
Surely that's the hardest,
Especially as I am here, ear to the red-light radio
And you. Off among the army ants and jaguars,
Request only songs of insular longing,
Should I, with head cocked, continue to attend
The brown Bakelite casing
Or go and bark at the ocean.

ANTEDILUVIAL: FOR JOHN

Men of clay
Left over from those days
Before the earth hardened
Draw near
And hear this your song of praise.
Cancel all subscriptions,
Put the cat out,
The time of jubilation
Is at hand. Shout now. Smile.
Happification
Lays smooth upon
The rising lands,
And vested by this new-made sun,
Sorrows dried 'neath minted skies
Into rainbows bend.
Nothing left for us to do
But slip the kayaks in.

HERE
Here straight out of left field
Comes a morning's mourning dove.
See! There! Quickened April out of March,
Weaving air, hissing light,
Peeling 'round the spring swamp line
And 'cross these wants of mine.

HOW TO
How to read a river:
Well first you lock the door,
Then open to a private place…
No. Check the lock. Be sure.

And take the phone off the hook,
Draw the curtains shut.
You wouldn't want the shores to know
Just how the currents cut.

A river reads from left to right
Unless the moon is up.
Then flip the puddle over
And read from back to front.

There. You start to get it.
Instructions now bear fruit.
Delight is in the drifting.
Deep bends we skim to suit.

Each reading is a promise.
What else can I say?
These judgments of my mouth
Fall short of river's ways.

Lee among his creations, McClellanville, S.C.

THE DAM: FOR EDDIE W.

Before the dam was built
The Santee drove far wide,
Through the spring woods,
Over roads and up the Echaw side.

Carp they fed on corn mash
And flipped where wild hogs ran.
The bees they danced confusion
That made the sky expand.

Wild turkeys rowed in bateaus,
And men went 'round on stilts.
A world of fancy vanished,
When the dam was built.

Longleaf pine sculpture, Awendaw, S.C.

WE SET

We set a transit by the woods
And shot a line that bore
Oak and ash and pine away
And through the goat's rue tore.

We brought the mosses to their knees
And rooted down below.
To man-ifest a site
Where beggar lice can grow.

We robbed the woods, the trusting woods,
Cut unsuspecting trees,
Drove numbered stakes through its heart,
Tied blue tapes where we pleased.

And now that night has fallen
Such ghosts in moonlight
Come with paw here, hoof there,
And urine splashing bright.

AN ACRE MORE

An acre more, an acre less,
This quilt stitched up from clay,
With birds and clouds and sun
All patched in crazy ways.

And at the head a stone
Marble trimmed out square
To mark the staid division'
'tween here and over there.

THE HANG: FOR CAPT. CHARLES

The coal barge struck and stayed here
It drifted o'er with sand,
The coal barge crew got buried
On Presbytery land.
Now 'round that wreck
Bright trawlers tow,
Computers churning soft.
Coffee poured,
Chart ignored,
'least this part of life
Is marked down on a screen.
For all the rest the waves may crest
And sea gulls pitch and scream.

A SWAMP: FOR SHARON C.

A swamp can keep a secret.
A pine grove wouldn't try.
It'd tell you where the doe passed through
And where the buck might lie.
Cypress hides a chest of pearls.
To guard that worthy prize
I've seen the sun stoop low
And set the limbs afire.
Then waters turn as black as ink
For into stubble
Fire sinks.
Into sky the pearls are thrown
Which tells the buck to rise and try
His passion on the restless doe
For she has secrets of her own.

Reflections in I'on Swamp, Awendaw, S.C.

HAULING BACK

There are dark mysteries in that sea
No net will take nor hook unlock.
There beyond the coal barge wreck
Still inshore of offshore rock
I've felt the pitch of webbing gone.
Hauled back doors and lines alone
And angry set a course for dock.
Anchor left from sailing days
Buried deep with only tip of tine
To snatch? Who can say?
Once they thought the ocean filled with
Creatures fierce, monsters no man could resist
Who rose at night to feed on blood and mist.
Then hid away in monster caves.
These days that stuff's above the waves.
All that mess that we've forgot—
I see the rage of water things
In vomit pooled on bedroom floor,
I trace with trembling finger,
Inspect, divine, predict,
Then close my eyes.
They say the ocean's in ourselves.
I've read those books.
I keep them on the wheelhouse shelf.

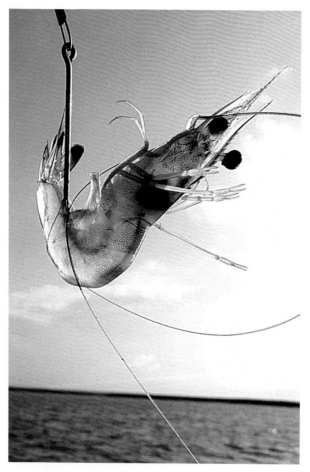

Casting, Cape Romain, S.C.

WITH OLD DAN

Let's make an art of common things:
The crab pot floats and dorsal fins
Of rolling, gray-fleshed porpoising,
Above the marsh the hawk's trim wings,
While in our hands the taste of dreams,
What some call *only apples*. These we
Polish, turn, and turn again,
Then take a bite, remembering
How it was to scheme, to lose, to win.
We here where the creek bends,
Narrows in and spreads again.
Can drift like so until the flood,
Then lift the paddle,
Dip the blade, accept with smiles
These lives we've made.

READING

Have you seen the white whale?
No? Then up-helm.
Keep her off around the world!

Around the world. Now, there's a line
That once brought lofty thoughts to reading boys.
But these days Melville overwhelms them.
All that boiling down of blubber
And wickedness too broadly trimmed.

Put Harry Potter before the mast.
I suppose he's built to last
But only in these modern climes,
Where whales just make 'em ooh and ah
And magic comes in wands.

WALDEN, TOO.

I went into the woods
To squeeze a cypress knee,
To suckle honeysuckle,
And live deliberately.
But Mother-Father Spring
Got there ahead of me
To clothe the poplar girls in green
And 'round the naked ladies
Weave a cat-briar screen.
What it was I take, I bring.
Oh, sweet, sweet fecundity,
Here's your wounded close at hand,
Deck in scent the promised land,
Bloom wild roses, raise a smile,
And find a place for one more child.

THE ISLAND

There. In the dunes
Oaks honed 'round by wind and
Sandy sweepings of the earth.
Green but stunted, these
Boasting a luster all their own,
Can warm the rain,
Mend hearts, bend steel, melt ice cream,
And best both sun and moon.
Do you hear the thunder out at sea?
Such trembling, howling envy
Of life's unriven trees.

NEEDS

Everything I need
Could fit into a cardboard box
As big as the moon.
No. Not round shaped.
I just mentioned moon
To suggest the vastness
Of the neediness.
A square moon but still bright white
Except where pale blue shadows
Rim the craters,
Scars from past collisions,
And by that I mean derisions.
Oh, Lord.
I see the seams are spreading.
Wrapping tape.
I'll need a light-year's worth.
And lots of string. Bring the string.
The string. The string.
There. That's it. Hold your giant
 Finger tight while I tie this knot.

PAWLEY'S HAMMOCK

Inside my head I've spun a globe,
Peopled it with clown,
With dog, with lady love,
Found things for each to say,
To bark, to sing,
But life is here to stay.
The fig tree blooms,
The hammock creaks,
Popped Orville Rendenbacher
Tumbles from the bag,
And woven in the woven ropes
Is an afternoon's sweet sag.

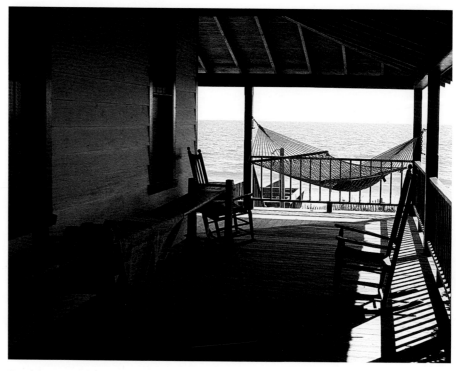

Beach house porch, Pawley's Island, S.C.

POE ON SULLIVAN'S ISLAND: FOR MY SONS

Poe stood this battlement,
Faced the Atlantic,
Whistled 'neath his breath,
And recalled the frantic
Scrabbling for his mother's breast,
(Aureole of pursed nipple flecked white)
And how he got his schooling
Beyond the Atlantic's bright bulge,
In places where language sang
With dark effervescence.
He gives thanks and thinks: What about a bug?
Make him gold-trimmed
And hang him from a string
And dig down deep for pirate treasure,
'Cause that's his measure of a man:
Digging in the dream sand
Waist deep, neck deep, until travelers on the beach
Pause and whisper *Surely*
This must stop.
He has dug down way too far.
Even Death removes his sweat-stained fedora hat
And with sinewed hand roaches back thinning hair
As if to say, *what you have here, Mr. Poe,*
Is a classic case of digging down too far.
But only the flying shovel shows
And the white gulls scream.

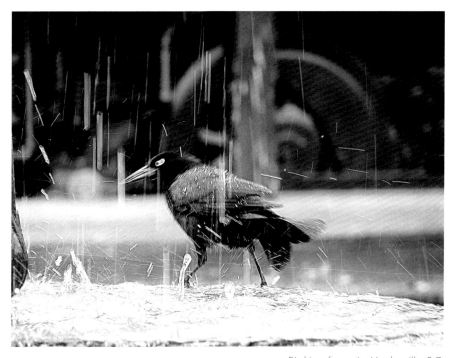

Bird in a fountain, Hardeeville, S.C.

A PLEA PRAYER

I think I'll make just one more plea,
Starts age of iron, age of wood,
Age of rotting fence post stood
Straight in a line run out to sea
Where beneath the Dixie waves
In vaulting fancy crystal caves,
There will pale poets and wheeling poetesses
Grow wild of eye, begrime their tresses,
With bloody fingers honed to sharpened bone
Carve out a prayer like this one.

THE SECRET HALFWAY CREEK SELF

Miss Pauline, gray dress, hair, skin
Gray ancient shapeless self,
Dispenser of dripping wet Bush Bavarians,
Assured us in a voice coarsened by smoking
Mostly Lucky Strike Reds, rose from her
Nauguehide and bent chrome throne
To insist
Listen here, boy, listen.
That pool there
Past Ackerman cemetery,
That'un is a bottomless pool.
May God strike me. May he.
If that ain't so.
A cow drinks, slips and falls in that black water,
That cow will go on
And sink forever.
Of course, the trouble with a hydrogen rich sun

Is when it's broke you and me and the sun, all three are done
And even a one-horned angry cow
With brindle markings and that Rocking C brand and
And both ears notched 'cause you can't trust a neighbor
Not to look out for his ownself,
No way, even that poor submerged
Cow floating ever downward
But still bucking,
Wild-eyed and twist-turning,
That cow will reach the limits of a bottomless pool
And so will you,
'Cause that's me riding her, one hand holding tight to brindle thatch,
Other waving wide, me with head thrown back,
Air bubbles drifting forever upward. See me, heels dug in.
And damn lucky to be wearing those Hollywood Nudie Cohen custom-made rhinestone boots.
The pants and shirt may be threadbare showing
But those boots once belonged to John Whatshisname—
If you can believe what a man
On eBay's saying.
Full blooming red roses carved into a pearl white beddin'.
Patience is a virtue and I'm not.
I'm all the sorrows, violent borne away business you forgot
To enter on that slim, two-page resume.
You remember.
I kept saying, *There will come a day* and this is it.

Self portrait, William Baldwin, McClellanville, S.C.

WHEN THE COMET COMES

This is the season of the wolf
See, our earth in fallow slumber lies
As a patient anesthetized,
Trestled, robed, exposed.
The Redi Mix, with snout extended,
Grinds and whistles, while
The cold driver claps gloved hands.
When the wolf does devour the sun
And we the further stuff
Of sorrow's metaphor must
Dwell in caves, ford wild streams,
Live in murder and deep sensual sin,
I should hope that kernelled love
Will burrow, sleep,
To wake upon eternal spring.
Men with pale skin then will say,
Could be tomorrow, perchance today,
The sun will rise and love will bloom
And have her way.
Until then, I've scratched our initials
In the wet concrete and circled this
With a ragged heart.

ON THE ISLAND

There are things on that island you would not take home to Mother.
That red bull that traced me like a hound, took my scent,
So there I stayed laid out on that oak limb, four days I spent,
With him pacing to and fro and us eyeing one another.
Or that turkey, a mere turkey, so wild and fierce
He killed a mule, drove a spur right into the poor thing's heart.
What the world undoes sometimes we must just leave apart.
I will not say all things, but what is pierced is pierced.
But already I have wandered from the purpose of this tale,
A tale told by the pale boy that the old man brought
A boy to keep him company and skin out what was caught.
Yes, was gators that they sought and for the most part they did fail.
So anyways, the pale boy is not one used to sun.
Most days he stays dizzy and waiting in the shade.
Was by the Spanish fort, a hidy hole he'd made.
What's seen on land you'll find in the sea, least some believe.
Do you believe that's true?

Landscape, Bulls Island, S.C.

Well, keep an open mind. You
Never know what might come by.
The pale boy saw a horse pass, pass close, a gray mare
Not an island horse, that much he understood. No marsh tacky
Set to graze on smilax briars, but a fine horse of pedigree.
And the boy does follow, thinks to make a dollar
Horse, with boy some ways behind, ambles off across the dunes,
A sleek patch-eyed horse and not bothered by the flies.
Right there he should have seen some strangeness lies
Ahead. And soon enough the horse is stepping light through the bones
Not true bones but forest roots, stumps by many waves worn white.
Tide is low, the present surf of little consequence, the horse don't stop.
She wades to belly, she wades to neck, she wades straight off,
That gray mare is gone from sight.
The pale boy waits and waits and waits and paces on the beach.

210

A horse might hold her breath, stay below for some minutes.
But now he sees the horse has something of the spirits.
The horse has gone to stay beneath man's reach.
That's when he came and got me. No use to get the old man.
What with the crutch and little dog underfoot,
The old man would have stood no chance, done no good.
As it was the sun was sinking, attaching dark to white-bone wood.
There were hoof tracks leading out, imprints deep in sand,
And none came back, least not up or down from where we stood.
Who can say? A horse can swim for miles.
One was found off the Caper's bar, legs churning, and heading
To the Azores or maybe Zanzibar.
Still, I am inclined to give the boy the benefit of doubt.
He saw what he saw and before the war
There were the Portuguese here shrimping
They pulled up their net, bucked her in
Hand over hand and tearing at the meshes
They find two live horses. They don't try to bring
A horse on board, not on a boat that small. Those Portuguese
Were glad to get the net back. They came straight in and lit twelve candles
And with the English at their command told all this.
And there was another that same summer,
Another man with one leg who saw three horses,
Race horses is what he thought.
Seen from a distance they galloped
'cross the sands and right into the waves
And away. That I heard secondhand but from a man of some authority.
What's seen on land you'll find in the sea, 'least some believe.
Well, keep an open mind. You never know what might come by,
What precious thing you hold inside.
What's pierced is pierced. Of that much I am certain.

THE BOY
The boy has found a turtle
Skull. The shells here pile high
And as a bright arc
Run some miles
Towards the inlet.
At hard dark these primeval
Waves will glow a tumbling green.
Once on this beach
I found a silver fork
Tines worn down to slivers.
My cousin found a boar's tooth
Dating back some piece of eons,
Back to when that first man
Grown tired of Korean
Shores, walked across the world,
Reached this beach
And with turtle skull in hand
Stood enthralled.

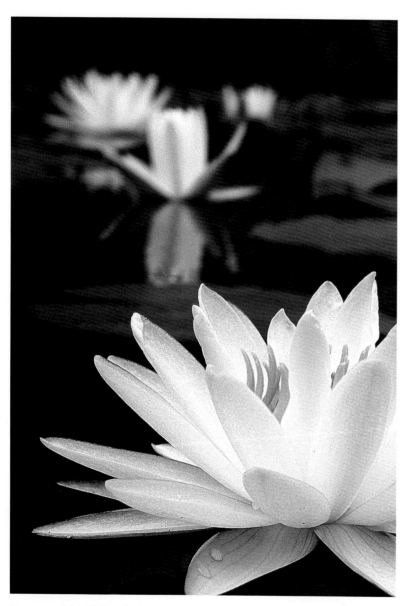

Home pond, McClellanville, S.C.

DEEP, DEEP IN THE ROMANTICS
Beyond the cedar trees, the osprey pitched,
Then, reconsidered, climbed again,
And seen's an Eden buried in the DNA
Of every fish and fowl, every kind of child
Born of flesh, born of promise.
In the pure all is pure
And in the foolish foolish.
A coded wing batters air
And whispers sound to the light.
Do I hear the lesson? Am I last in school?
At least this much I know:
These coiled suggestions of an honored body
Are spun and pasted with auspicious virtue.
Now let my eyes delight
In finding Eden dressed and kept by you.

DEEP RIVER II

Oh, our broad and deep Santee
Sweep a way toward the sea,
Let no bank or dike control
The purer rush of freshet roll,
But spread across the works of man,
Rise above the slave-built land,
Dull even press of God-built tides,
Flatten out on every side,
Make broad expanse of pearl-mud gray
That wipes all human thought away,
Then in a boat I'd like to be
Rowing from a nether shore
And glossy ibis, put them in,
A dozen straight up overhead
The hiss of water slipping past,
I've paused the oars,
The boat now spins
And rises high in cobalt sky
To scatter ibis on all sides.

Paint, McClellanville, S.C.

BILLY'S
Offerings

❦

Dwight and his buddy, McClellanville, S.C.

Margaret, soul of the horse, McClellanville, S.C.

Darby, McClellanville, S.C.

Lowry and Ali, McClellanville, S.C.

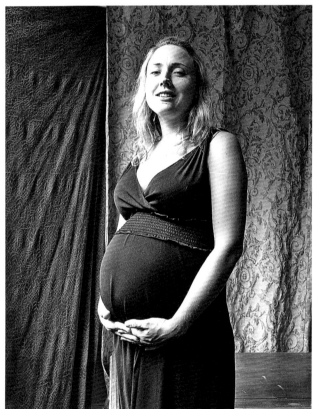

Aunt Lila, McClellanville, S.C.

Jane Erin, McClellanville, S.C.

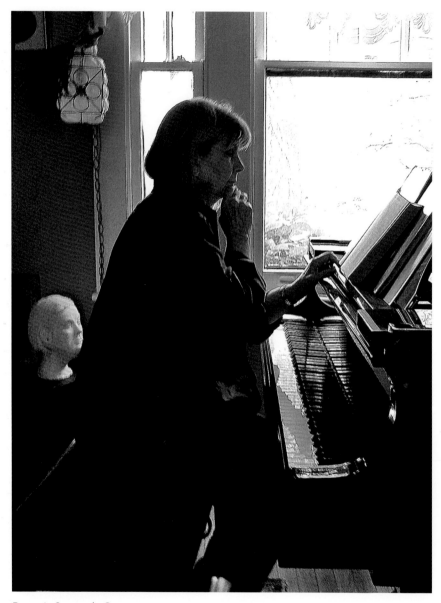

Emmy in Savannah, Ga.

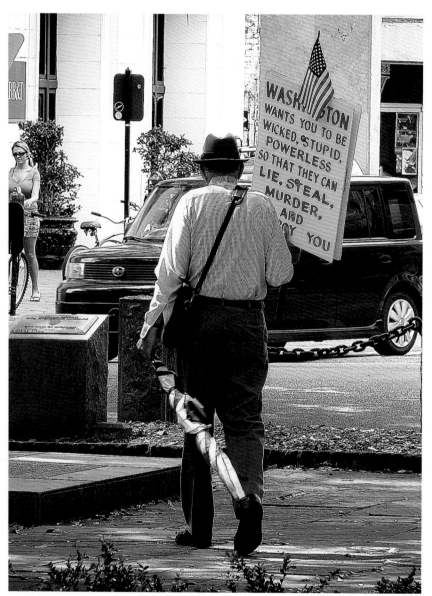

Something to say, Savannah, Ga.

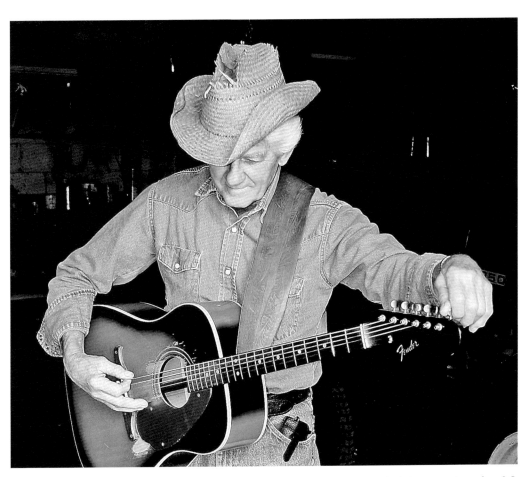

Andy tunes up, Awendaw, S.C.

Sharon is a singer too, McClellanville, S.C.

Ben and the Catesby's Lilies, McClellanville, S.C.

Lil and the Zinnias, McClellanville, S.C.

Pete and his mutts, McClellanville, S.C.

The kindergarten class, McClellanville, S.C.

"Sister," Pawley's Island, S.C.

Sam, McClellanville, S.C.

The End

A lifelong resident of the Carolina lowcountry, William P. Baldwin is an award-winning novelist, poet, biographer and historian. He graduated from Clemson University with a BA in History and an MA in English. He ran a shrimp boat for nine years then built houses, but the principle occupation of his life has been writing. His works include *Plantations of the Low Country, Low Country Plantations Today*, (both with architectural photographer N. Jane Iseley); *Mantelpieces of the Old South* with photographer V. Elizabeth Turk; and the oral histories, *Mrs. Whaley and her Charleston Garden* and *Heaven is a Beautiful Place.* For its depiction of Southern race relations, his novel *The Hard to Catch Mercy* won the Lillian Smith Award. He supplied the text for chef Charlotte Jenkin's *Gullah Cuisine,* the popular cookbook published by Evening Post Books. Done with photographer Selden Hill and also published by Evening Post Books, *The Unpainted South* won the 2012 Benjamin Franklin Award for Poetry given by the Independent Books Publishers Association.

Sharon Cumbee says, "I am a singer/ songwriter with a passion for good music, musicians, and songwriters. If you took a southern belle, crossed her with a swampwater-fed country gal, gave her the love of the lowcountry, then you could name her Sharon Cumbee. Correction. I am a singer/songwriter with a passion for good music, musicians, and songwriters. Besides my family, friends and music...my other love is photography!"

Selden B. Hill is a photographer, artist and founding director of The Village Museum at McClellanville, S.C. Some time ago, he was a printer, salesman, and furniture store manager. Along with Susan Hoffer McMillan he is the author of the pictorial *McClellanville and the St. James, Santee Parish* published in 2006. In 2007 the state of S.C. conferred upon him The Order of the Silver Crescent in recognition of his public service. He collaborated with William Baldwin on last year's award-winning *The Unpainted South.*

Robert Epps is a photographer and architect. He began his collegiate studies as a fine arts major at the University of South Carolina. He received a Masters of Architecture degree from Clemson University in 1977. While pursuing his Masters of Architecture degree, he studied photography under nationally prominent photography educator Sam Wang. This study concluded with a solo exhibit at the Clemson University Student Union Gallery with a selection of black-and-white silver prints. In more recent years he has exhibited as part of the Piccolo Spoleto celebration and other Charleston venues. He uses a 4x5 Linhof view camera. All his images are captured on traditional film. While producing 32" x 40" large color prints requires more involved technical processes, his smaller 16"x 20" black-and-white silver prints are produced by traditional enlarger process in his office/studio at 1 Pinckney Street in Charleston.